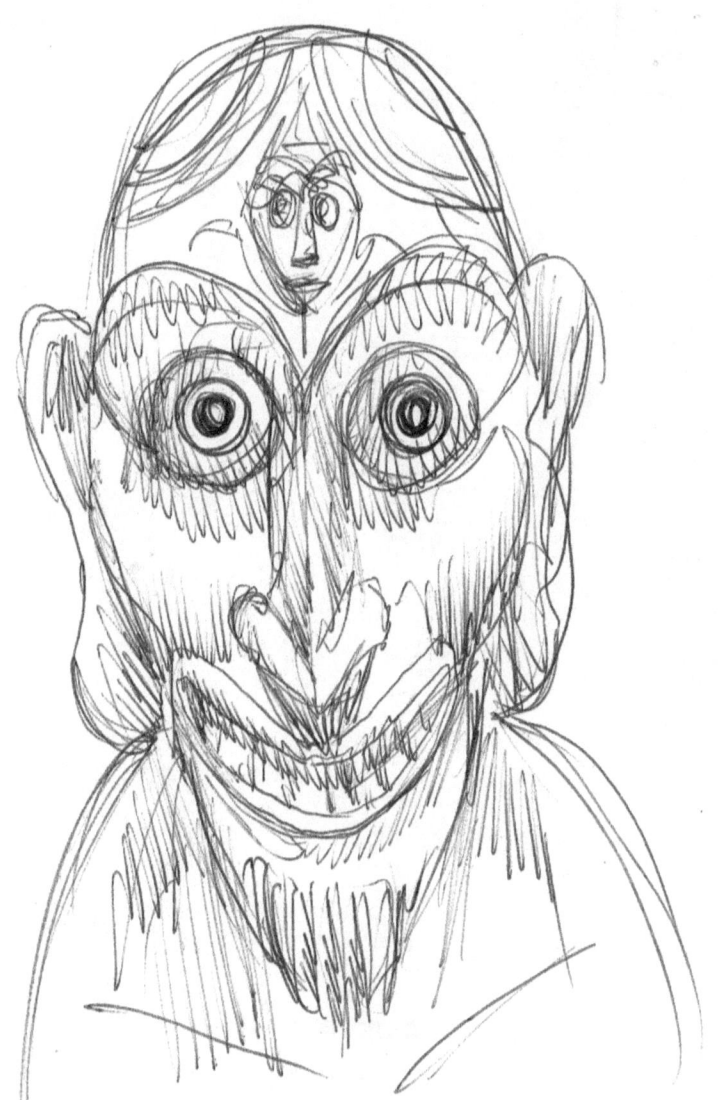

SOPHISTICATES AND WEIRDOS
Sketches & Scribbles

ROBERT JIMÉNEZ

SOPHISTICATES AND WEIRDOS

© 2019 Robert Jiménez

All rights reserved. No part of this work may be reproduced or transmitted in form or by any means, electronic or mechanical, including photocopying, recording, or by any information storage or retrieval system, without the prior written permission of the copyright owner, exempting for book reviewing purposes.

All characters in this work are fictitious. Any resemblance to real persons, living or dead, is purely coincidental.

Robert Jimenez
P.O. Box 260491
Pembroke Pines, FL 33026

www.zerostreet.com
www.strangewise.com
www.tikitower.com

ISBN: 9781793298669

SOPHISTICATES AND WEIRDOS

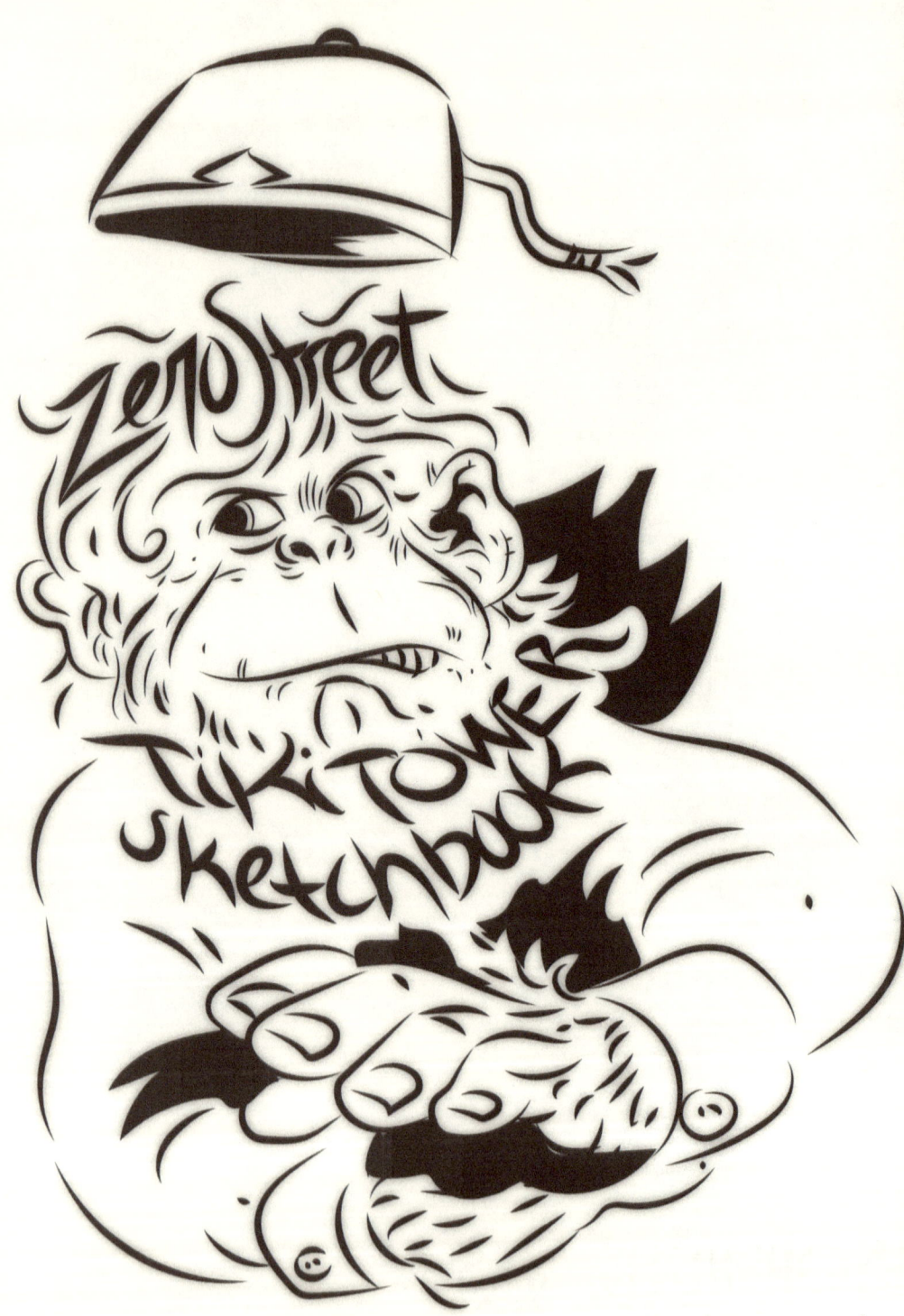

SOPHISTICATES AND WEIRDOS

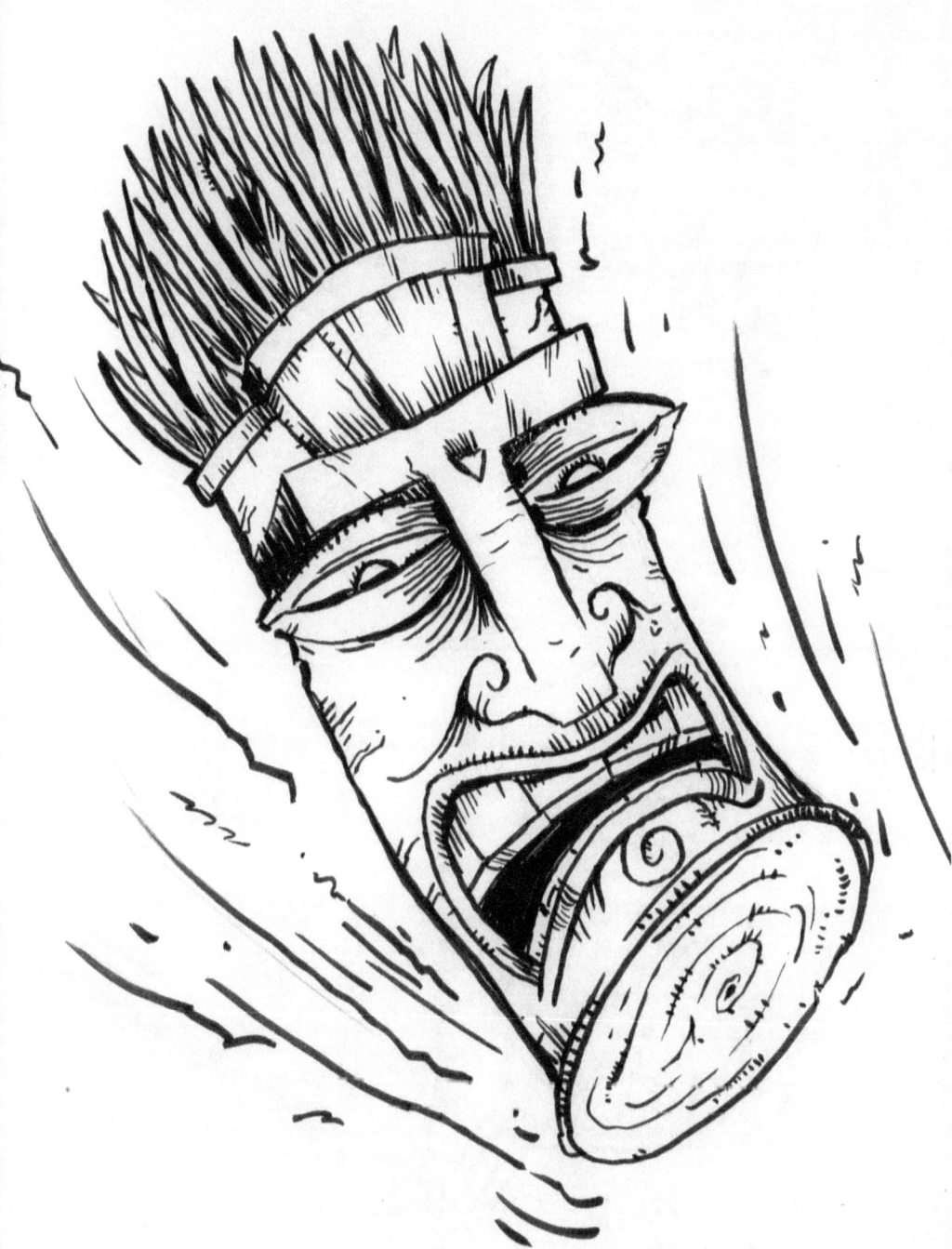

SOPHISTICATES AND WEIRDOS

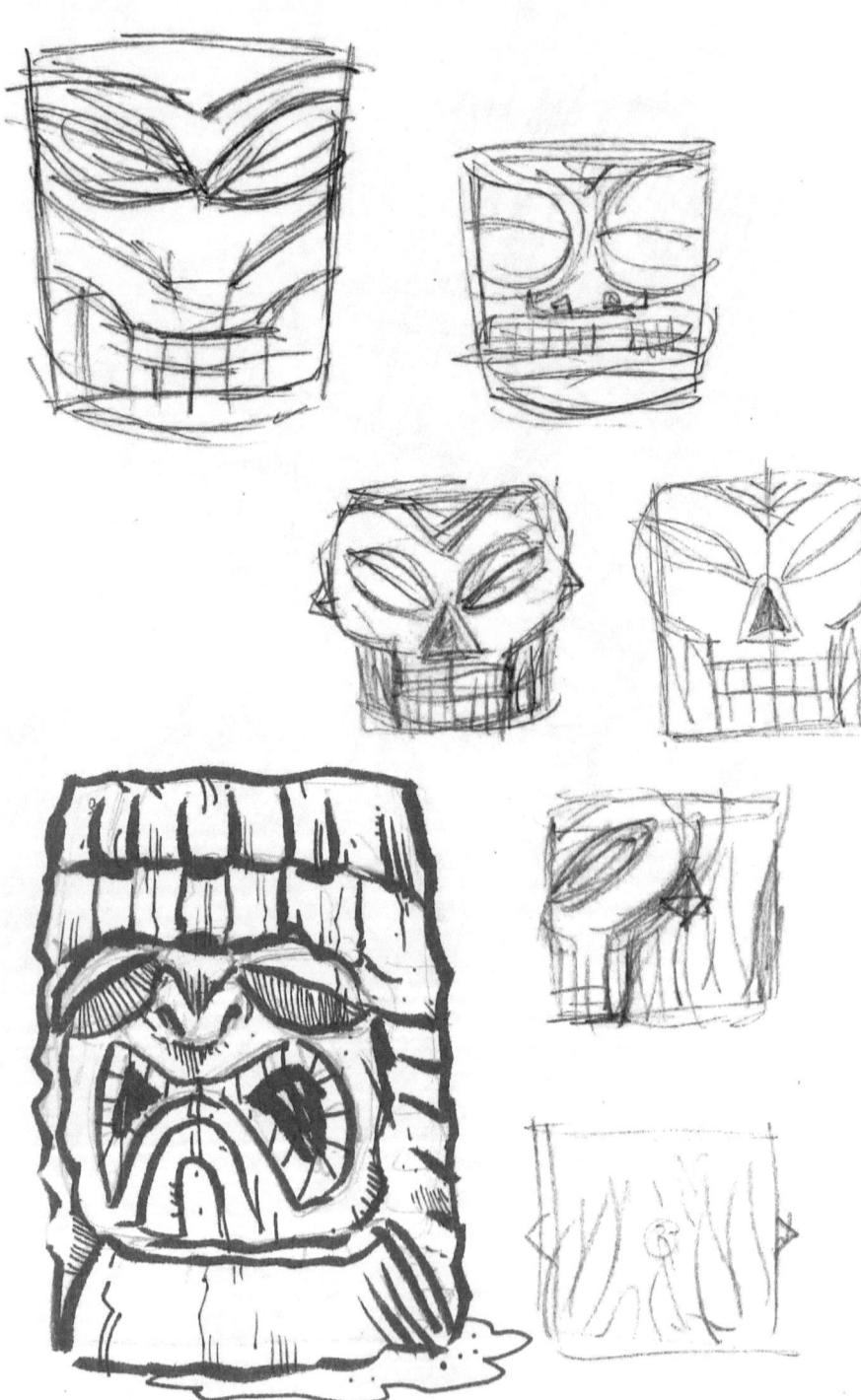

SOPHISTICATES AND WEIRDOS

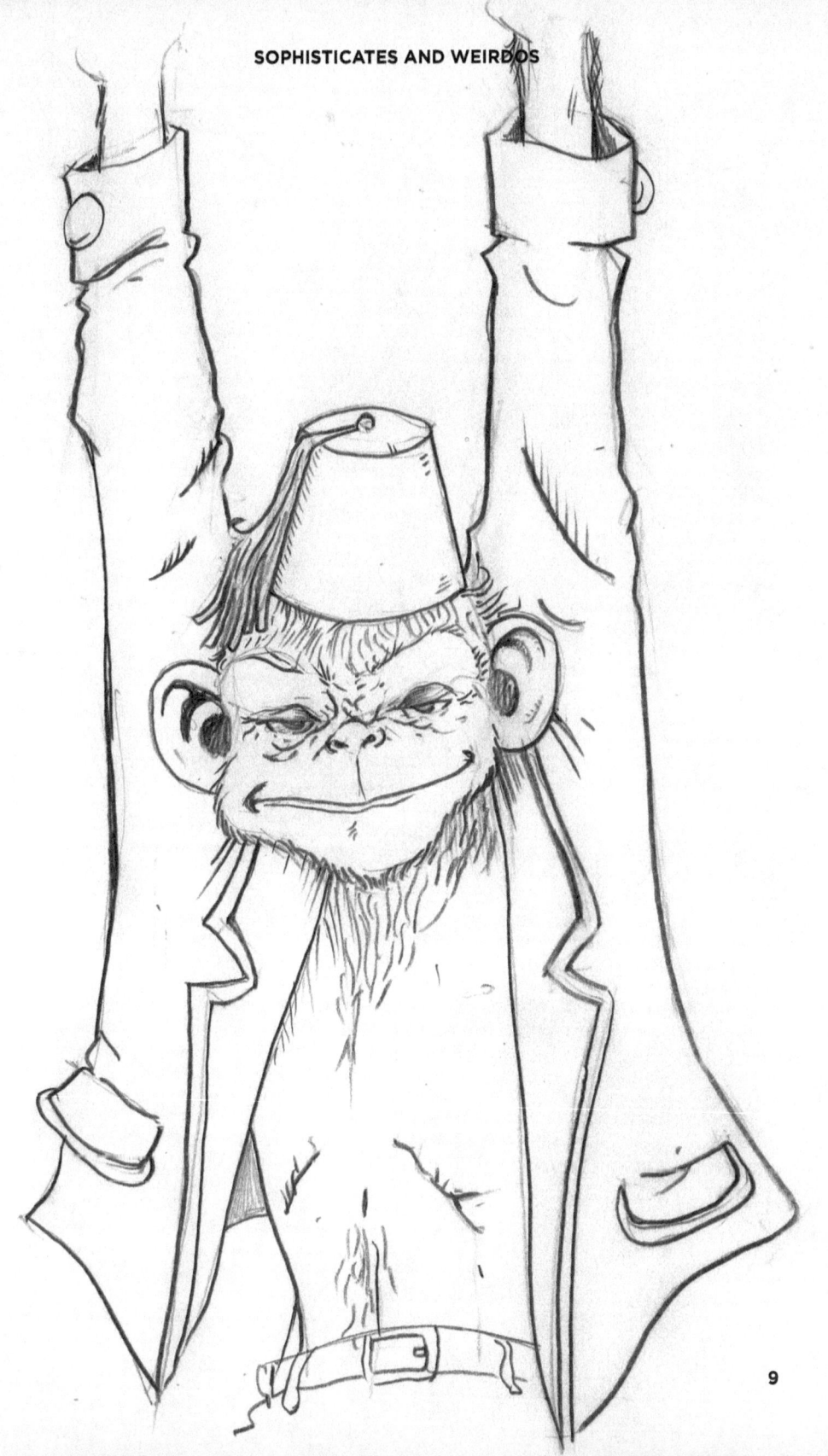

SOPHISTICATES AND WEIRDOS

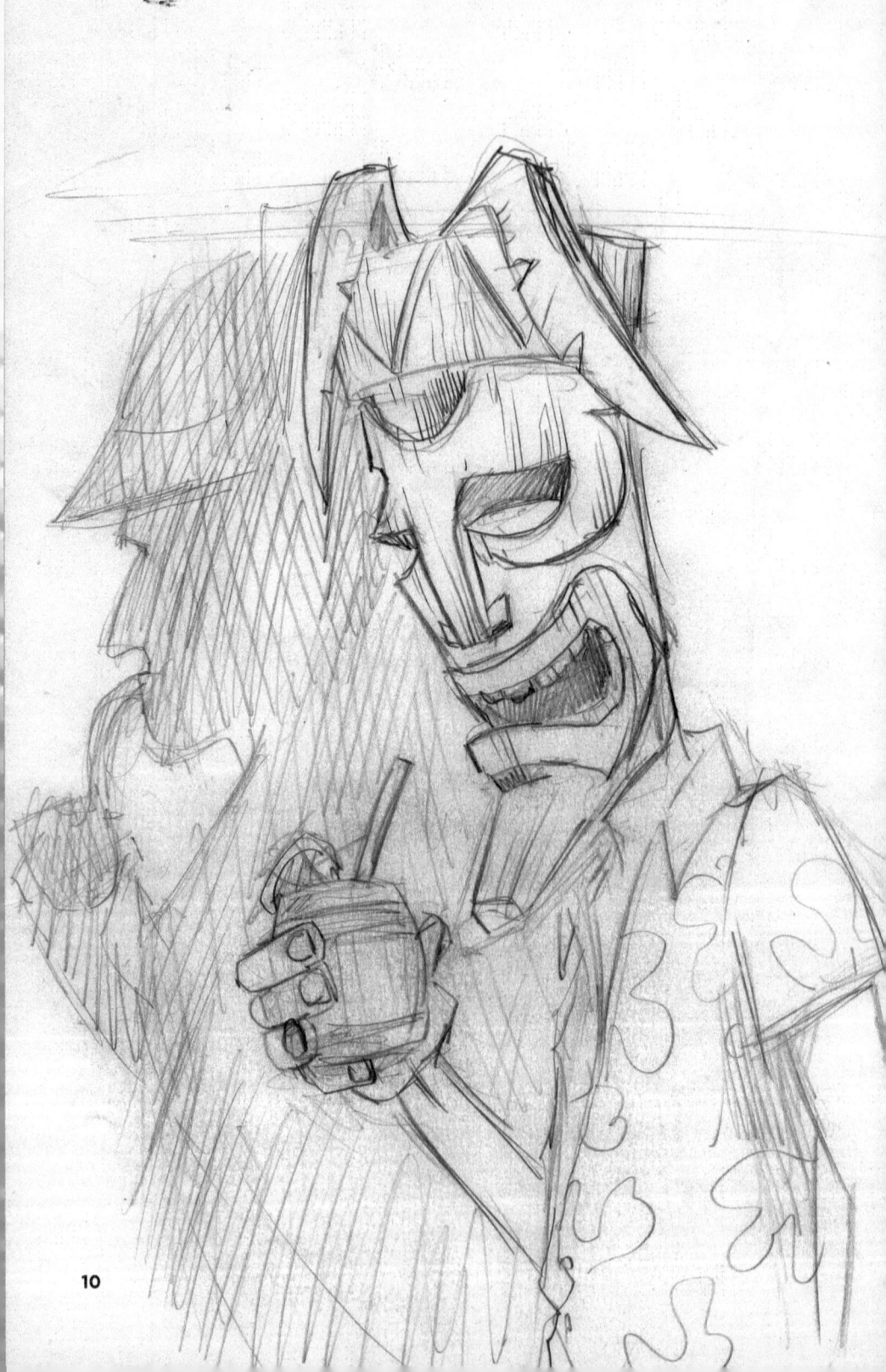

SOPHISTICATES AND WEIRDOS

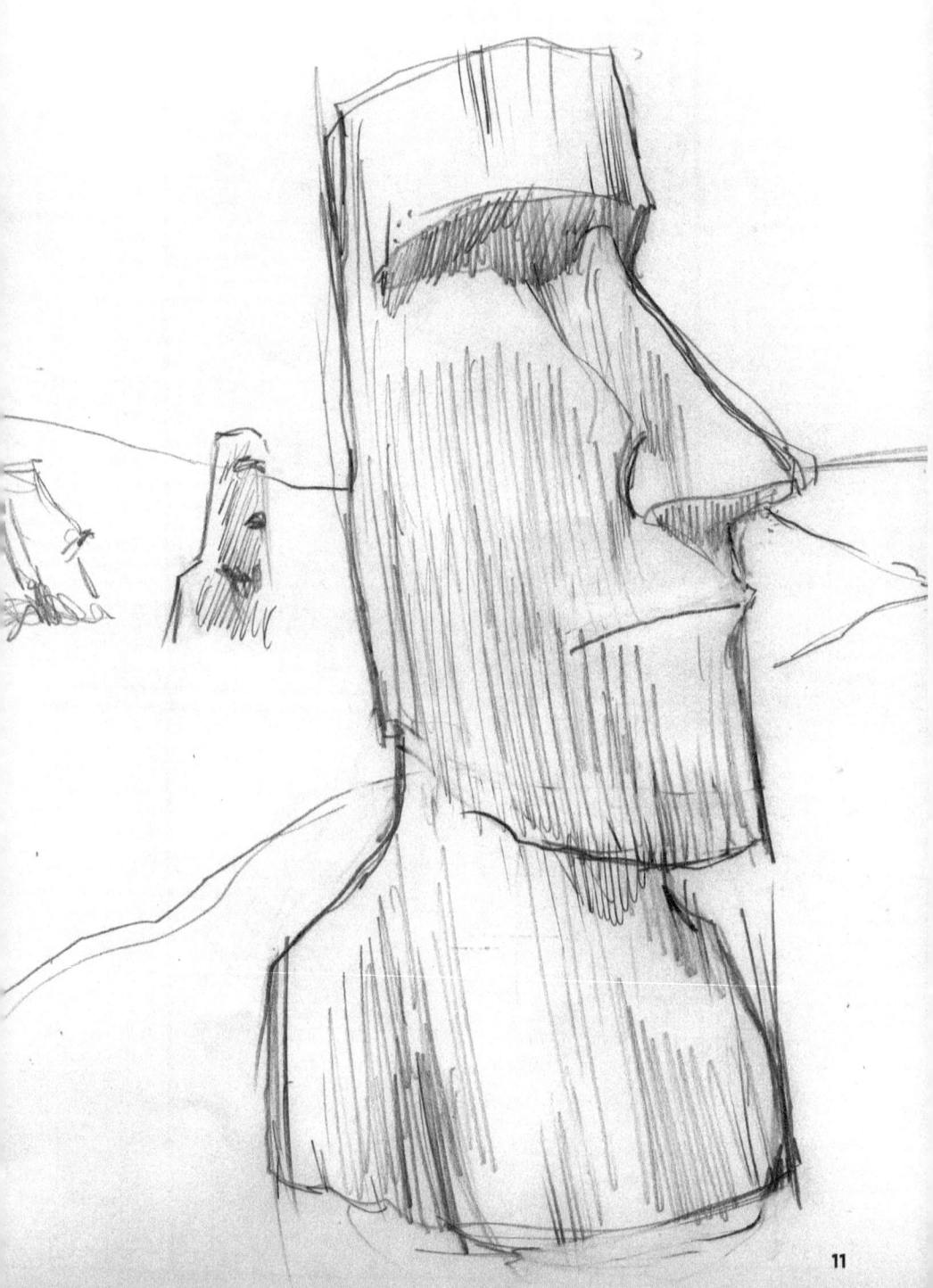

SOPHISTICATES AND WEIRDOS

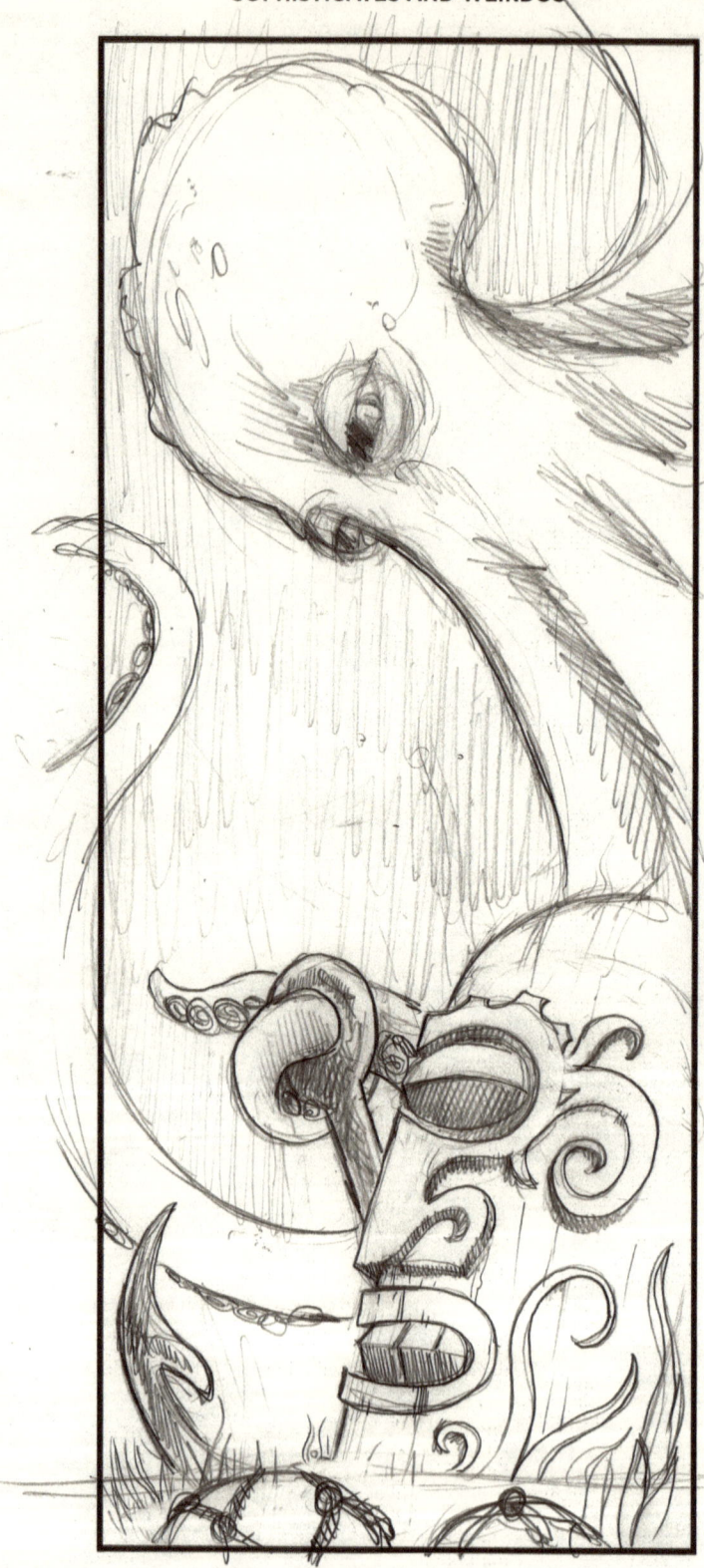

SOPHISTICATES AND WEIRDOS

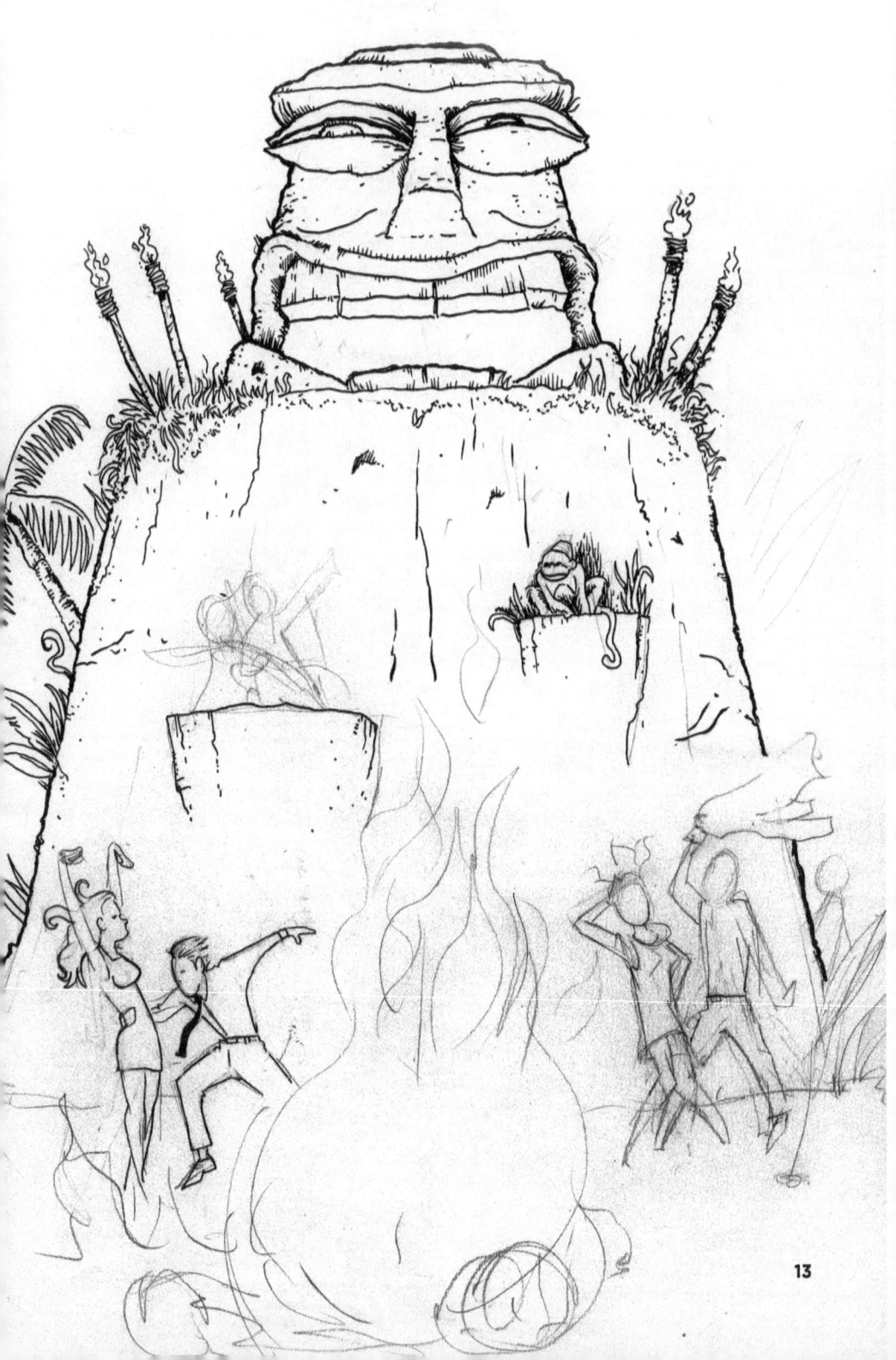

SOPHISTICATES AND WEIRDOS

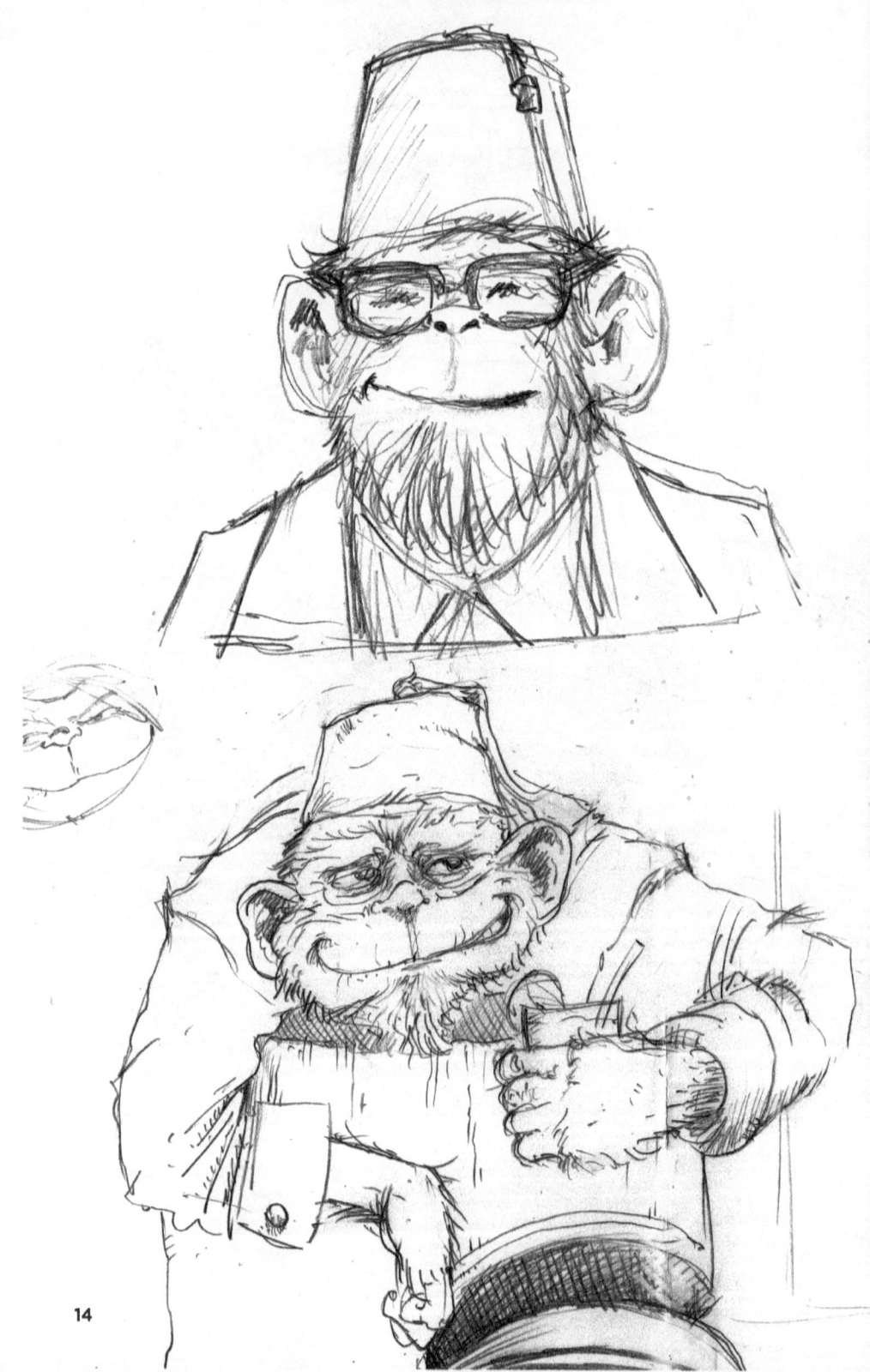

SOPHISTICATES AND WEIRDOS

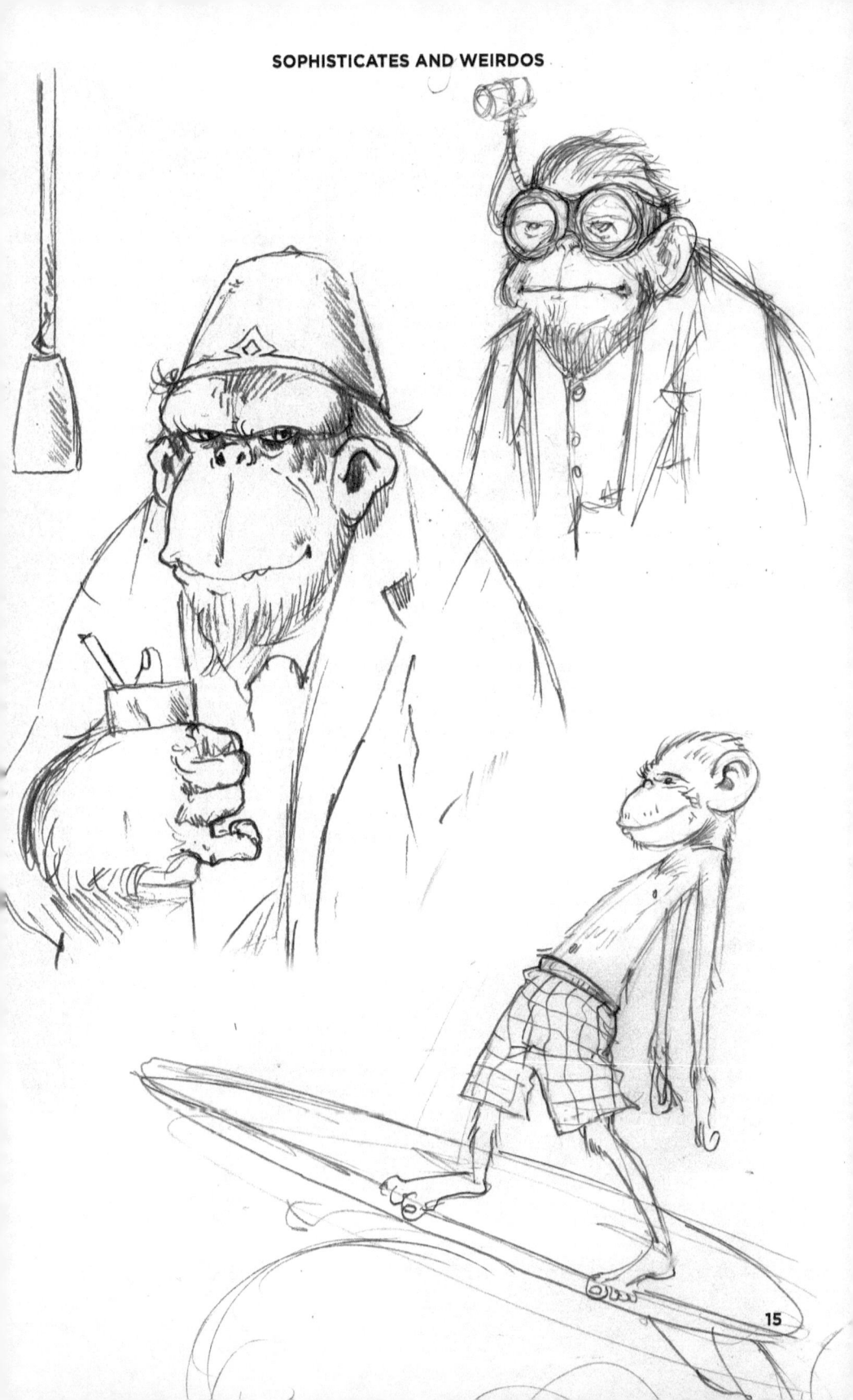

SOPHISTICATES AND WEIRDOS

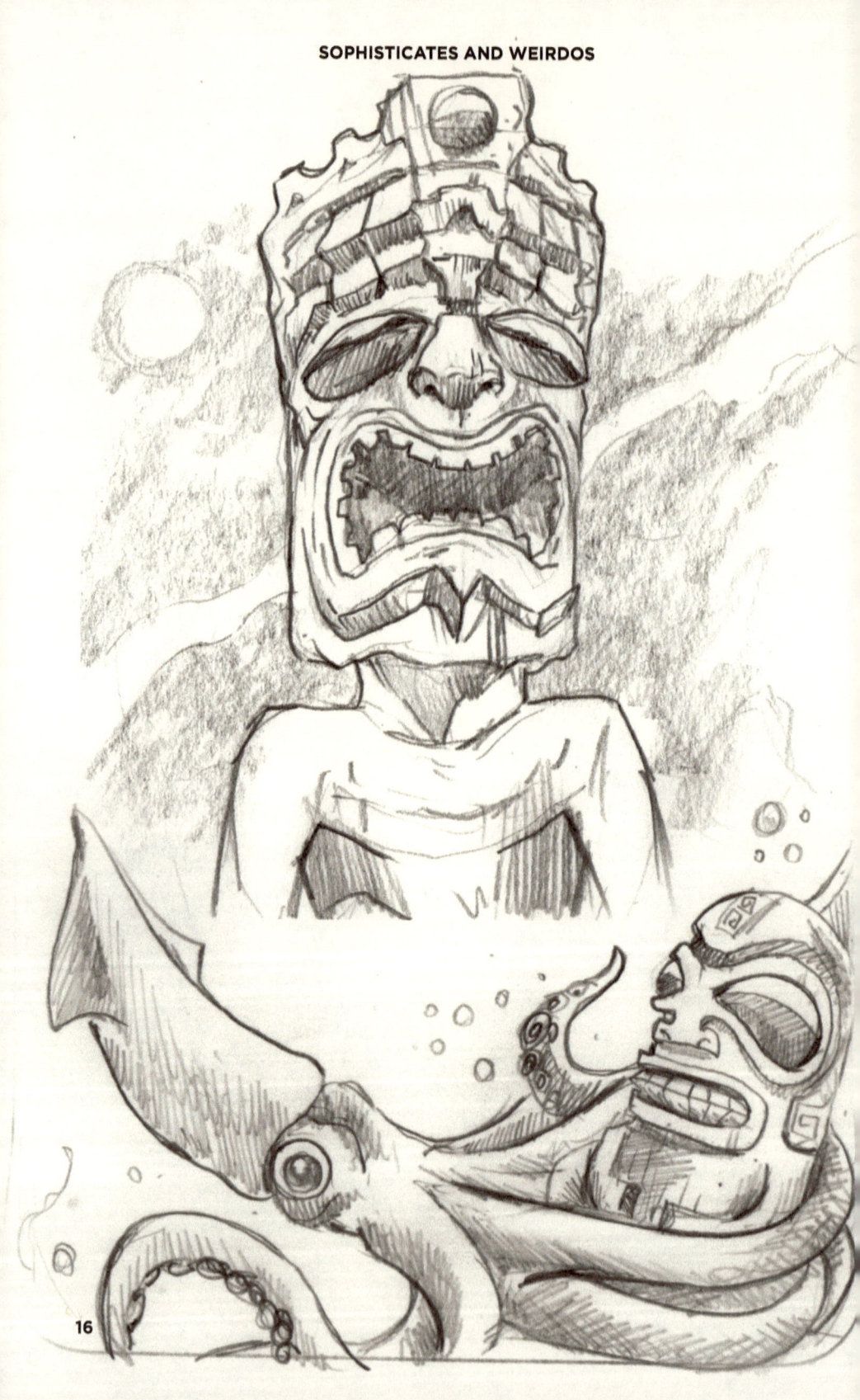

SOPHISTICATES AND WEIRDOS

SOPHISTICATES AND WEIRDOS

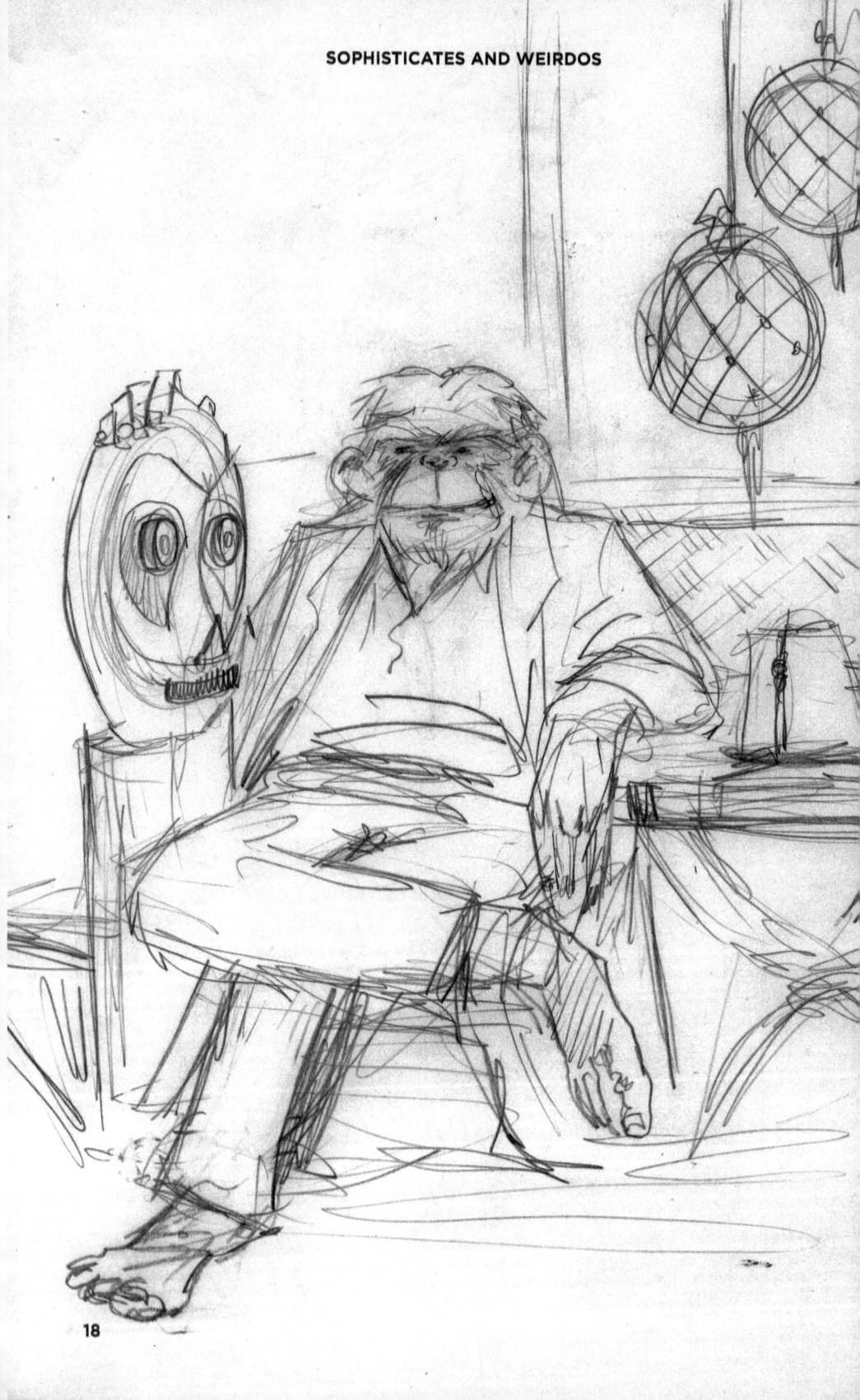

SOPHISTICATES AND WEIRDOS

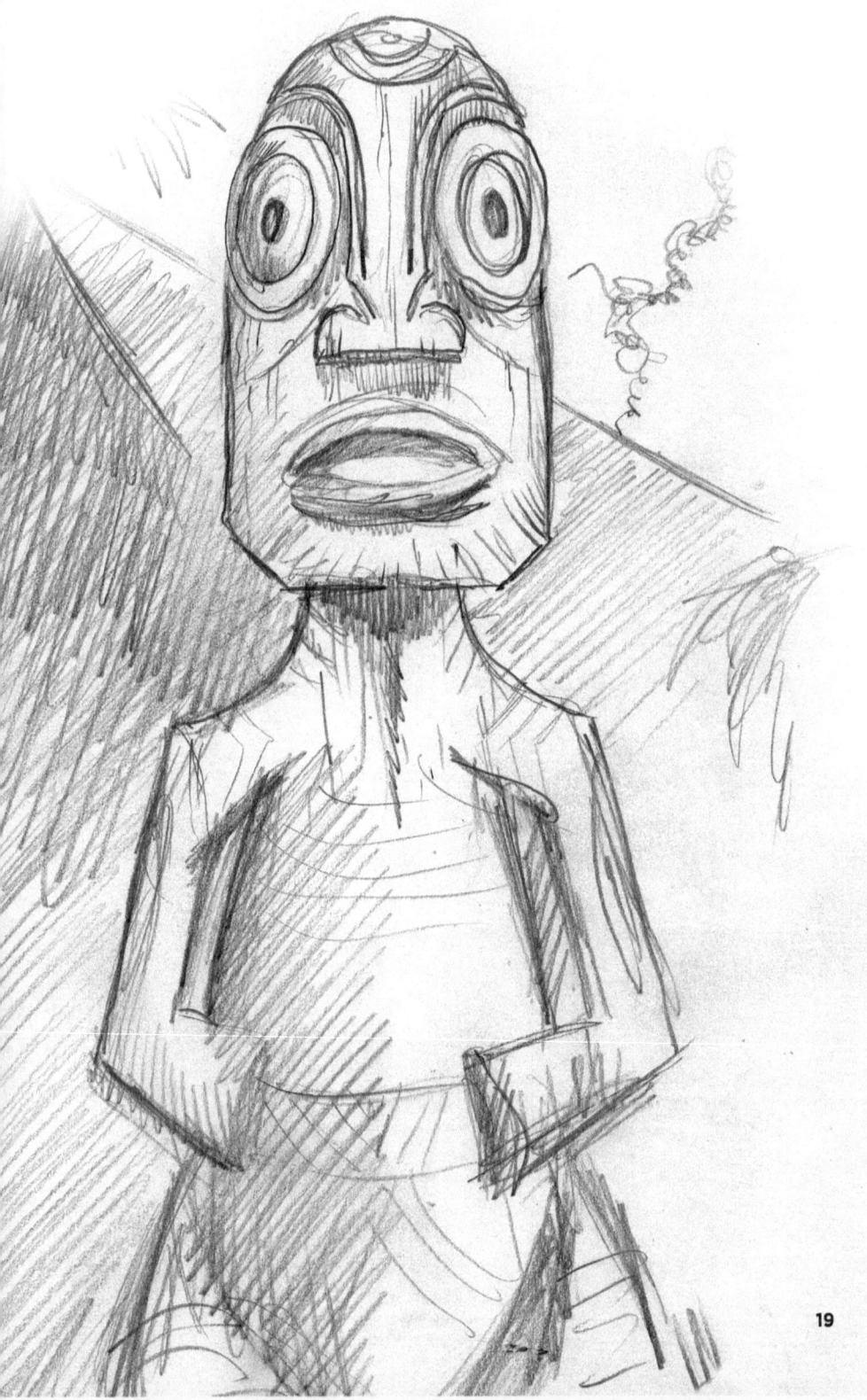

SOPHISTICATES AND WEIRDOS

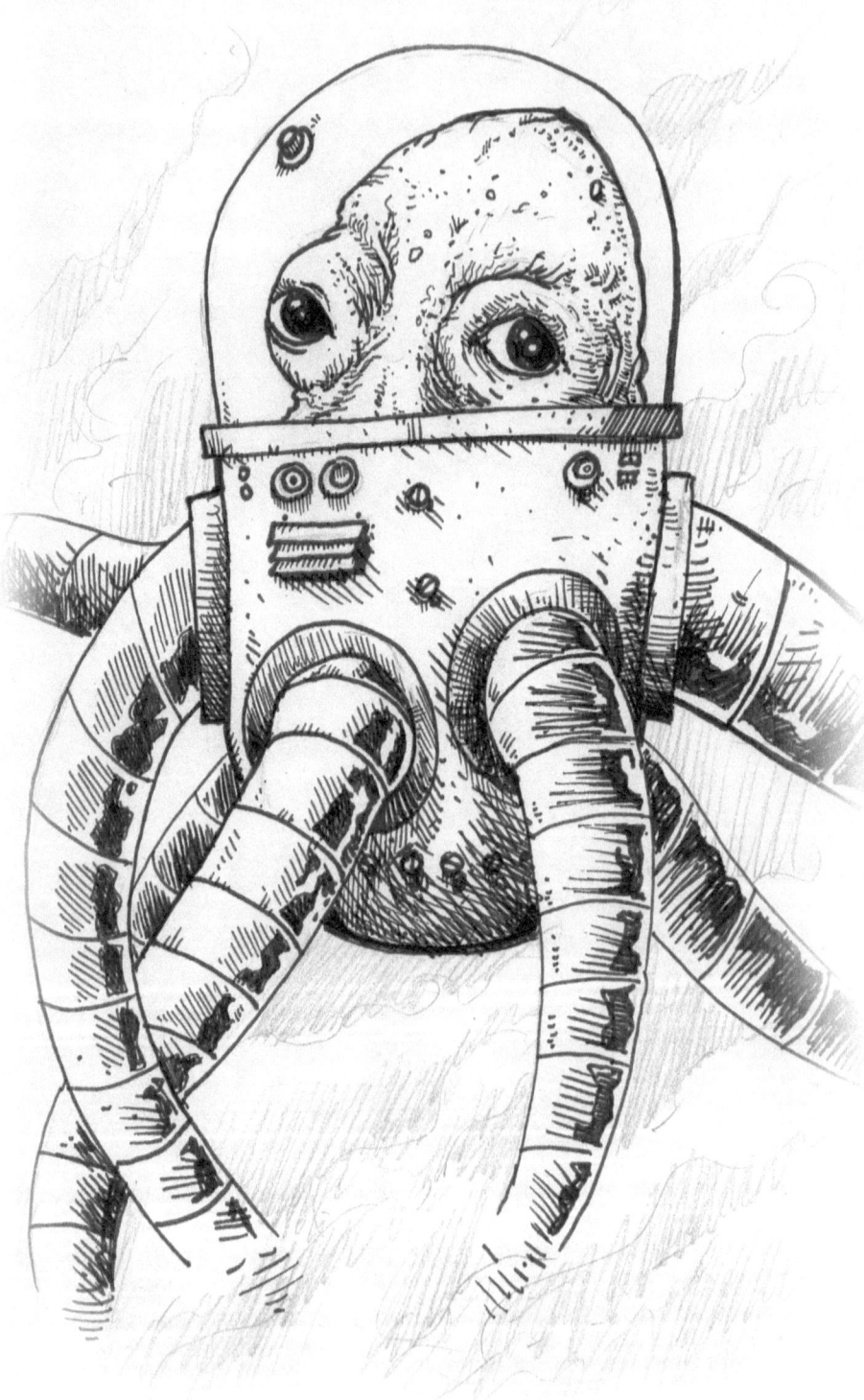

SOPHISTICATES AND WEIRDOS

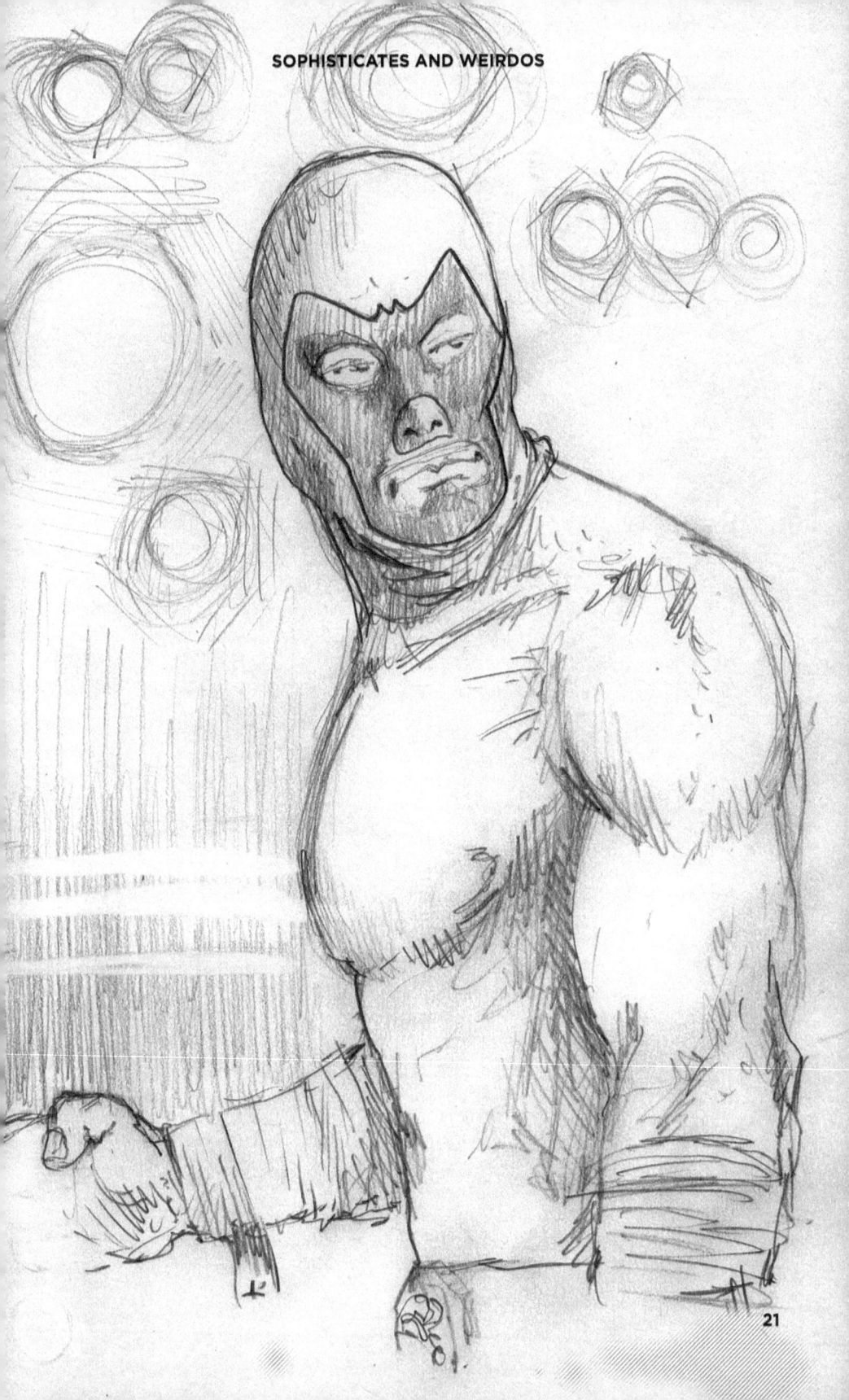

SOPHISTICATES AND WEIRDOS

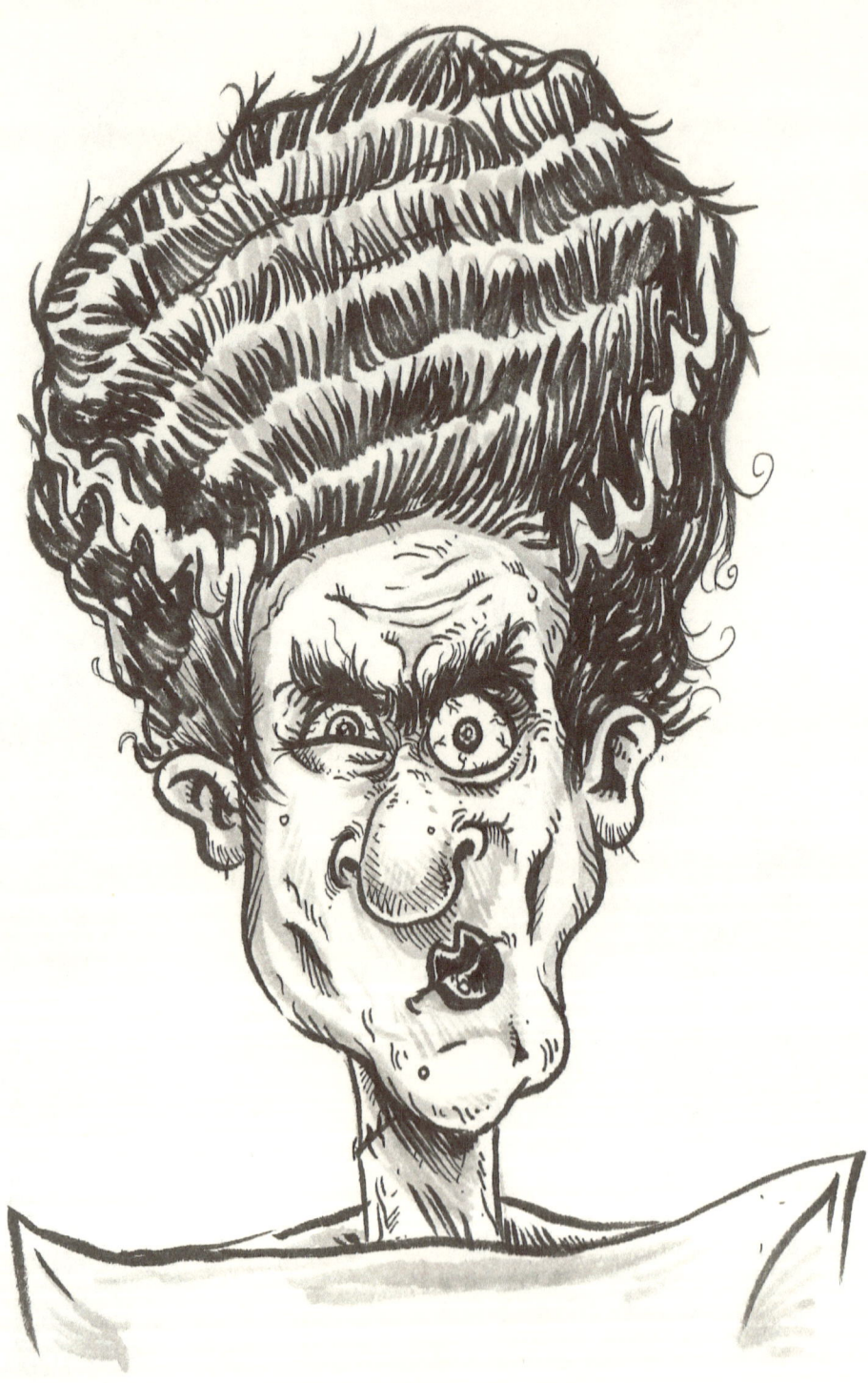

SOPHISTICATES AND WEIRDOS

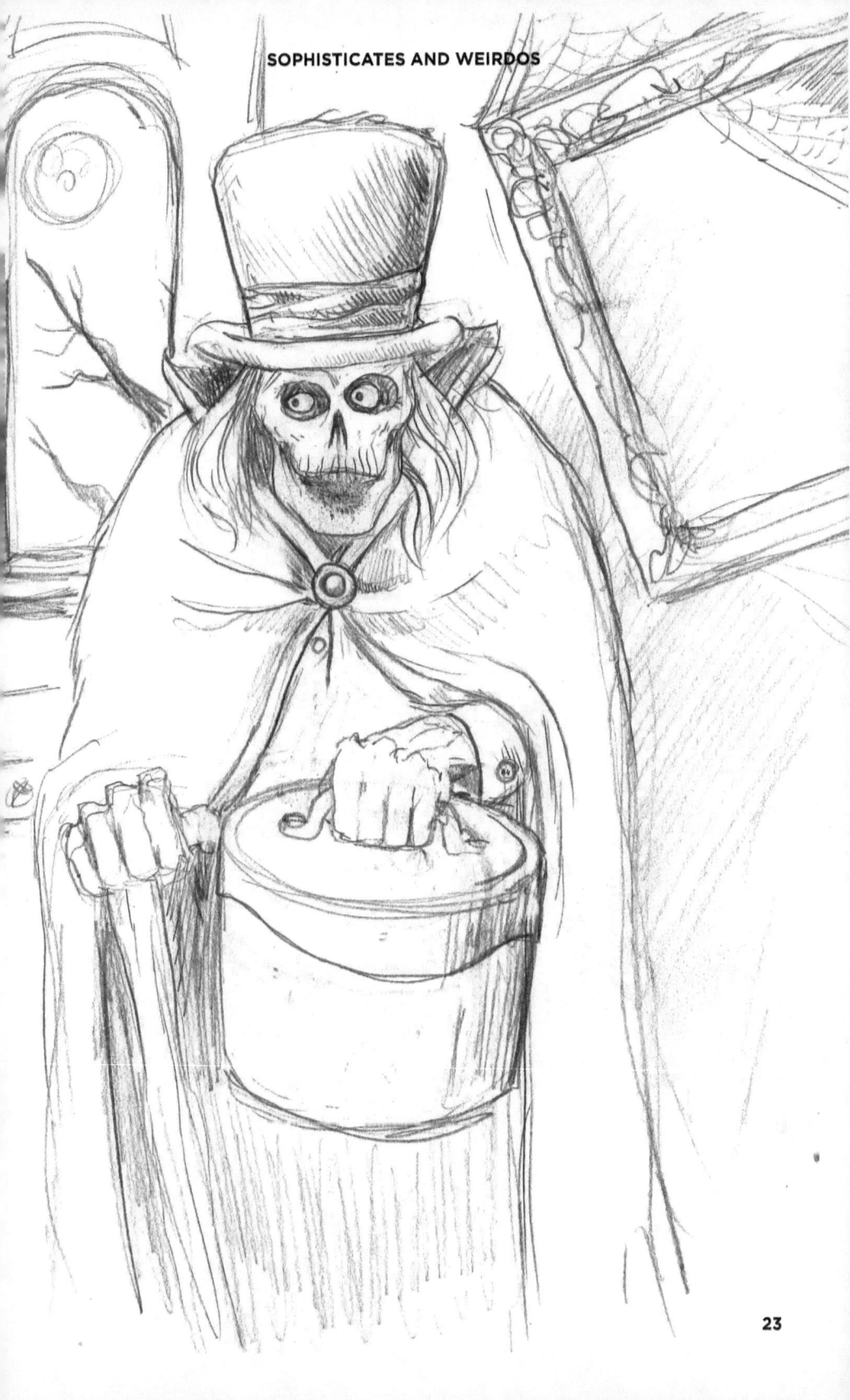

SOPHISTICATES AND WEIRDOS

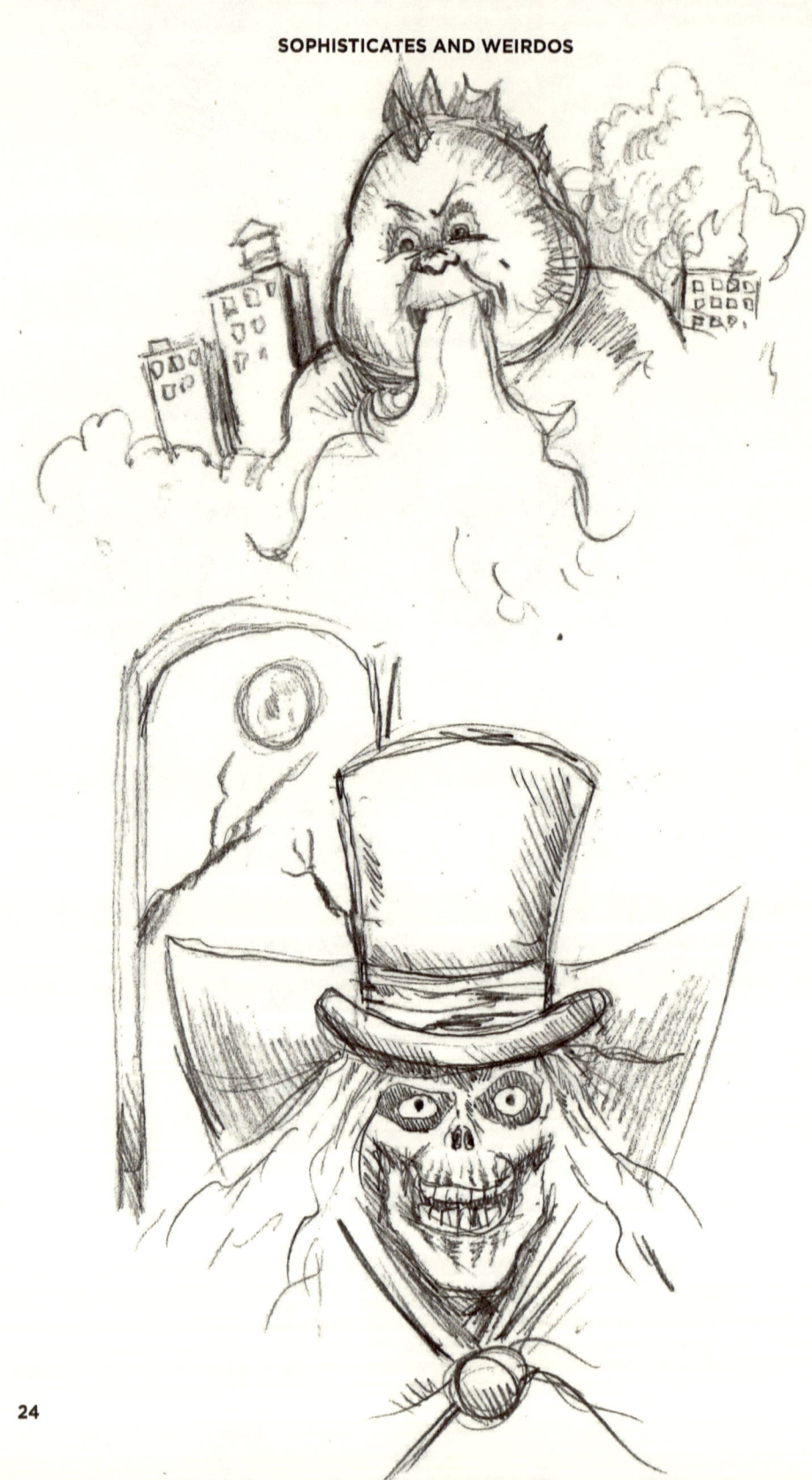

SOPHISTICATES AND WEIRDOS

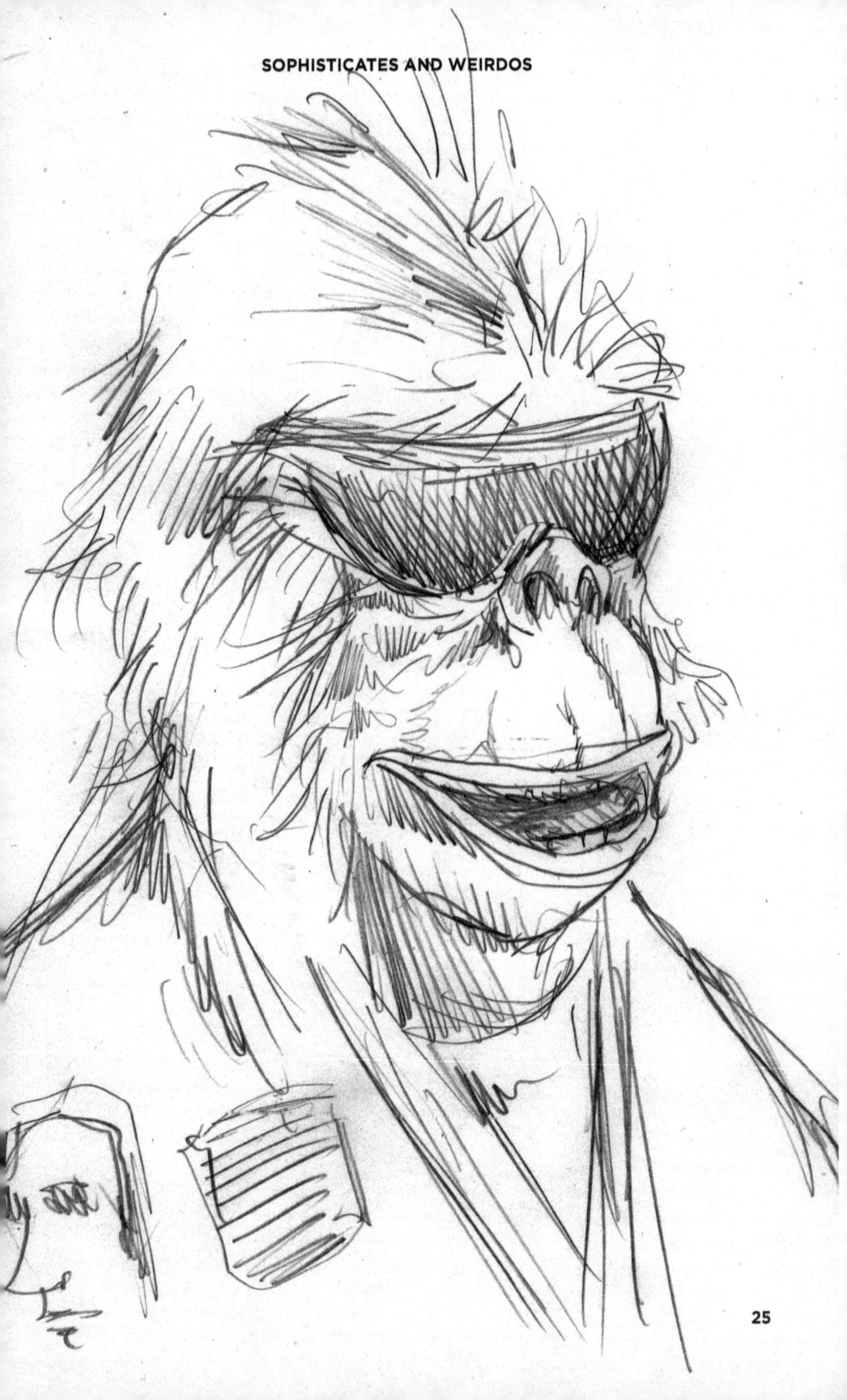

SOPHISTICATES AND WEIRDOS

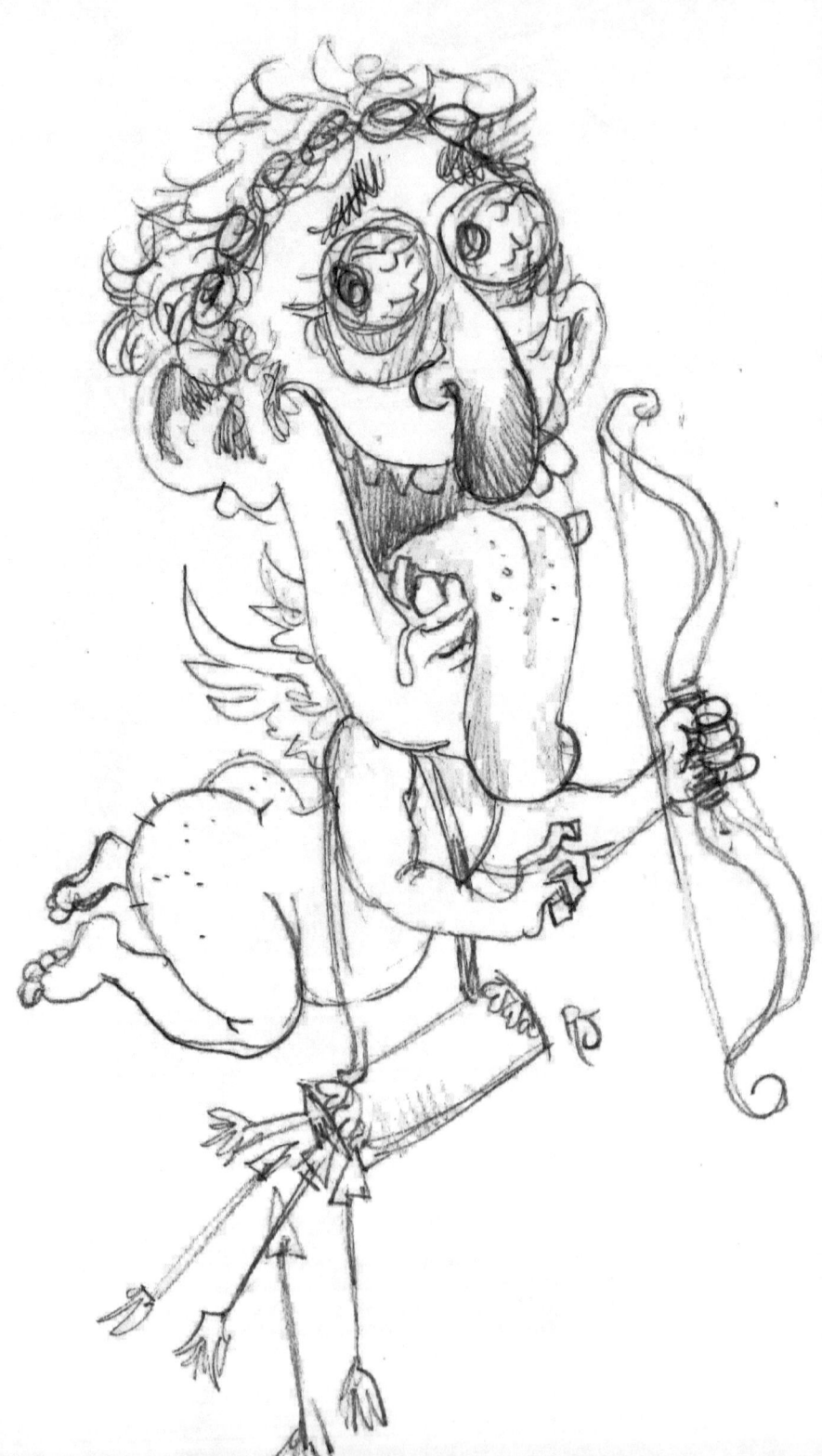

SOPHISTICATES AND WEIRDOS

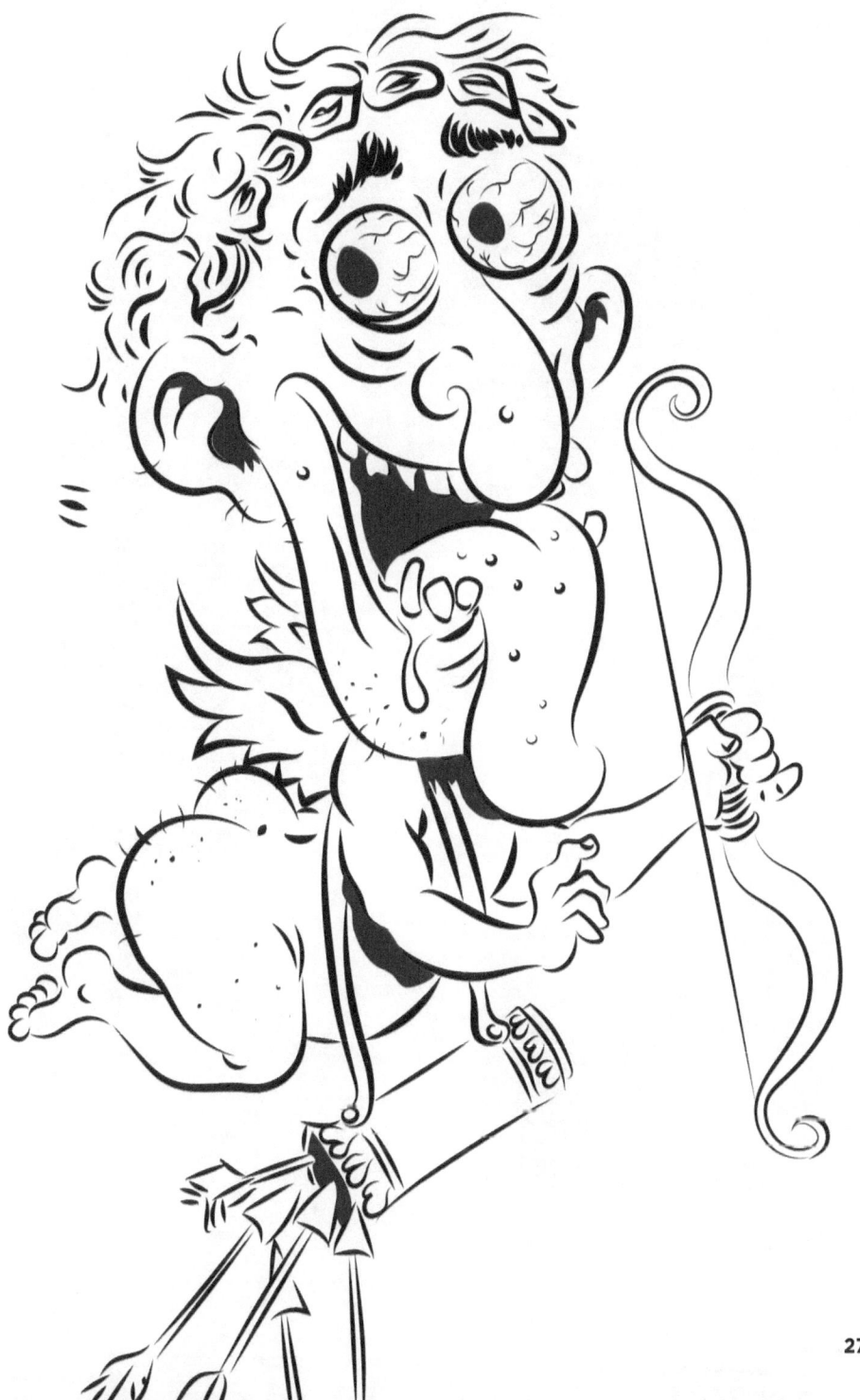

SOPHISTICATES AND WEIRDOS

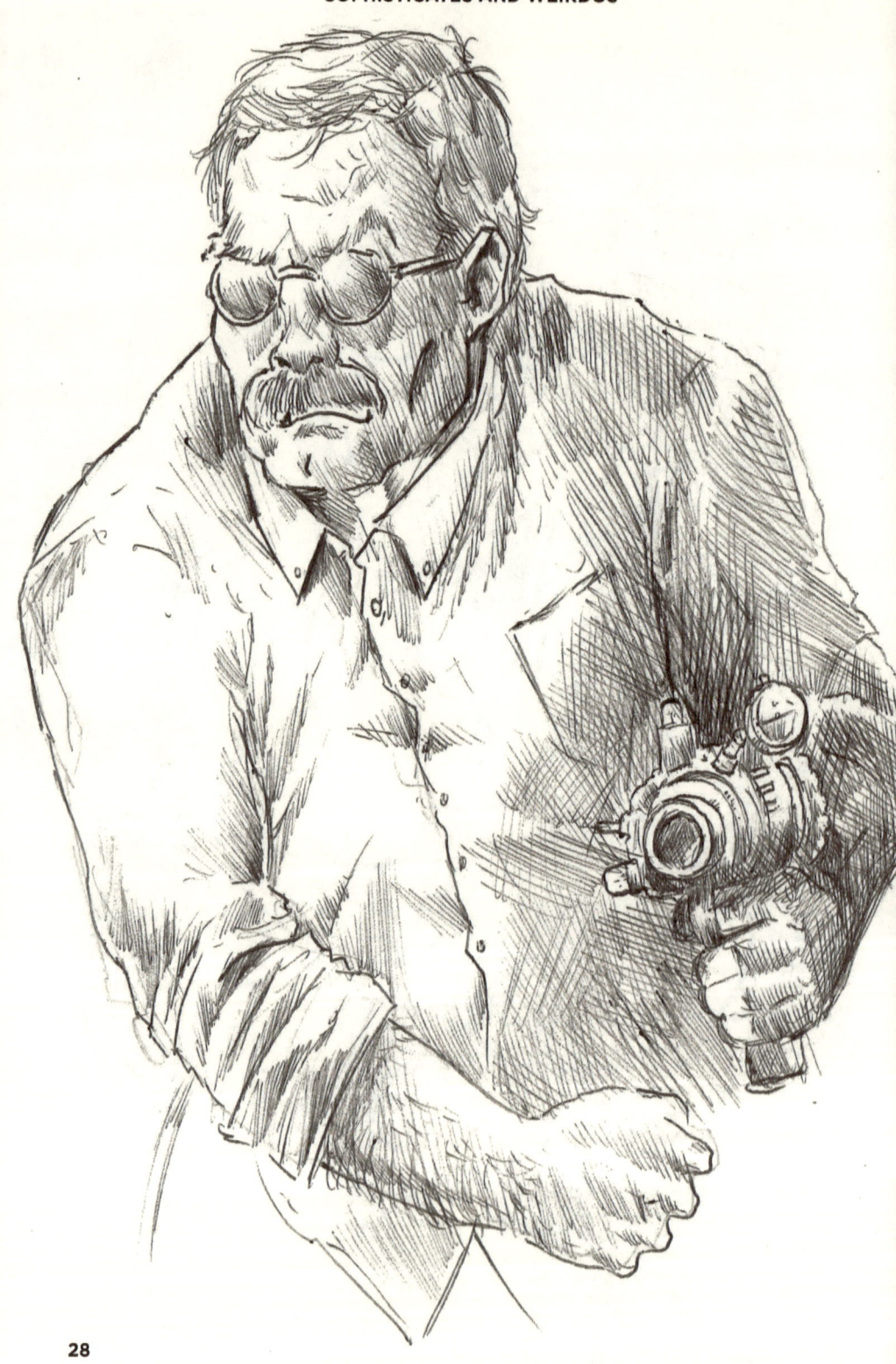

SOPHISTICATES AND WEIRDOS

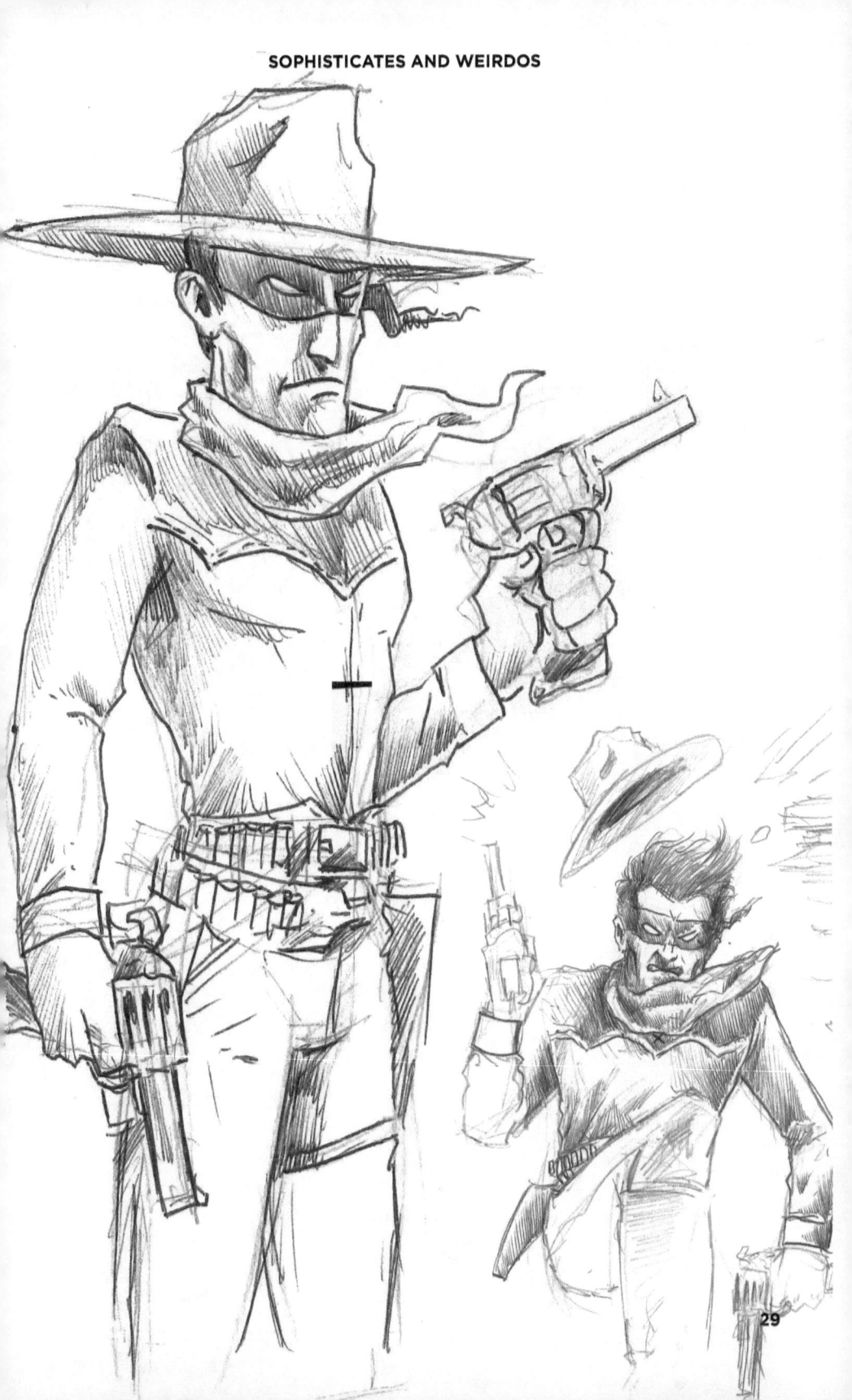

SOPHISTICATES AND WEIRDOS

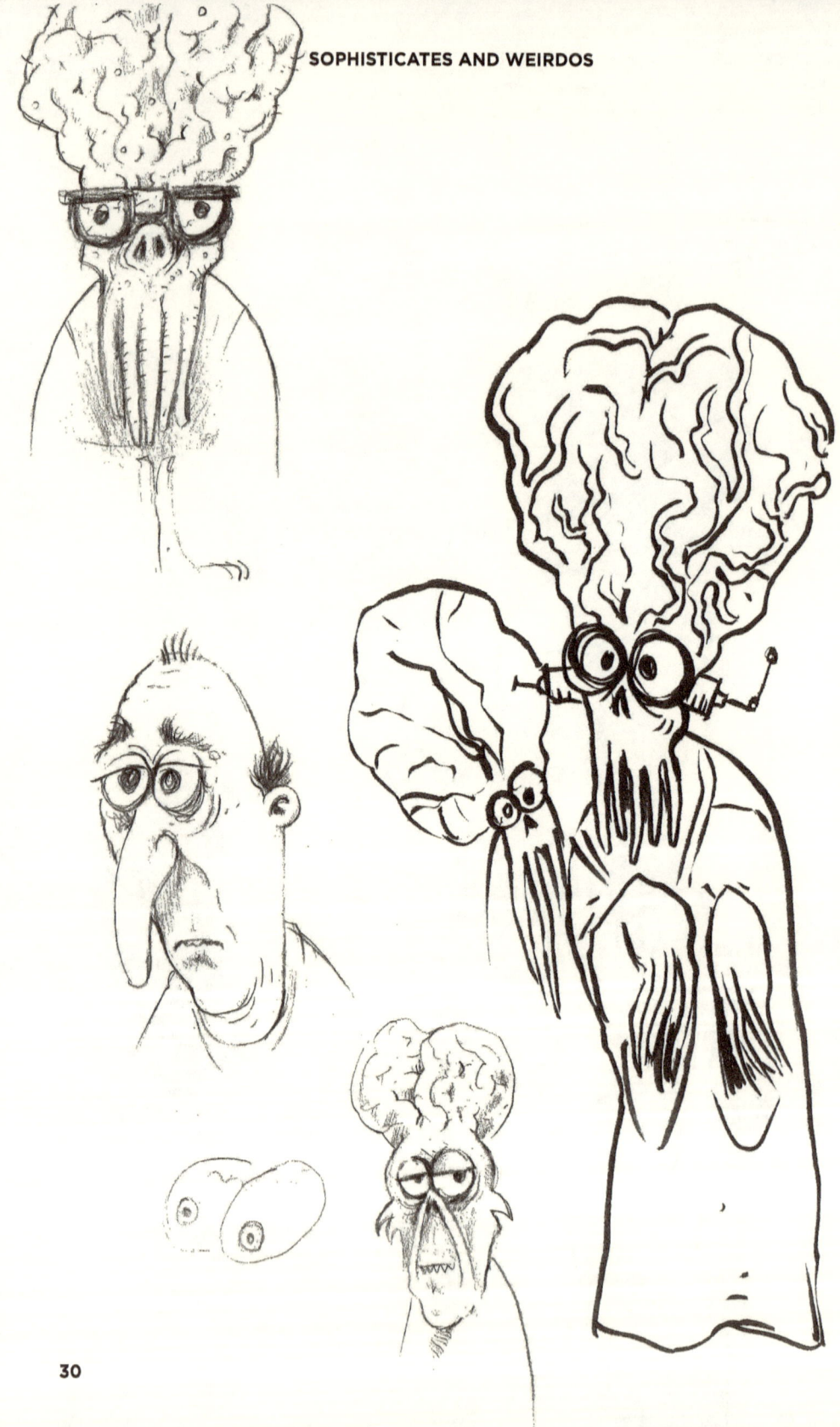

SOPHISTICATES AND WEIRDOS

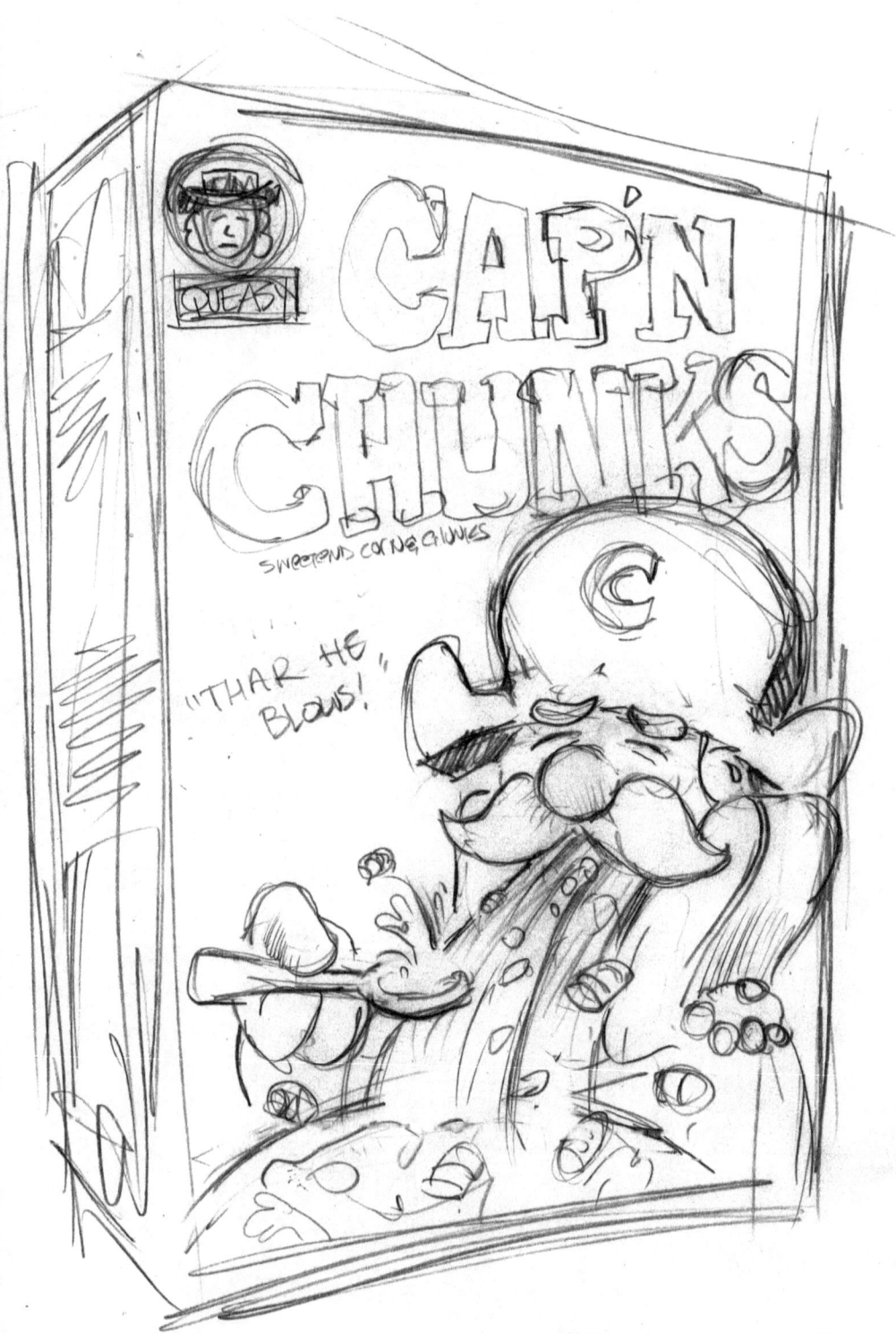

SOPHISTICATES AND WEIRDOS

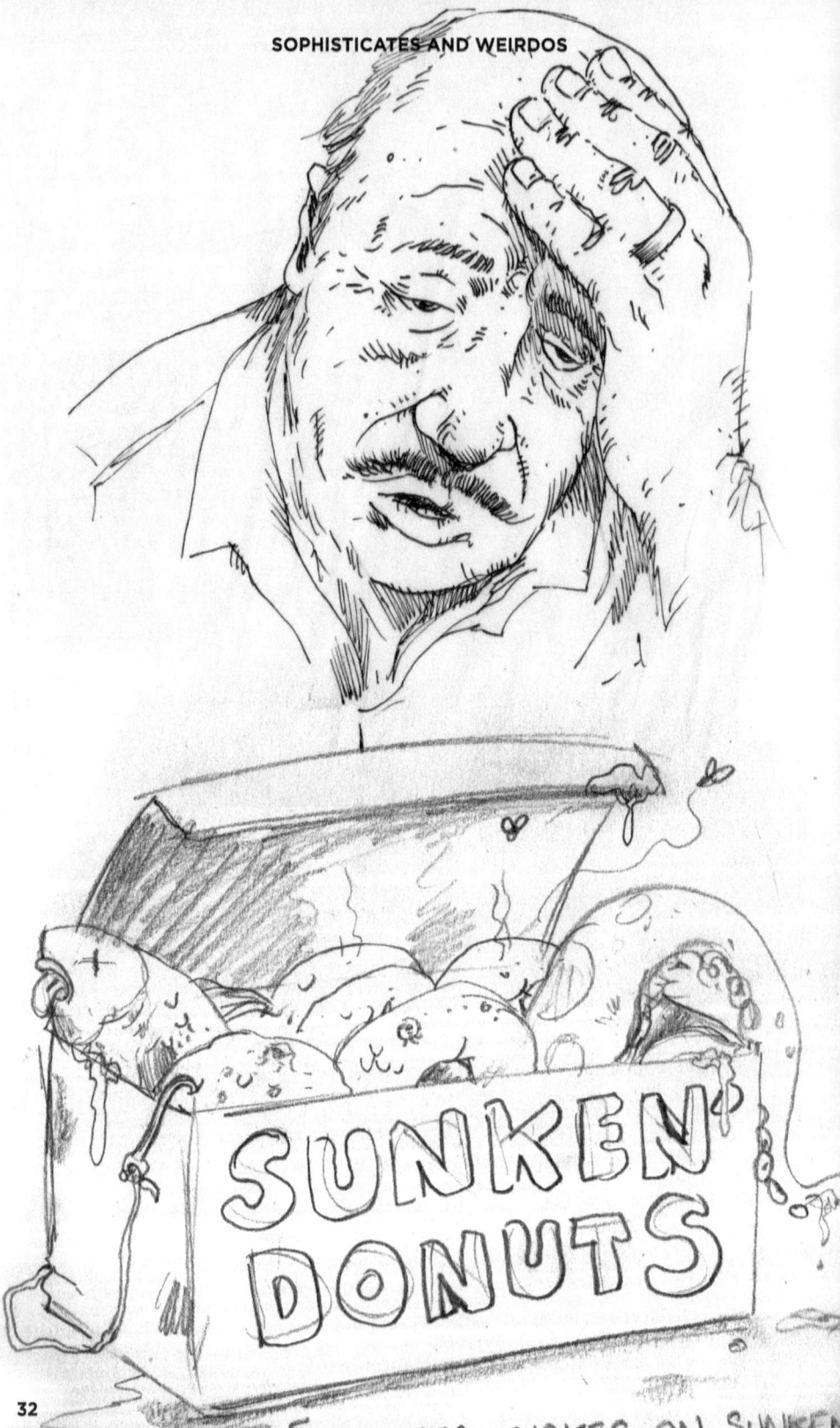

ATLANTIS CHOKES ON SUNKEN

SOPHISTICATES AND WEIRDOS

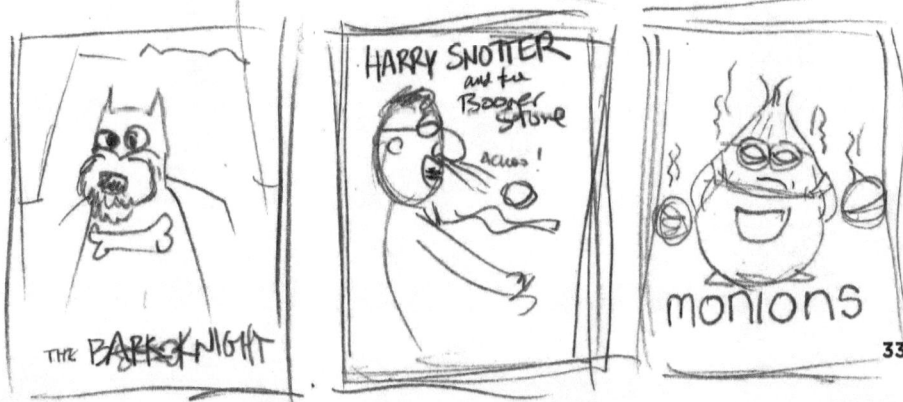

SOPHISTICATES AND WEIRDOS

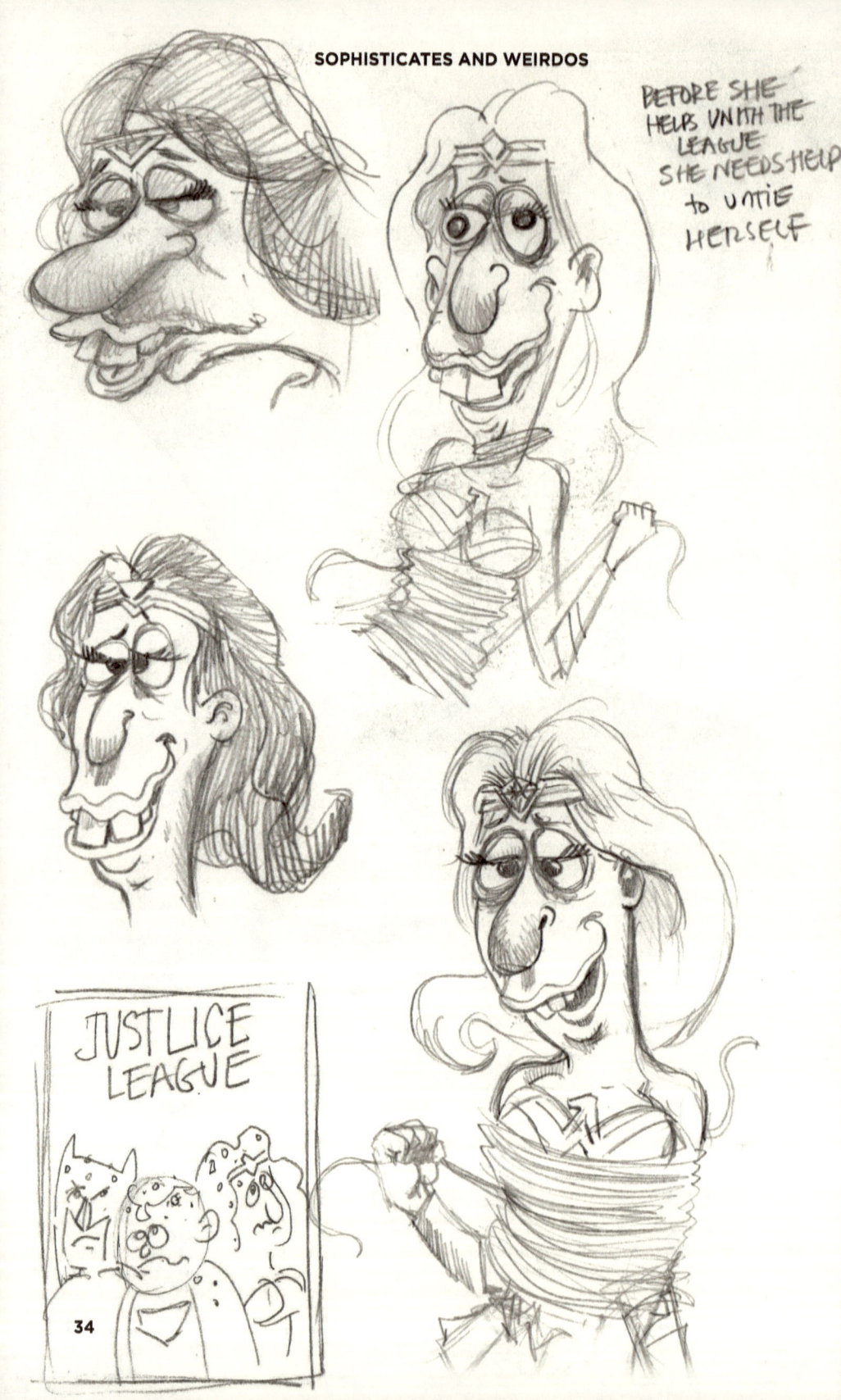

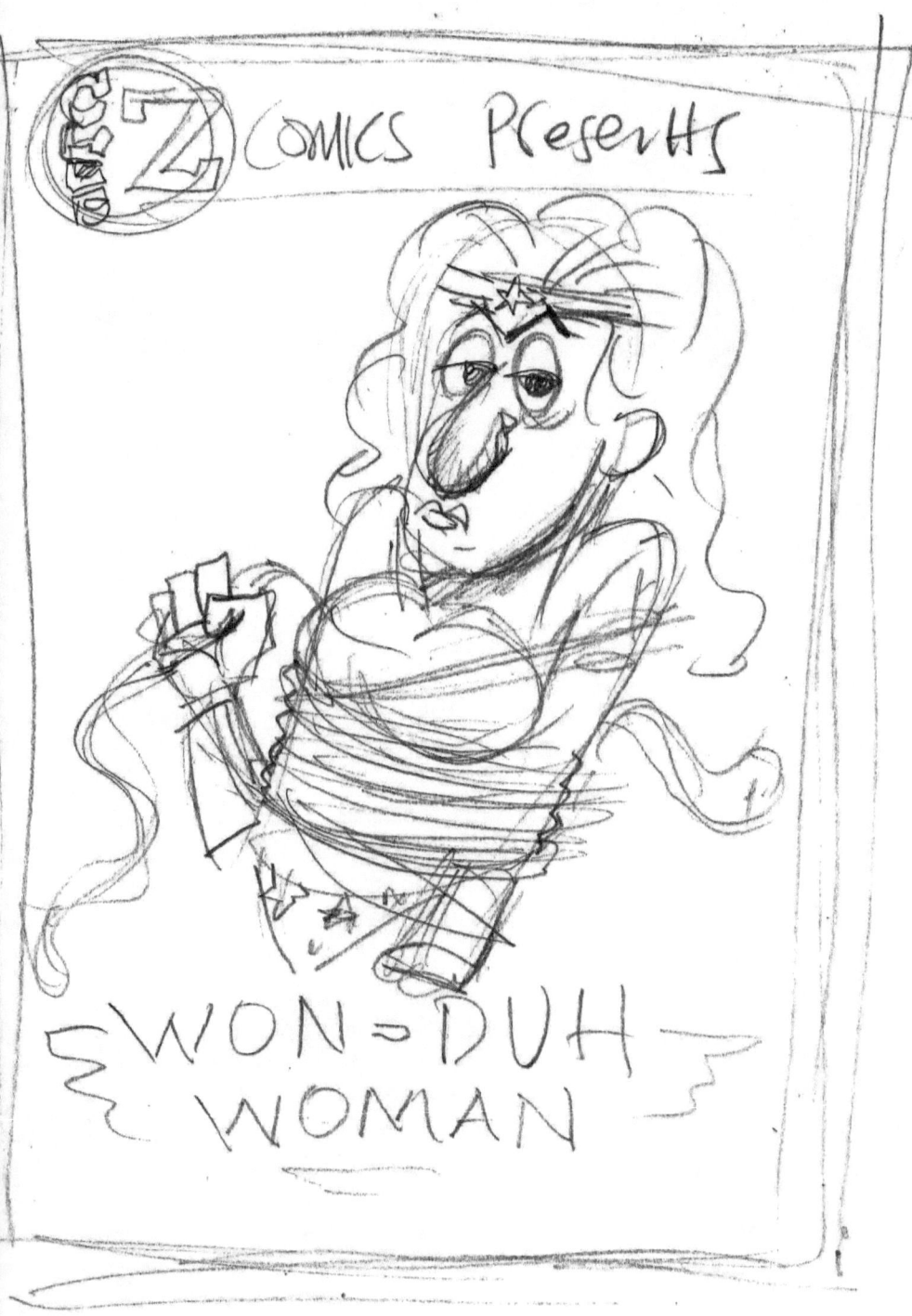

SOPHISTICATES AND WEIRDOS

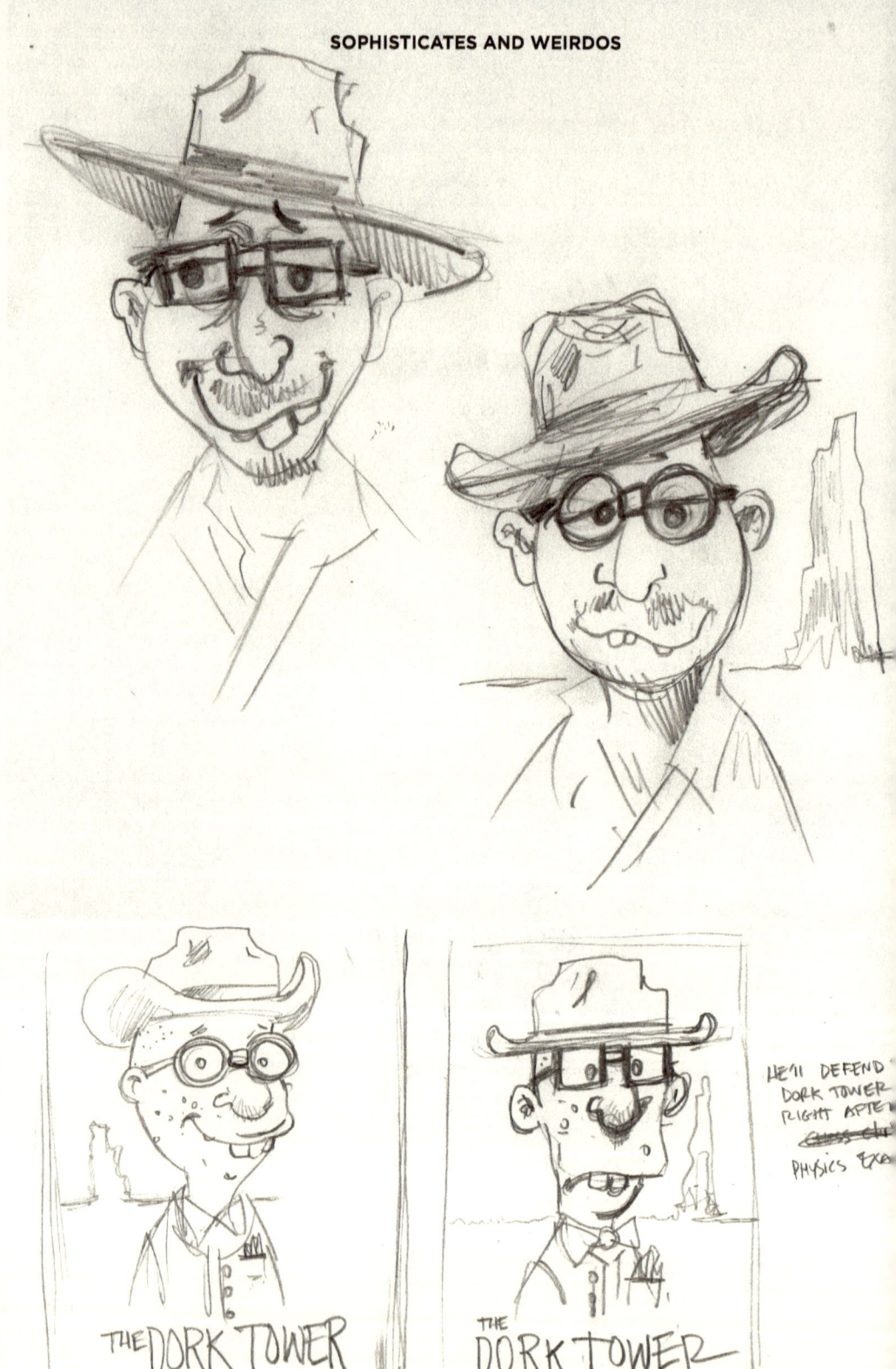

SOPHISTICATES AND WEIRDOS

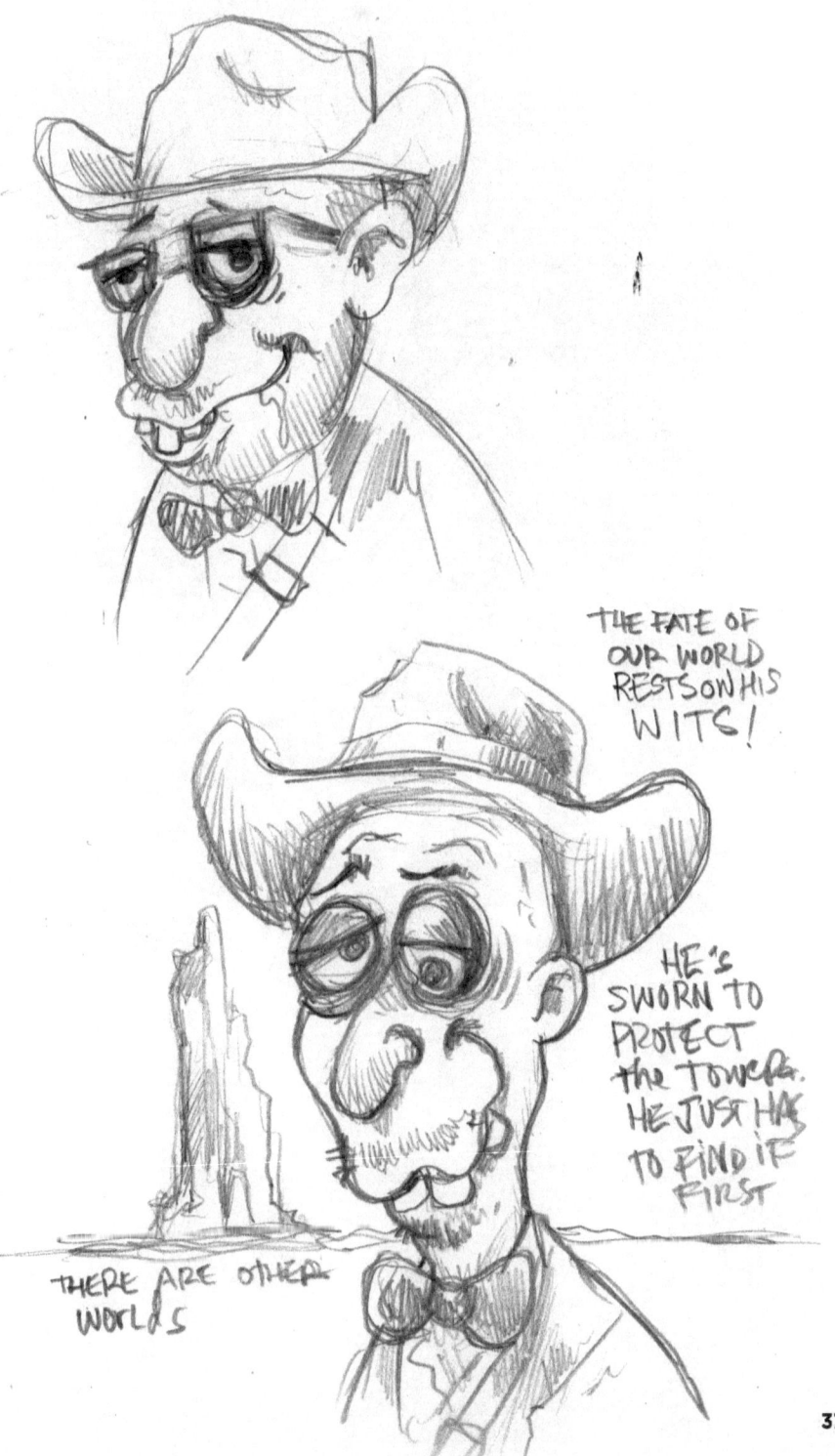

SOPHISTICATES AND WEIRDOS

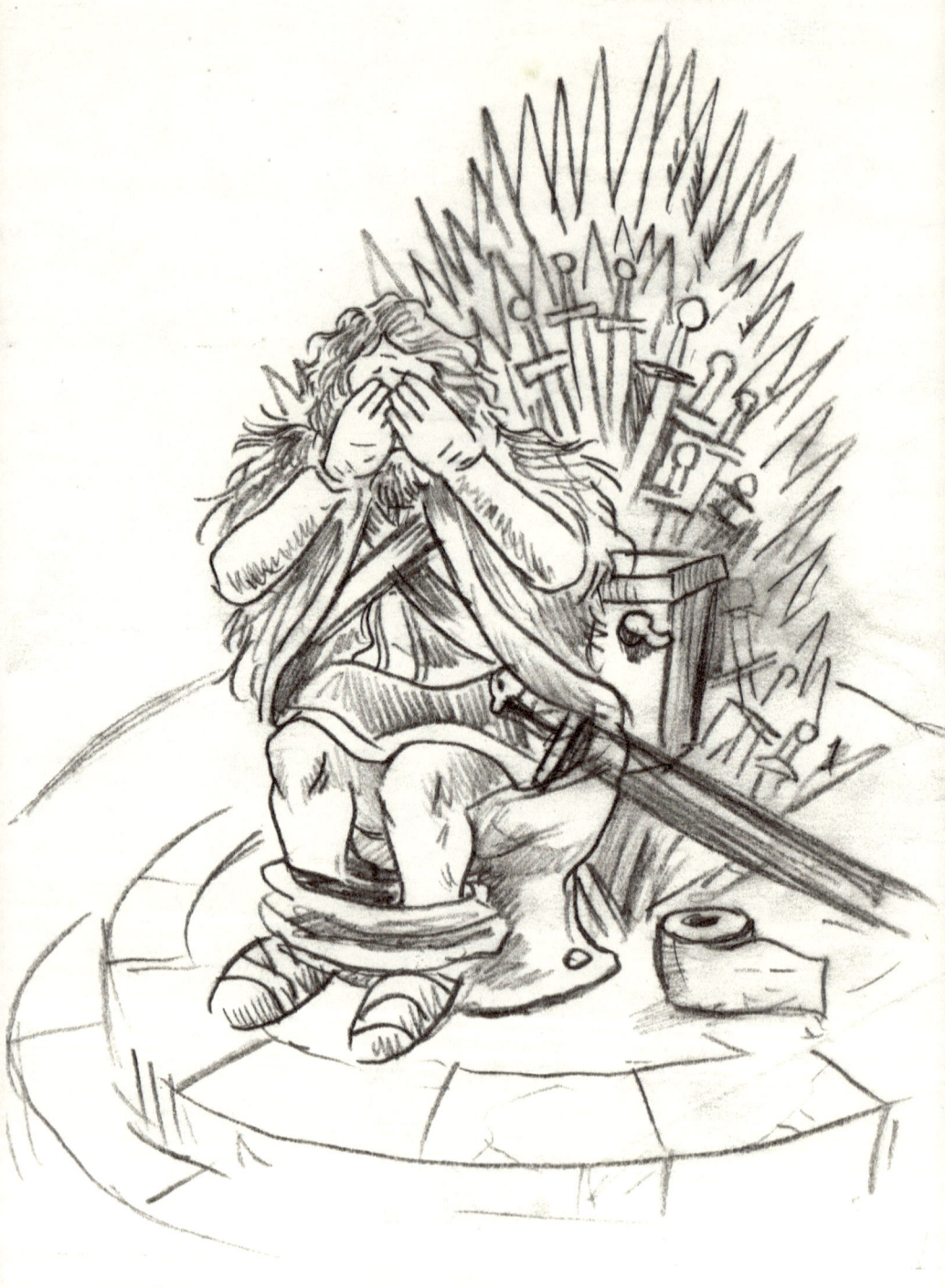

SOPHISTICATES AND WEIRDOS

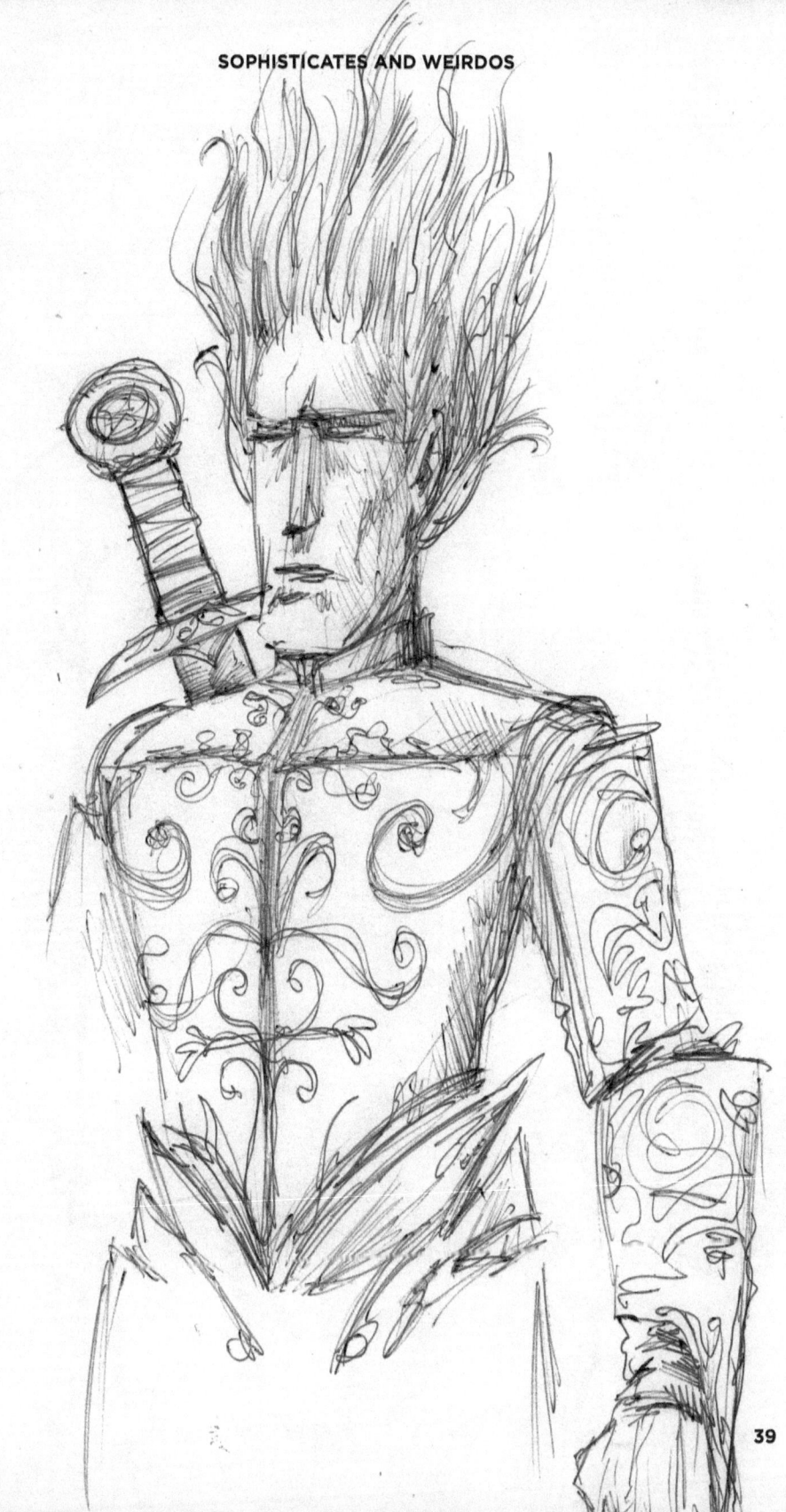

SOPHISTICATES AND WEIRDOS

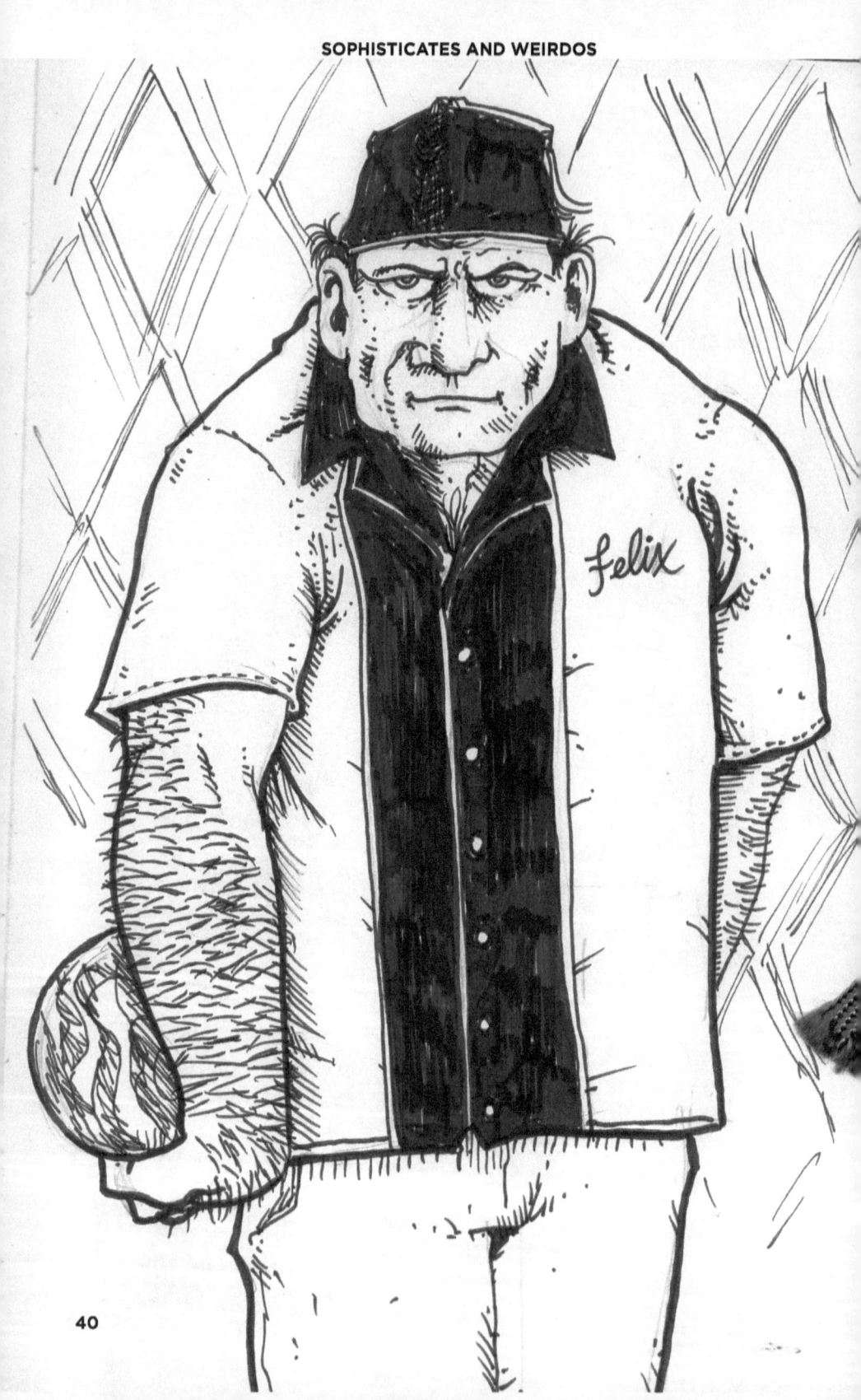

SOPHISTICATES AND WEIRDOS

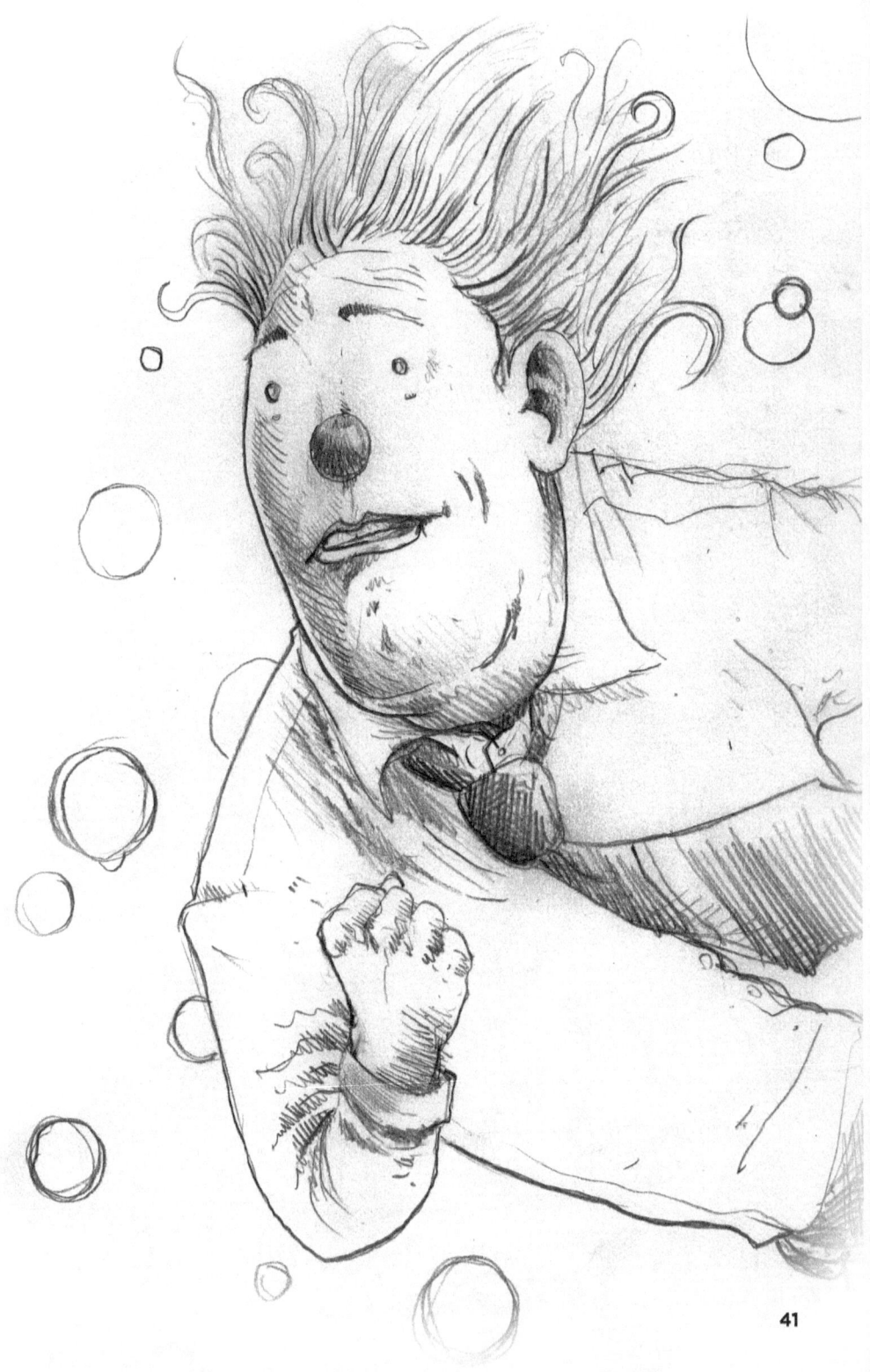

SOPHISTICATES AND WEIRDOS

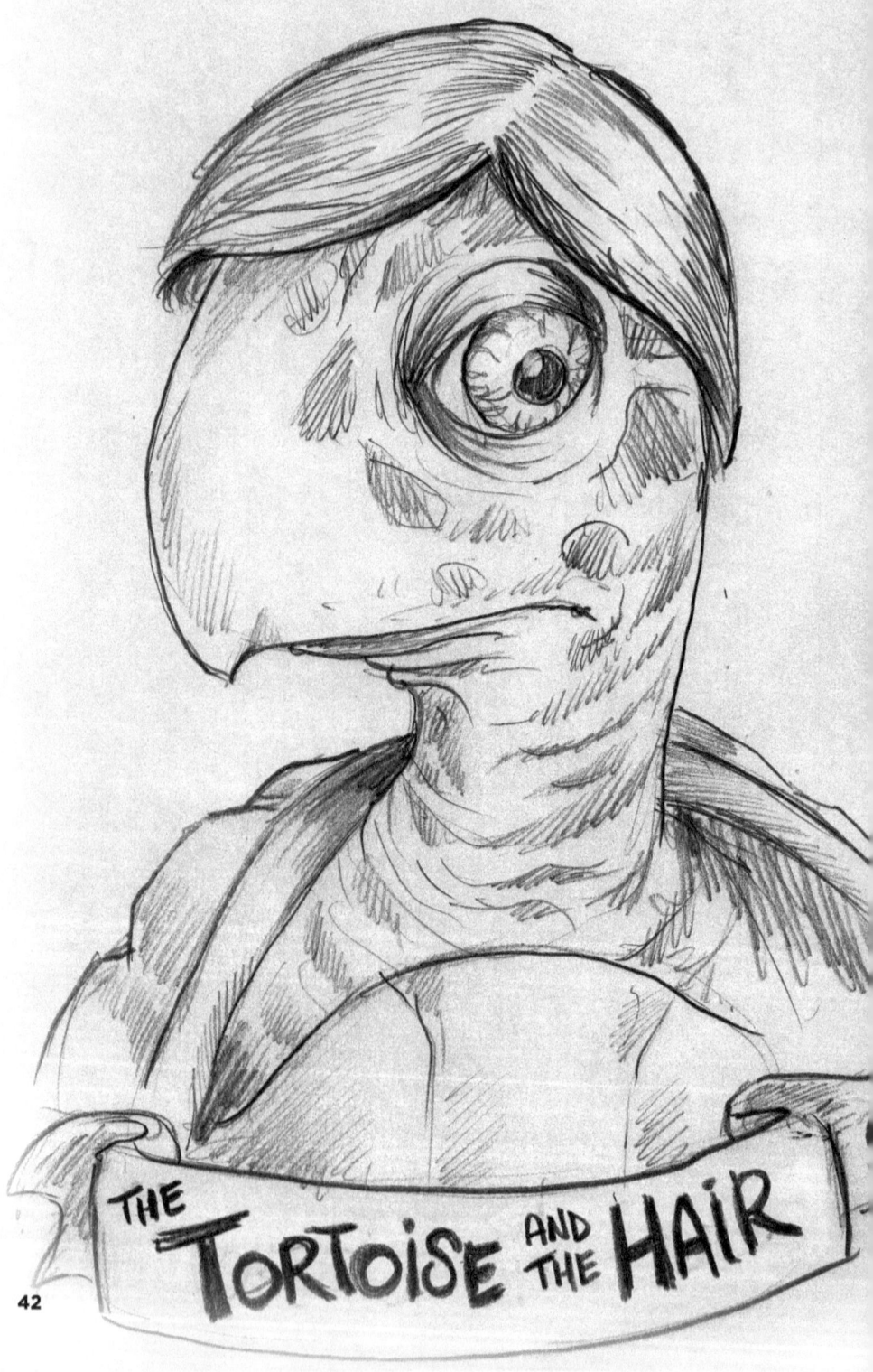

SOPHISTICATES AND WEIRDOS

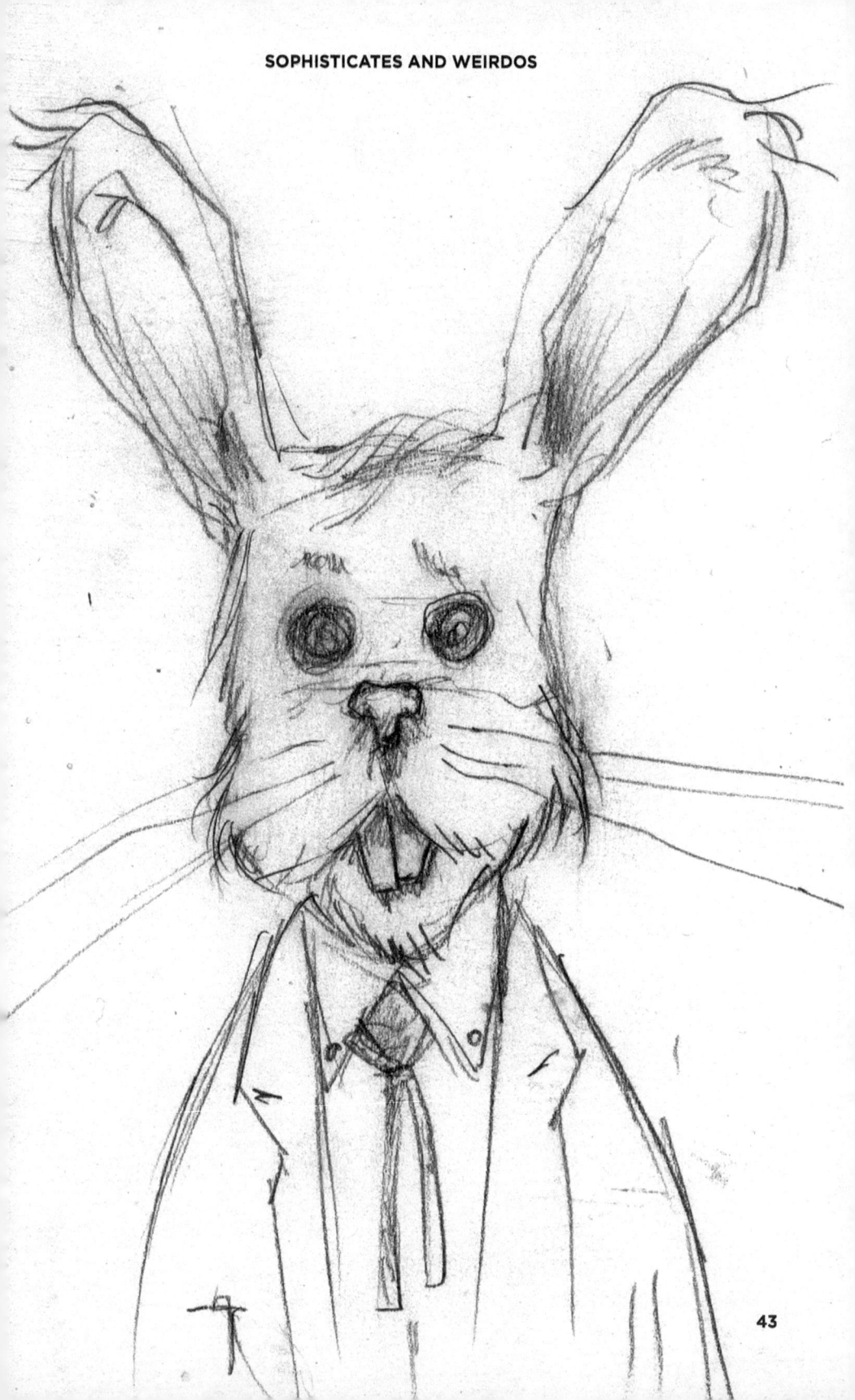

SOPHISTICATES AND WEIRDOS

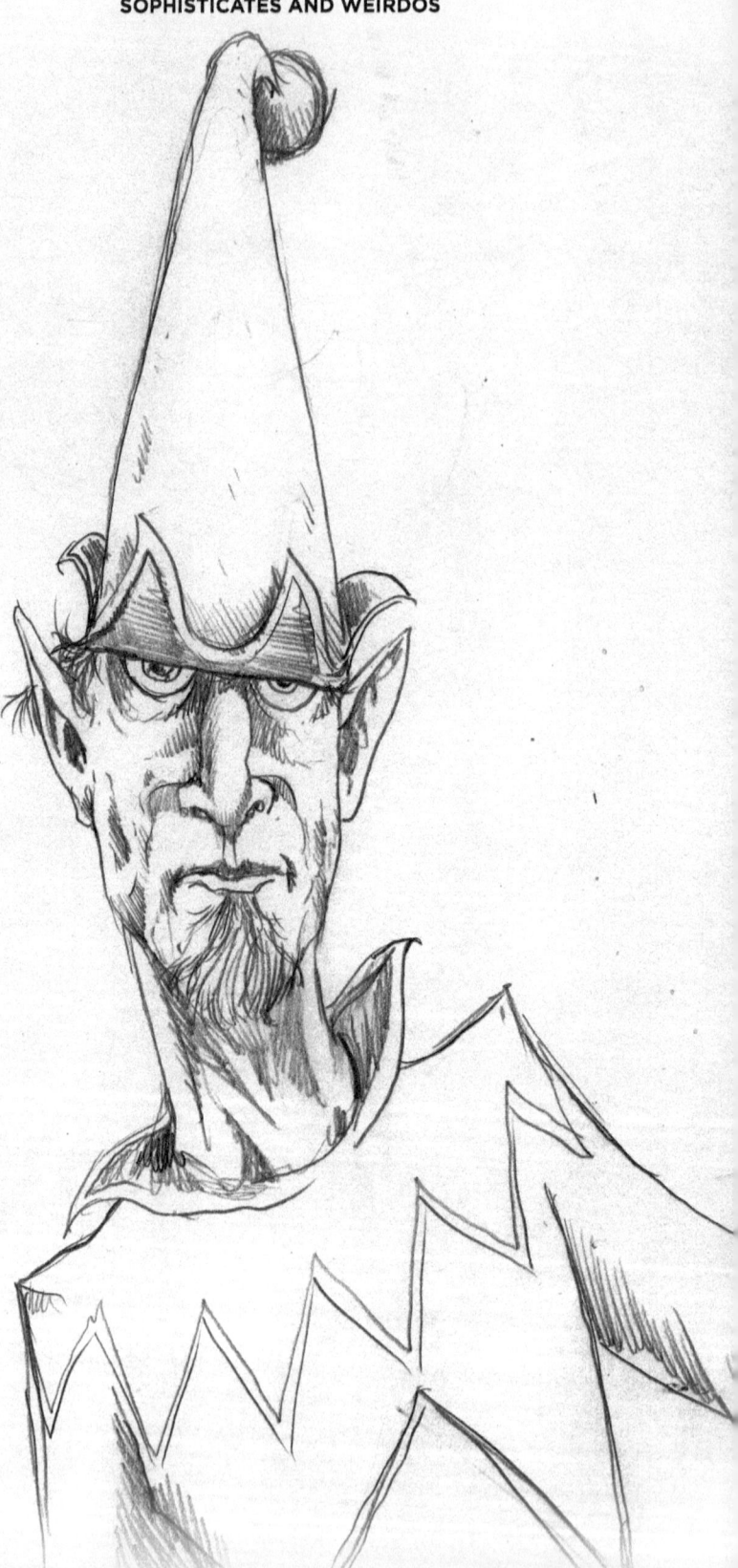

SOPHISTICATES AND WEIRDOS

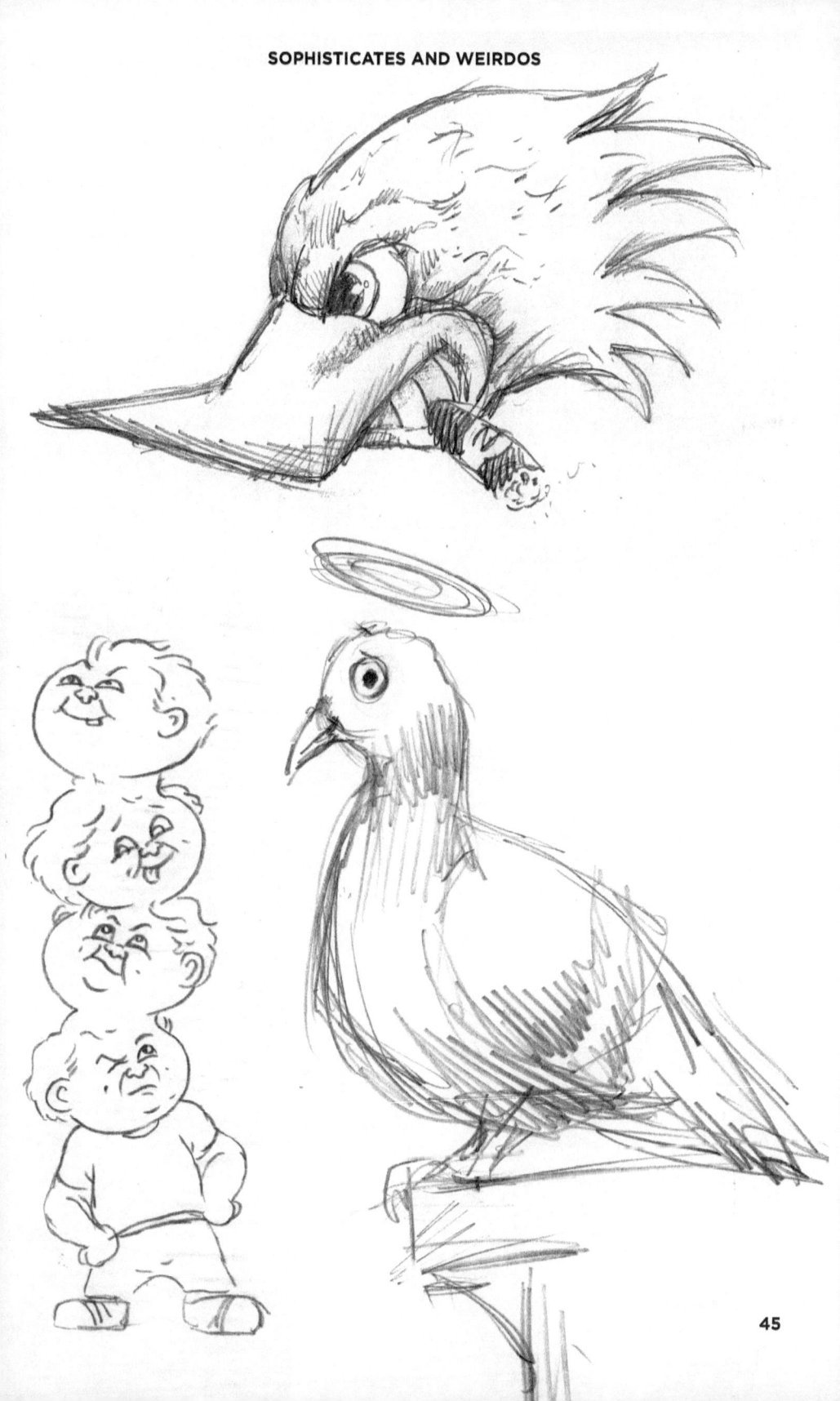

SOPHISTICATES AND WEIRDOS

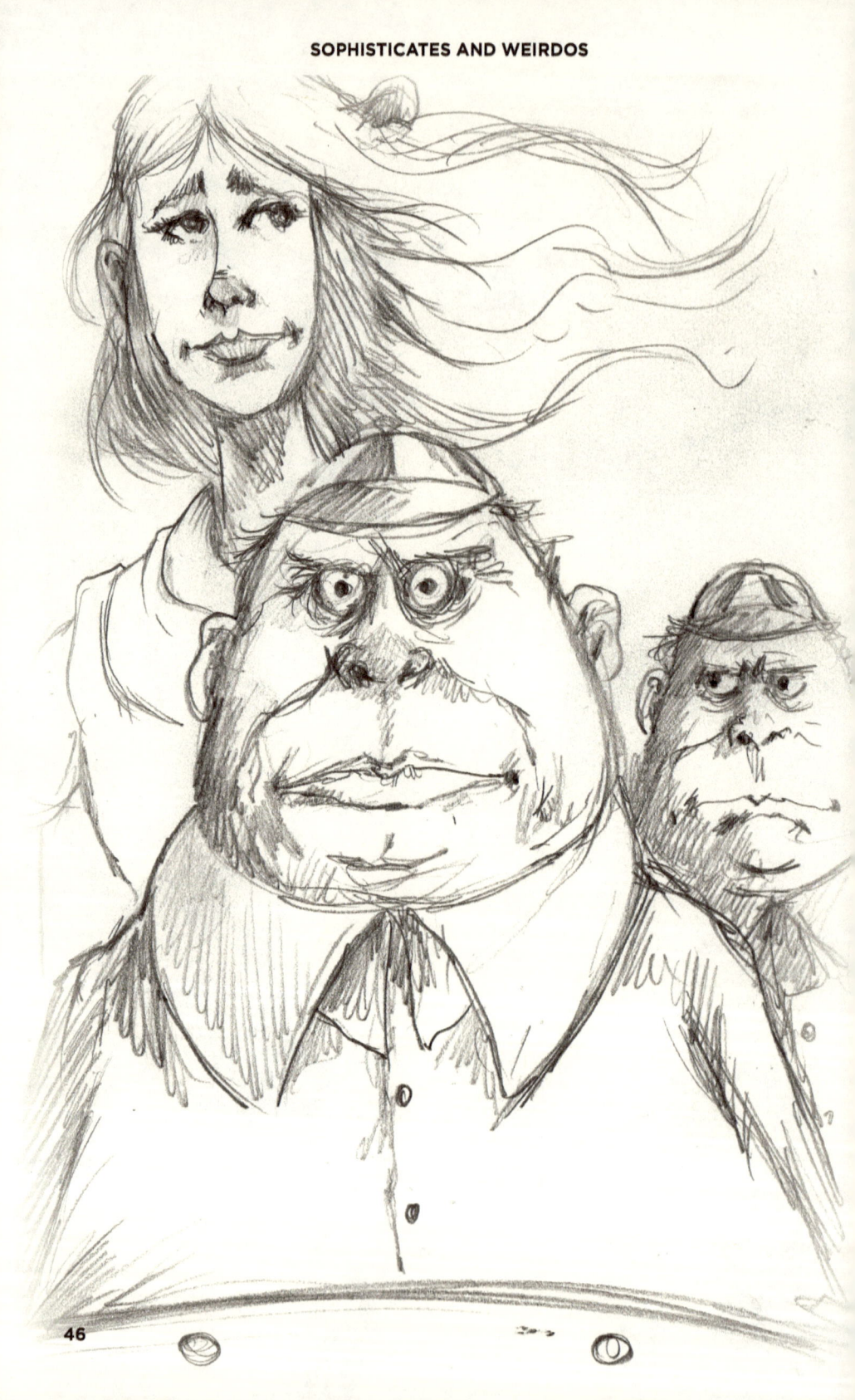

SOPHISTICATES AND WEIRDOS

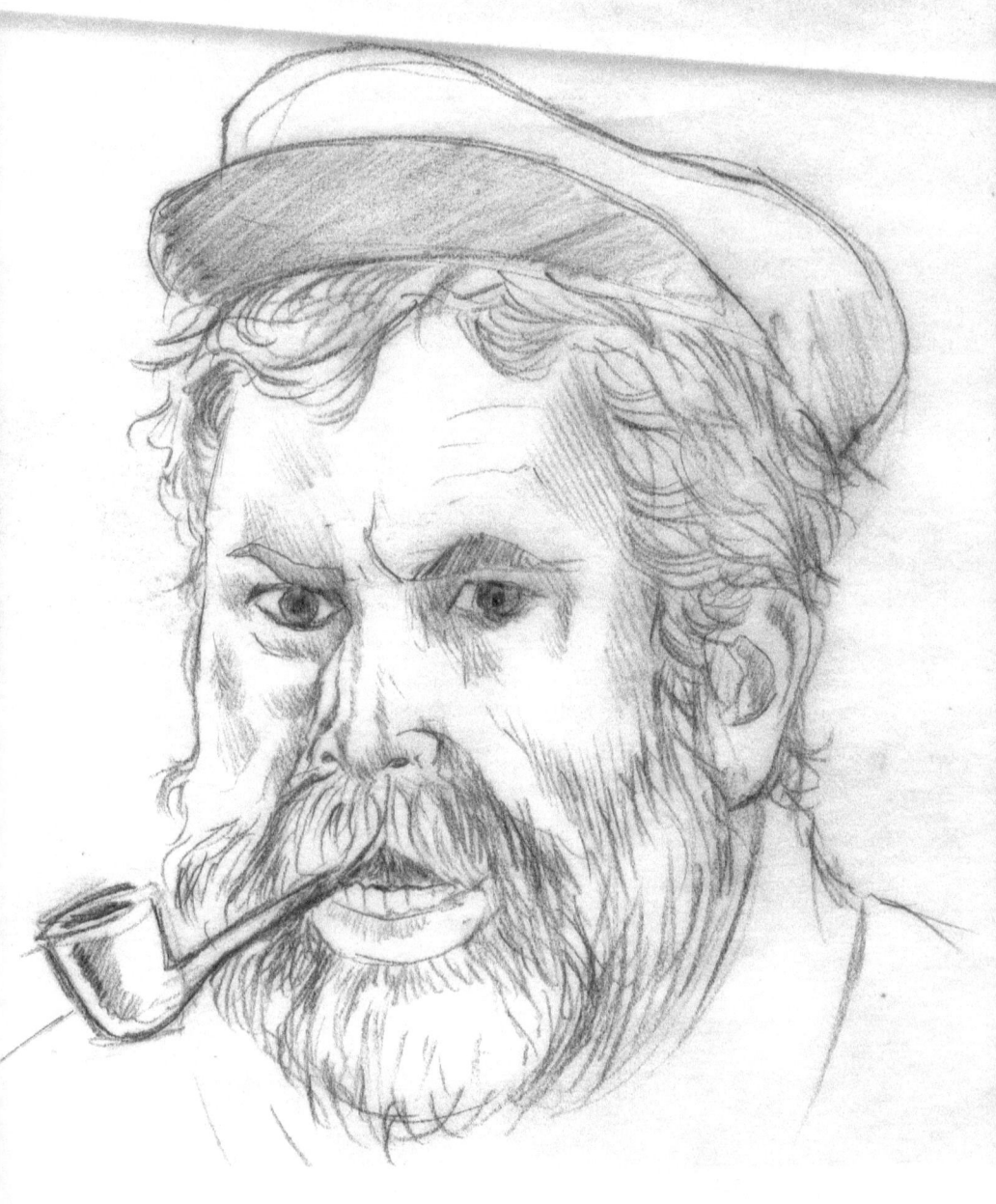

SOPHISTICATES AND WEIRDOS

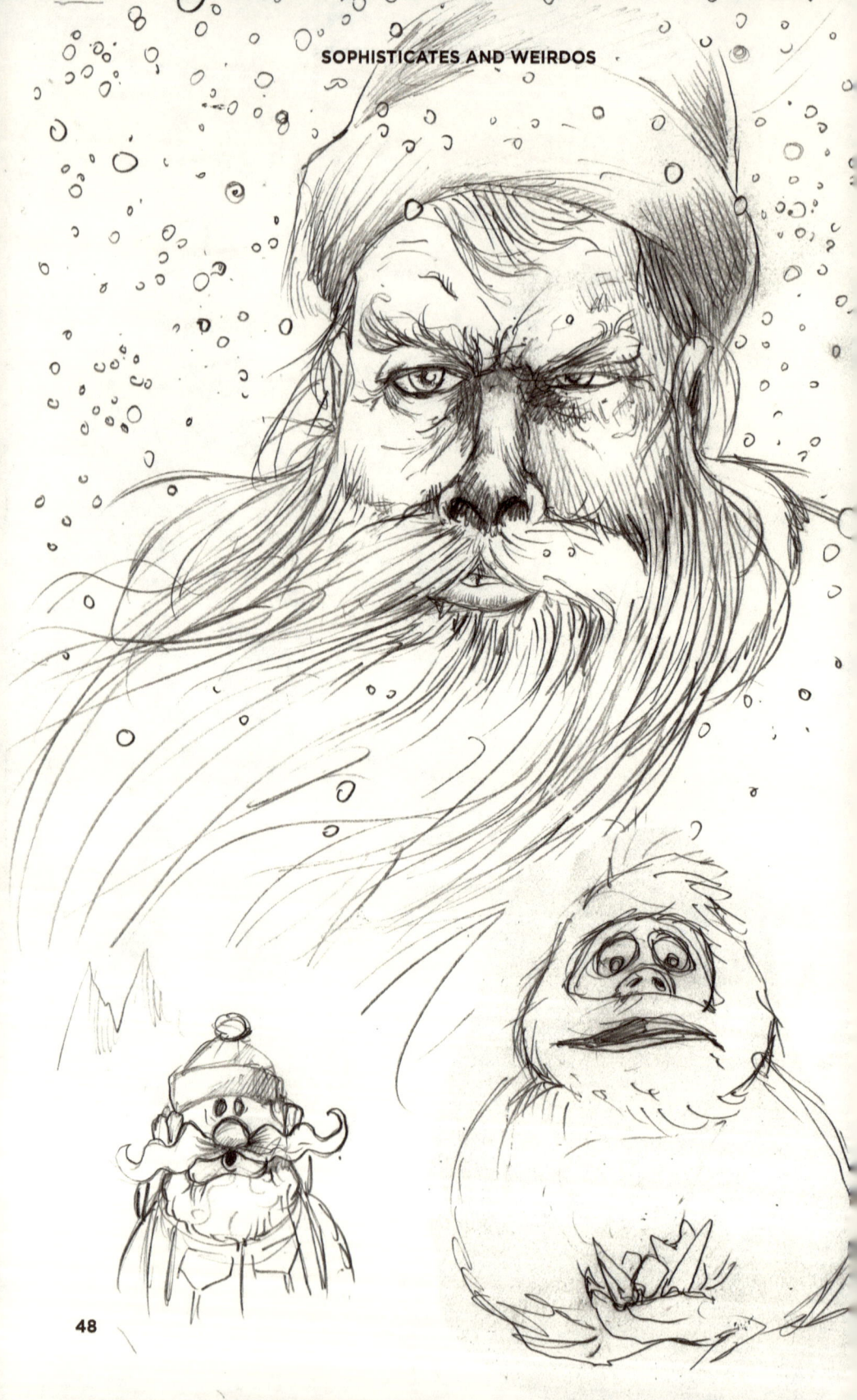

SOPHISTICATES AND WEIRDOS

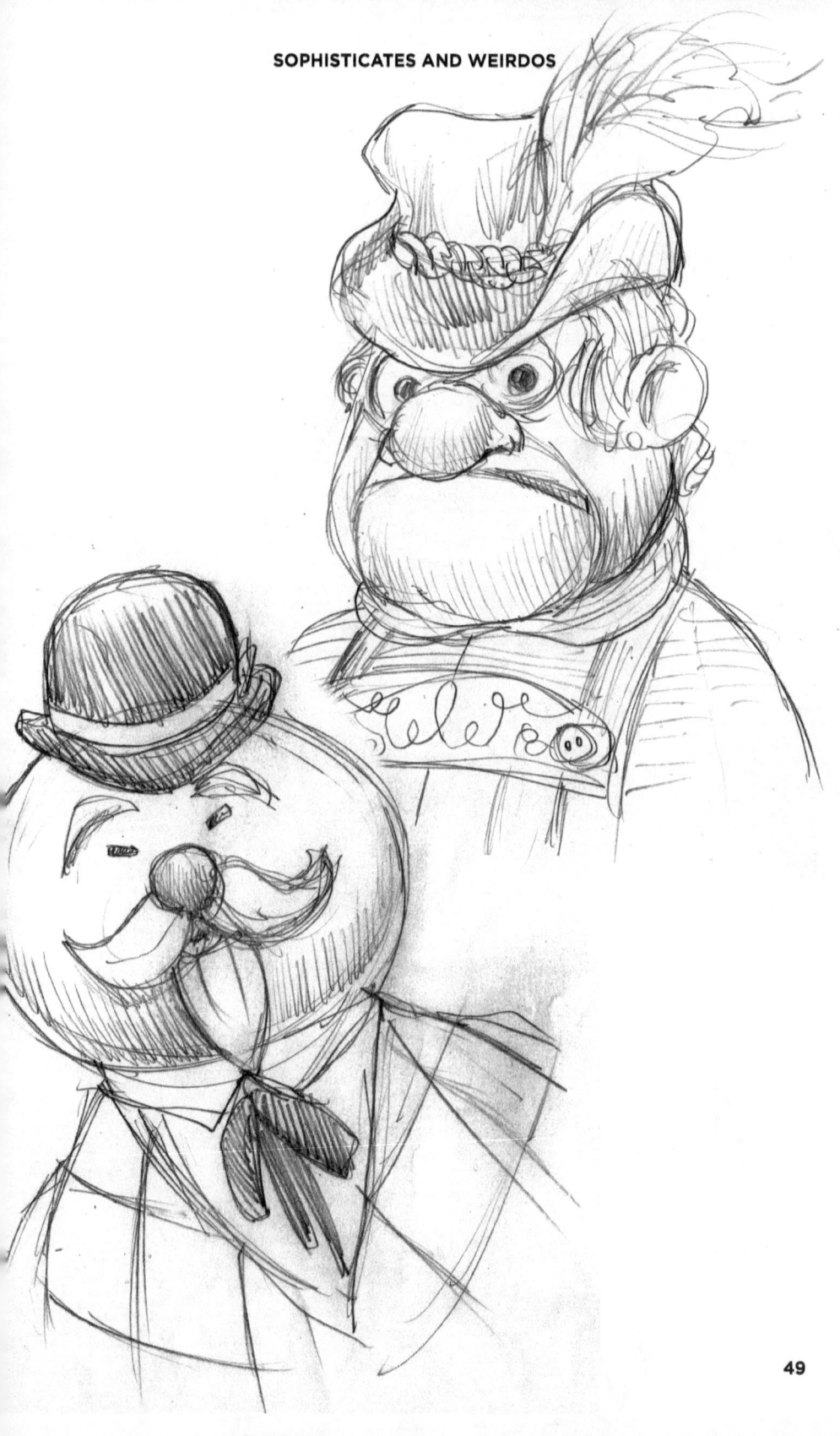

SOPHISTICATES AND WEIRDOS

SOPHISTICATES AND WEIRDOS

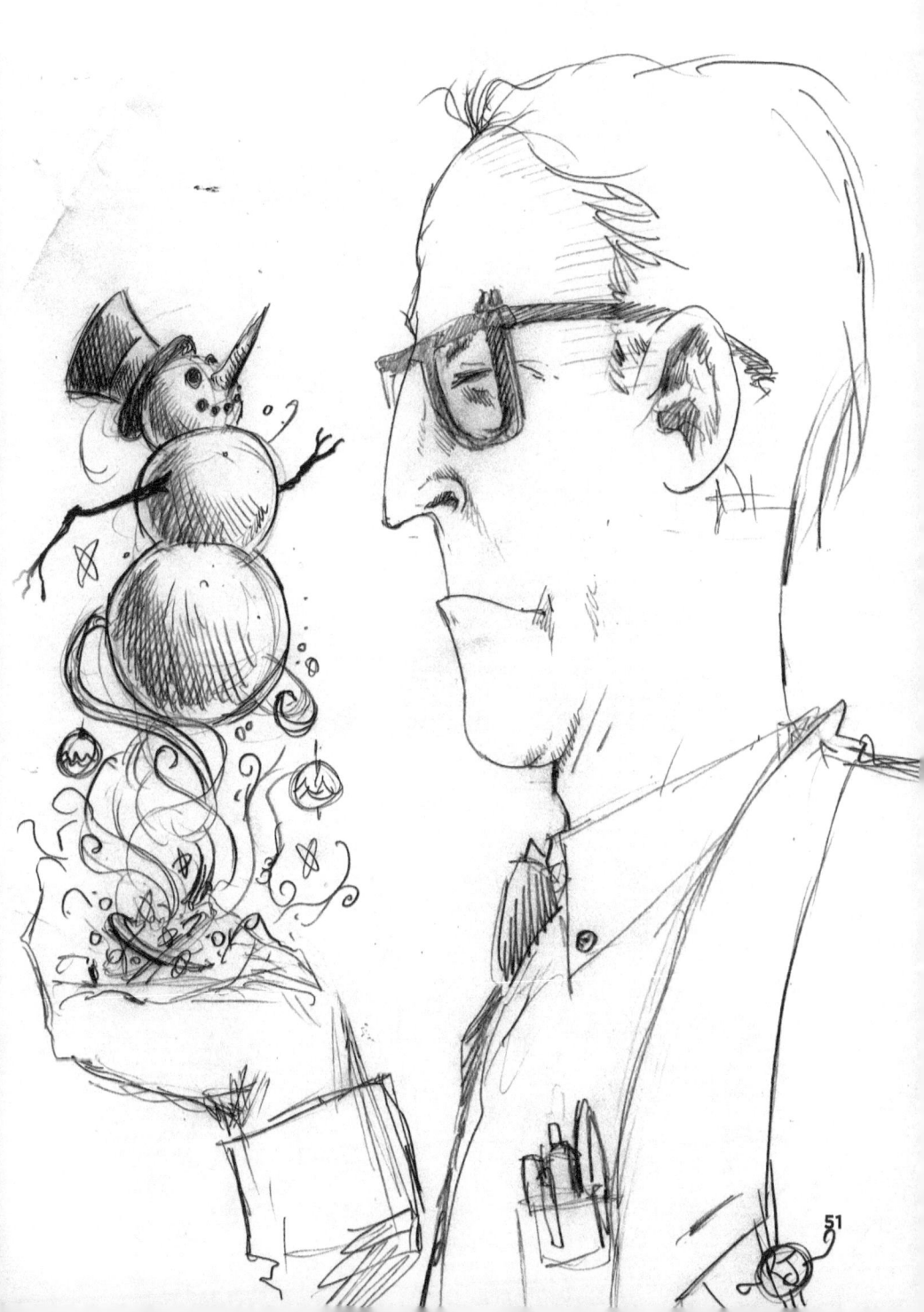

SOPHISTICATES AND WEIRDOS

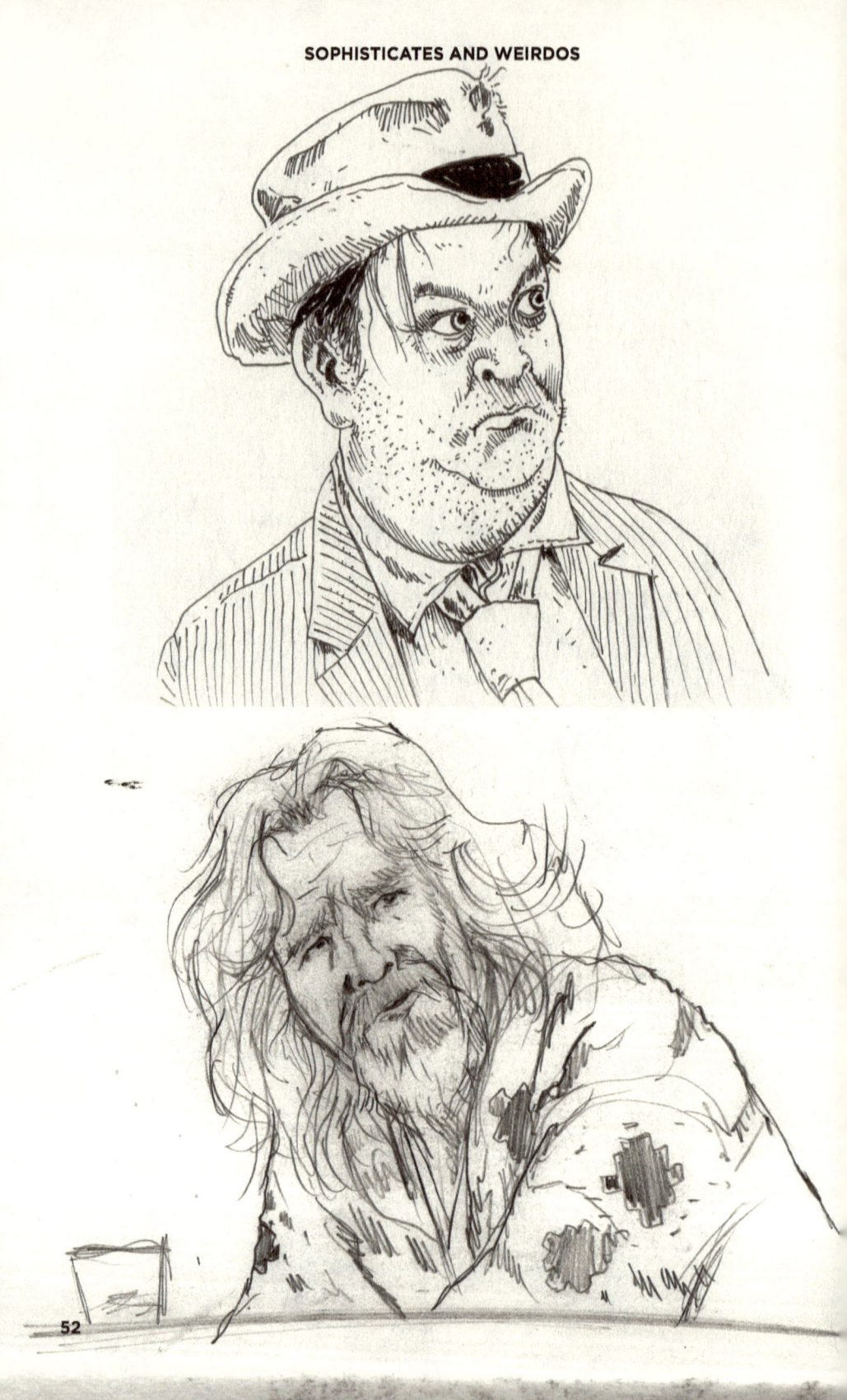

SOPHISTICATES AND WEIRDOS

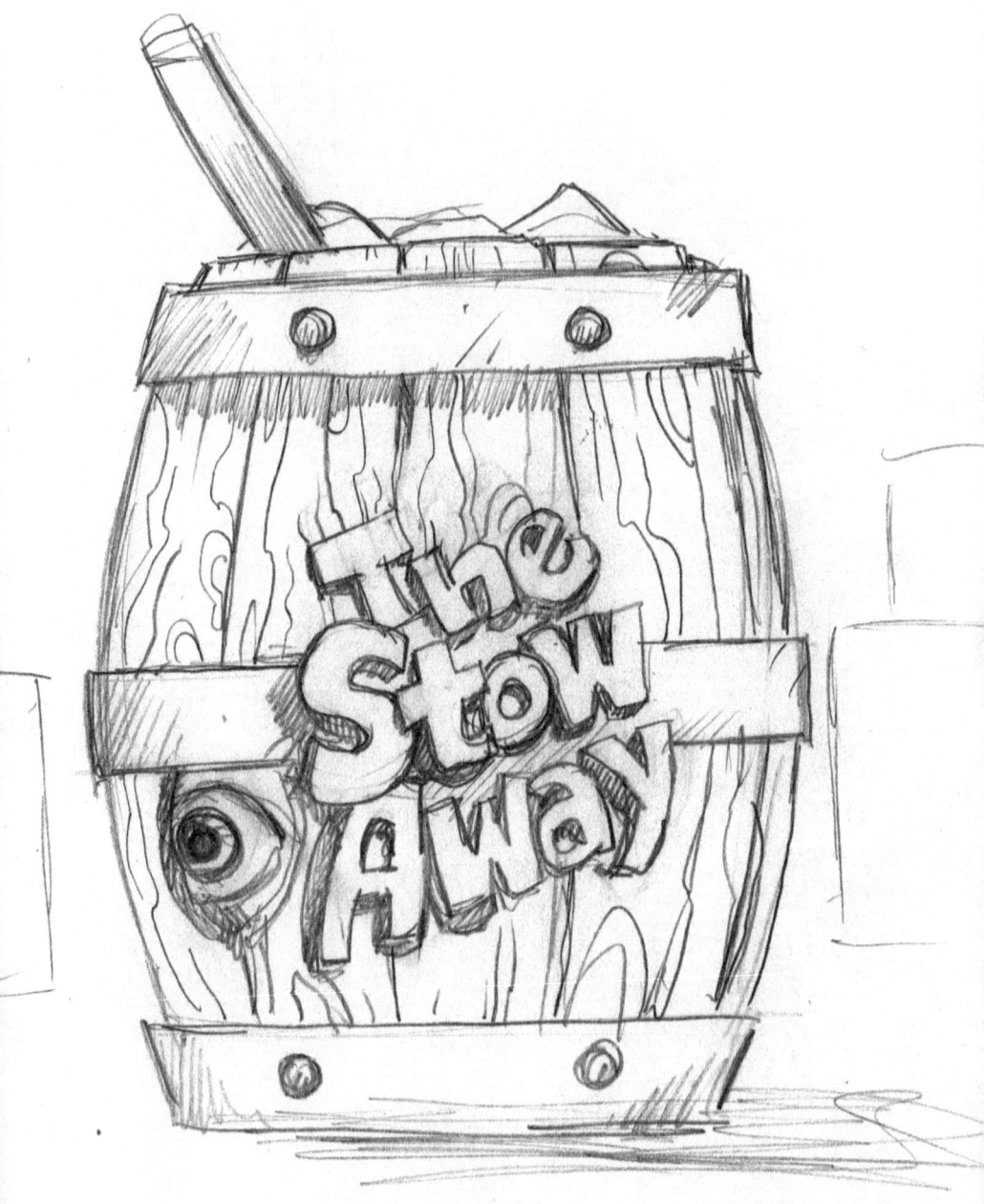

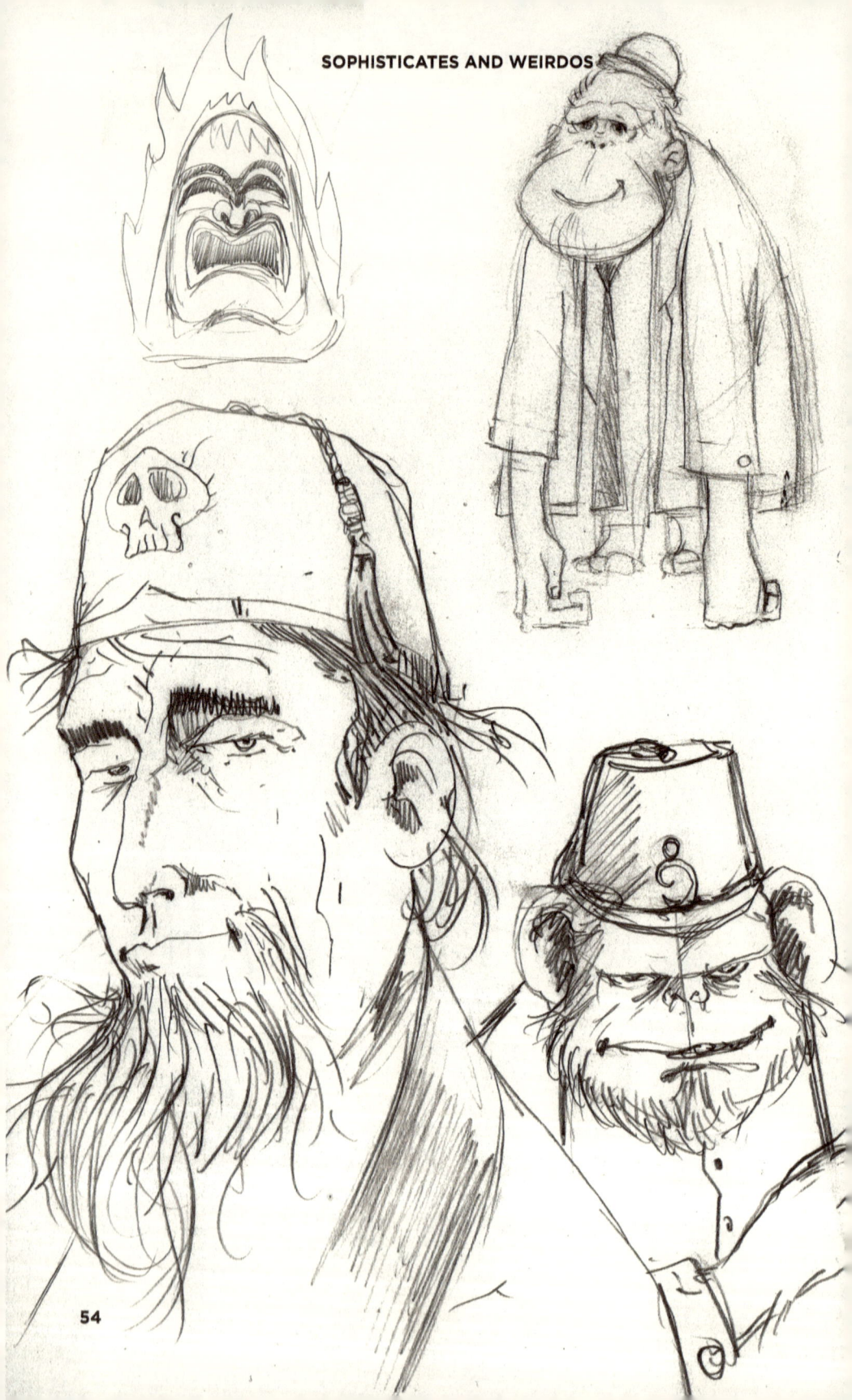
SOPHISTICATES AND WEIRDOS

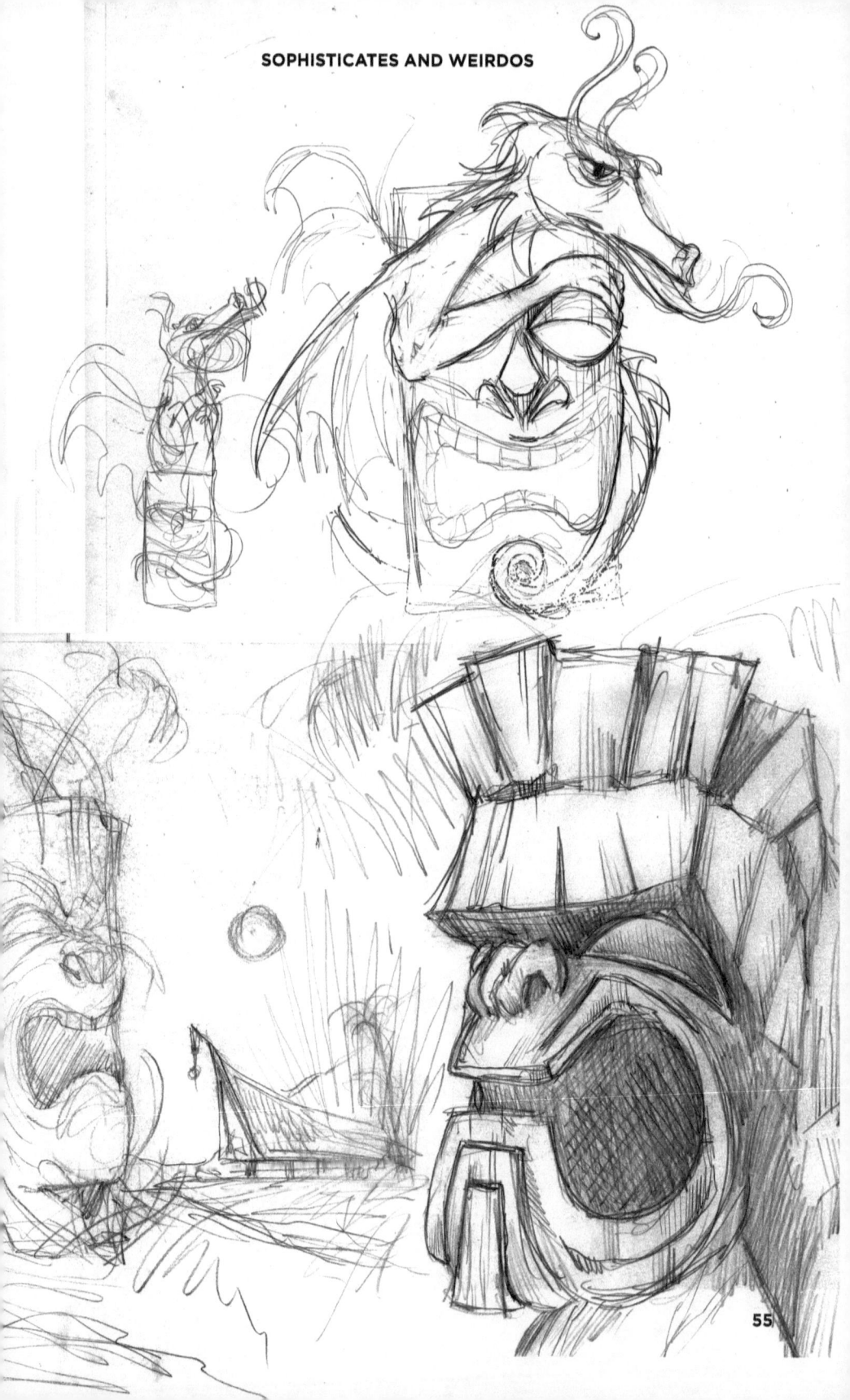
SOPHISTICATES AND WEIRDOS

SOPHISTICATES AND WEIRDOS

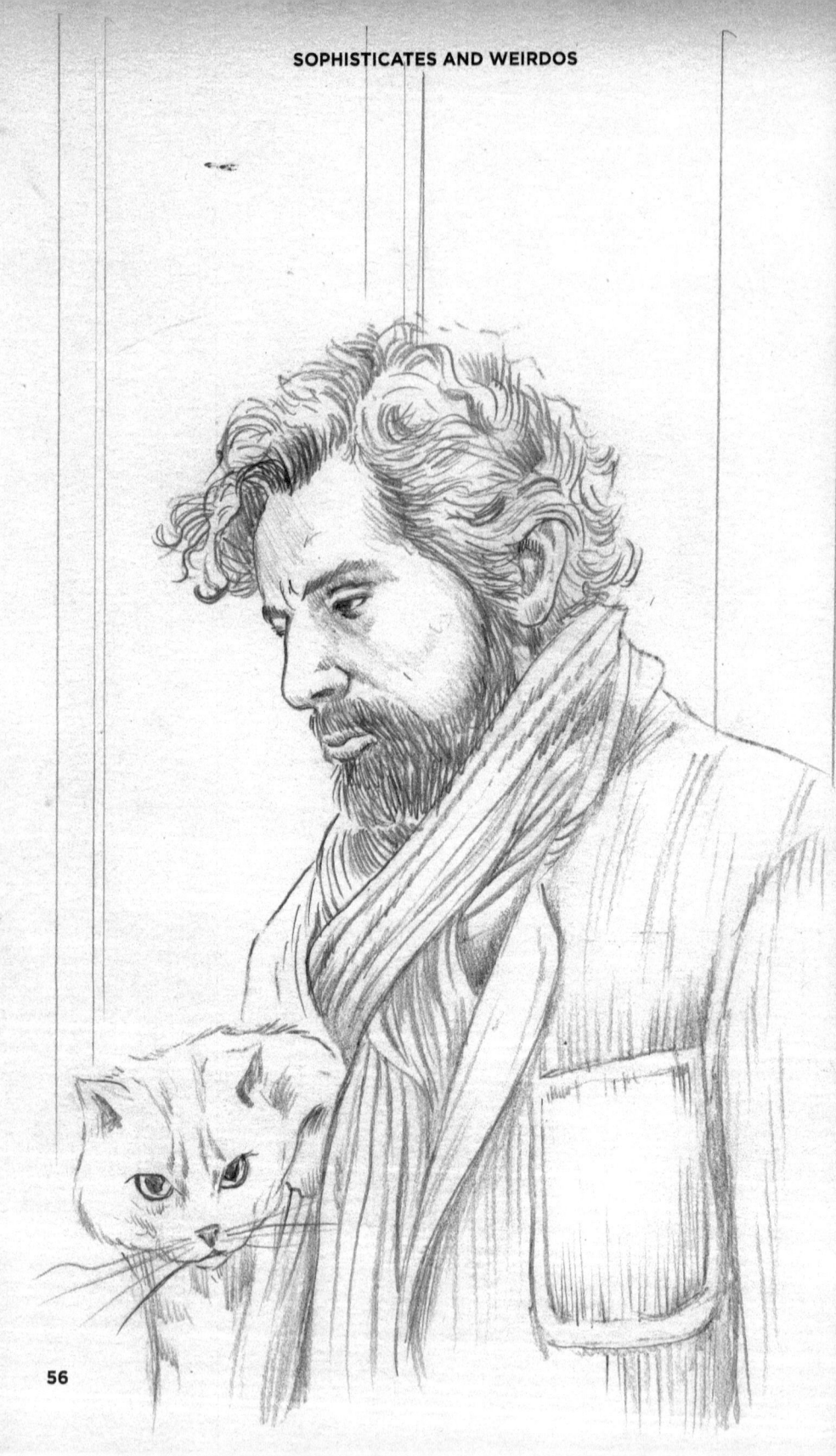

SOPHISTICATES AND WEIRDOS

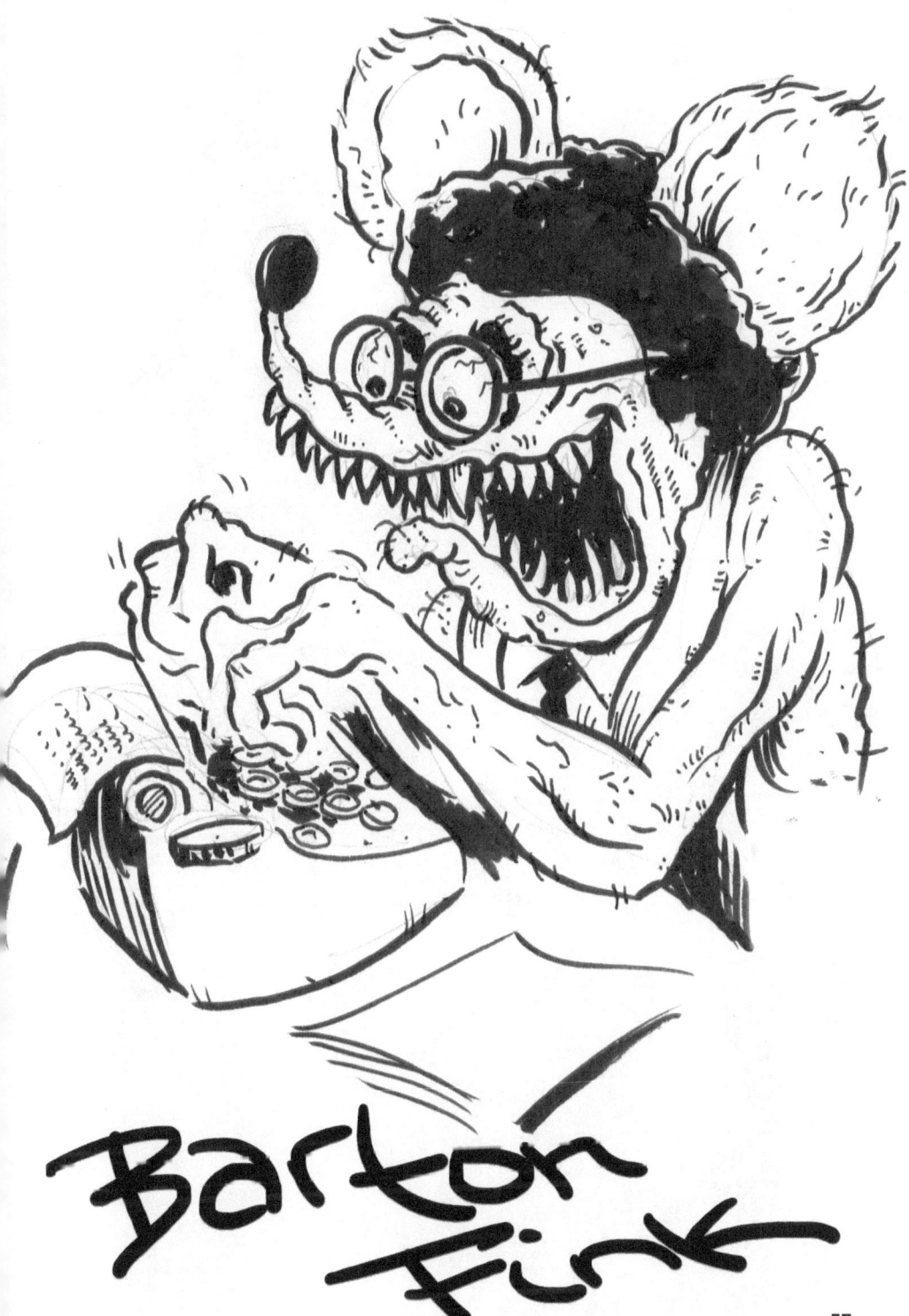

SOPHISTICATES AND WEIRDOS

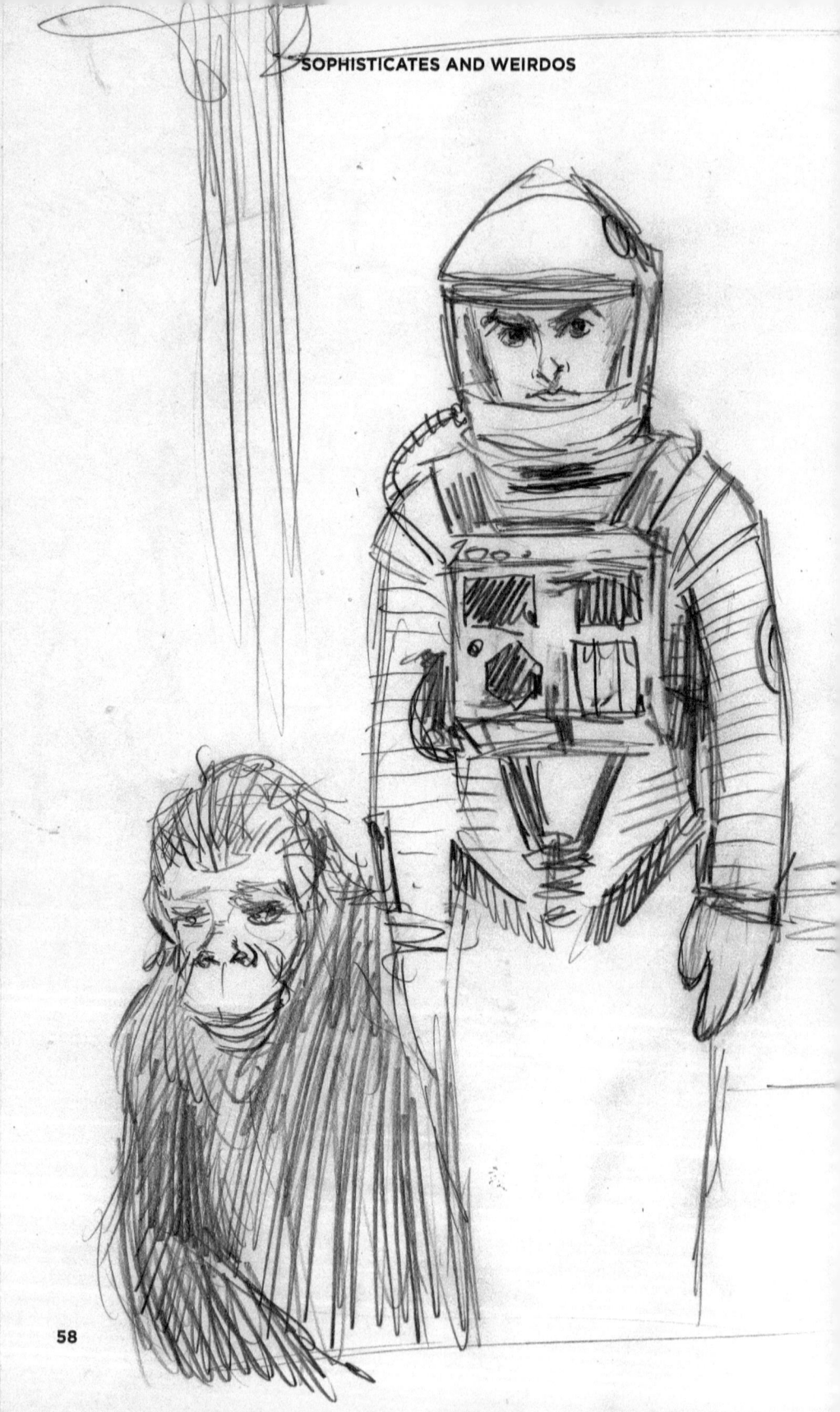

SOPHISTICATES AND WEIRDOS

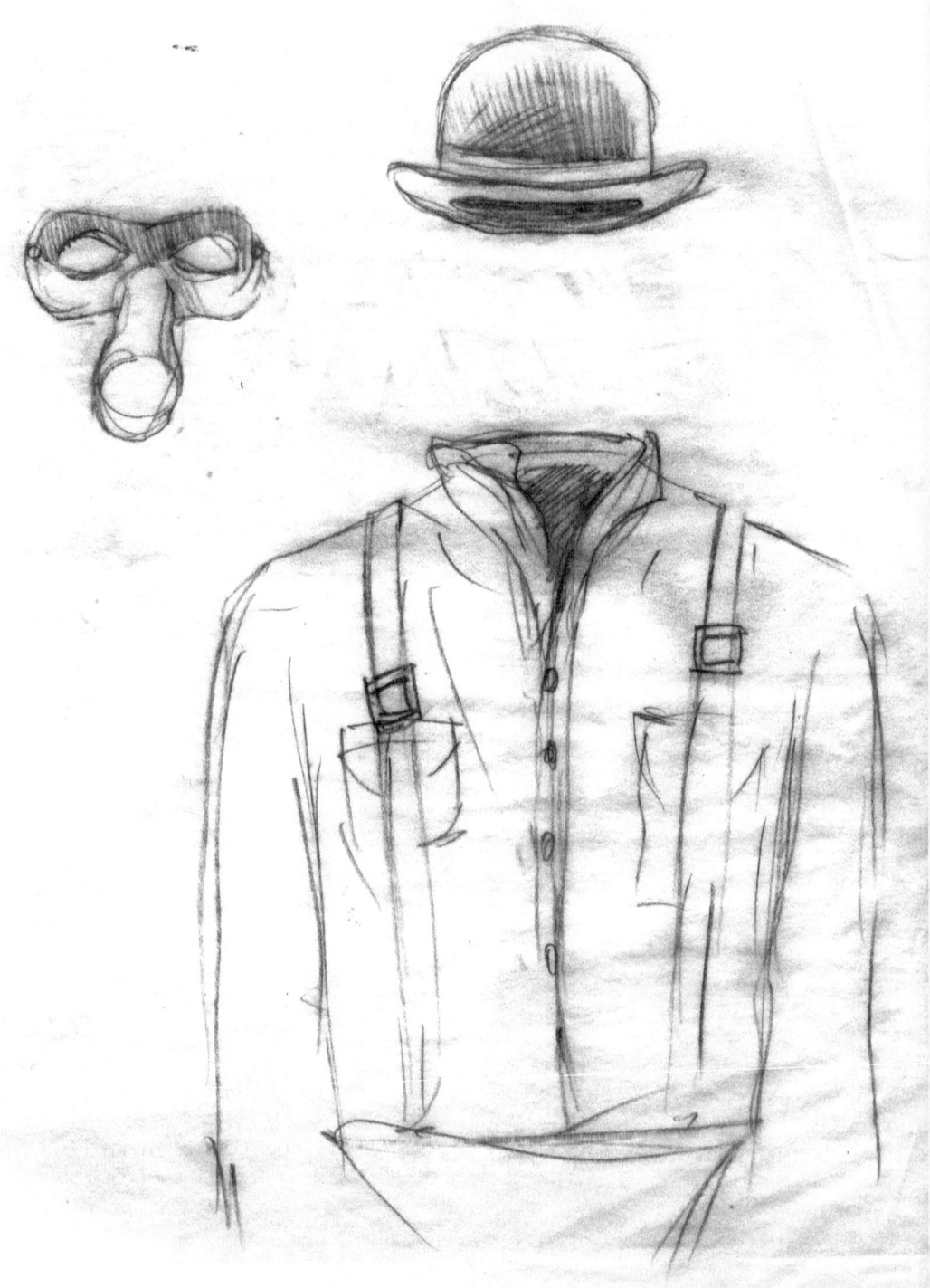

SOPHISTICATES AND WEIRDOS

SOPHISTICATES AND WEIRDOS

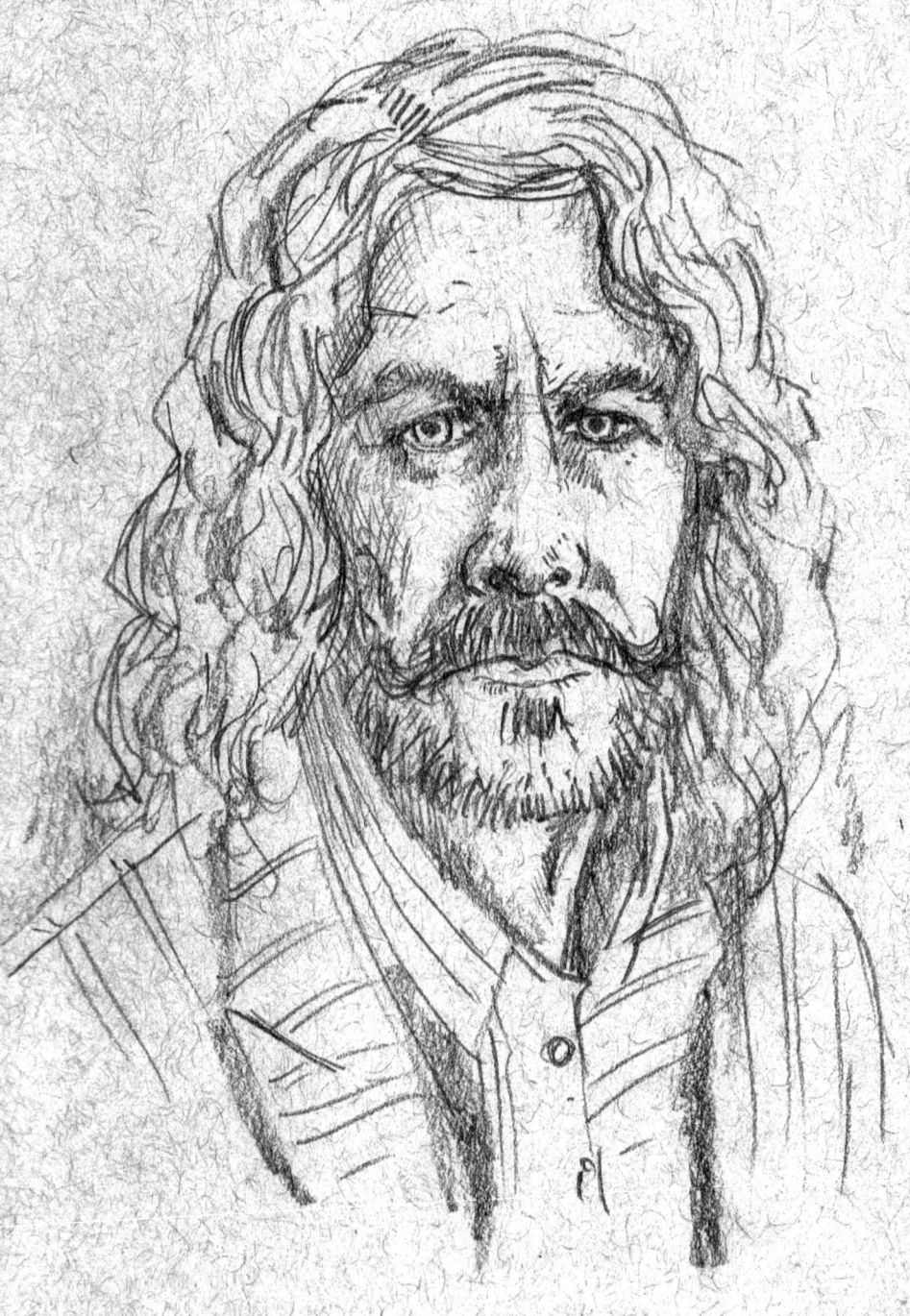

SOPHISTICATES AND WEIRDOS

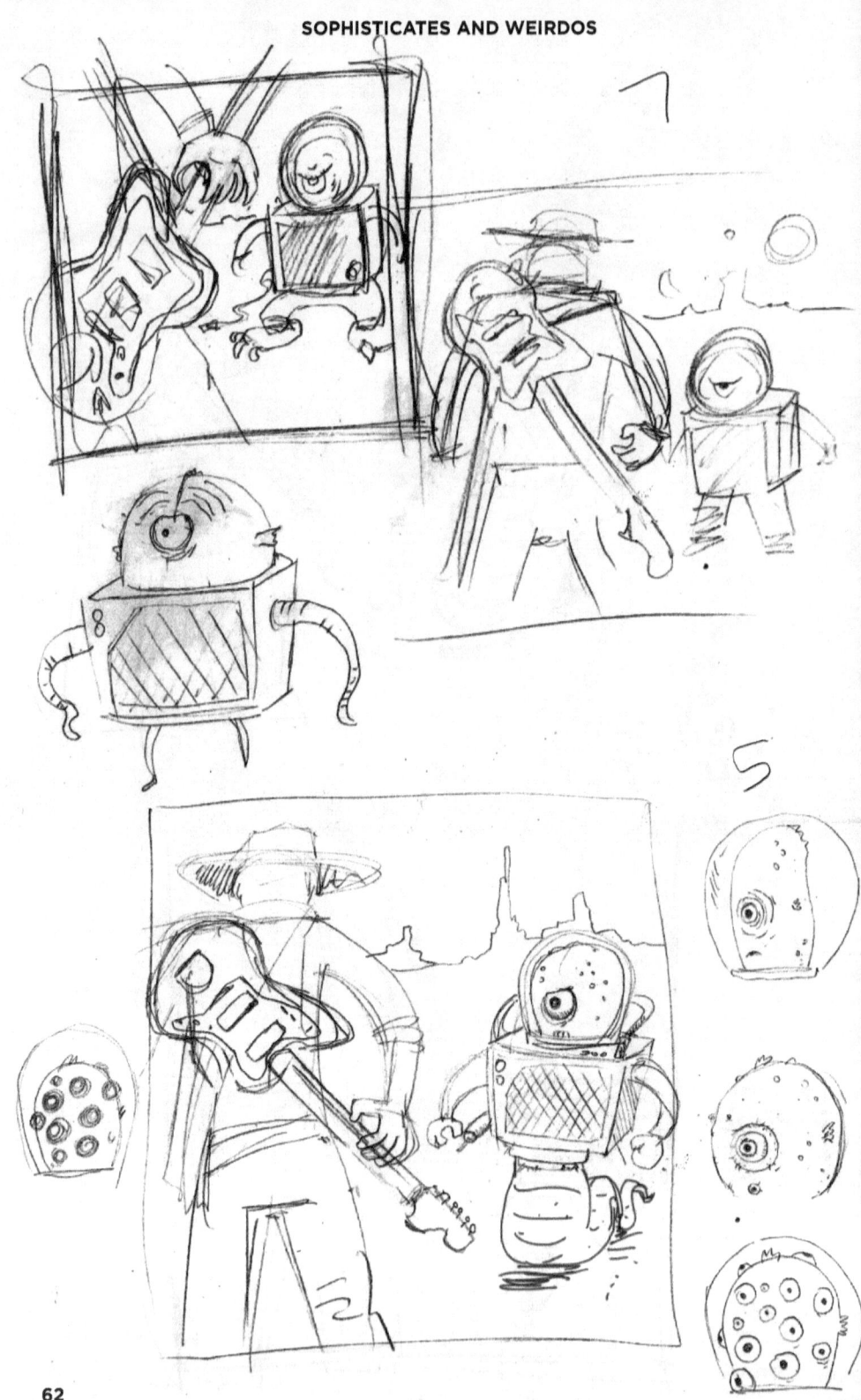

SOPHISTICATES AND WEIRDOS

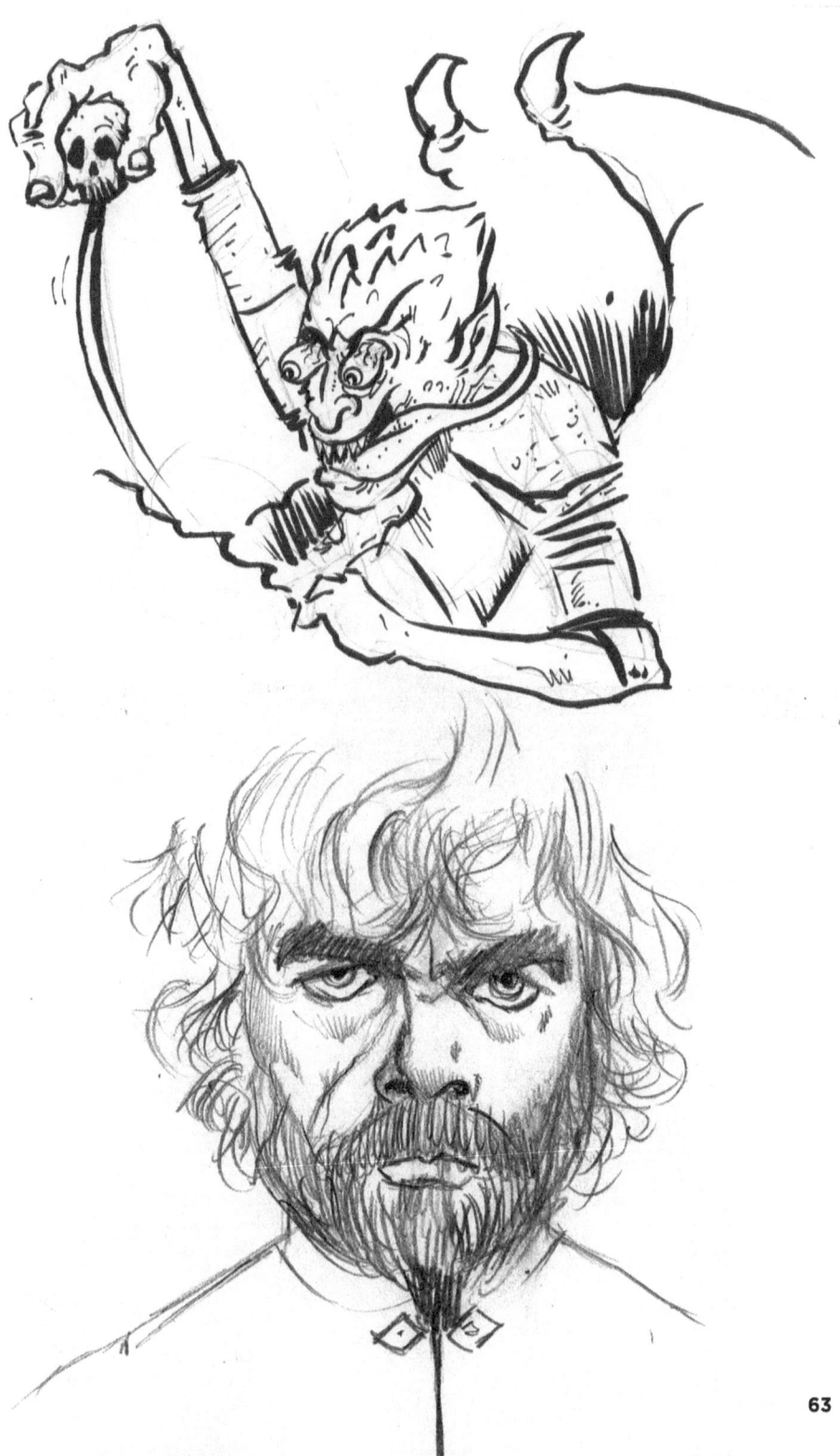

SOPHISTICATES AND WEIRDOS

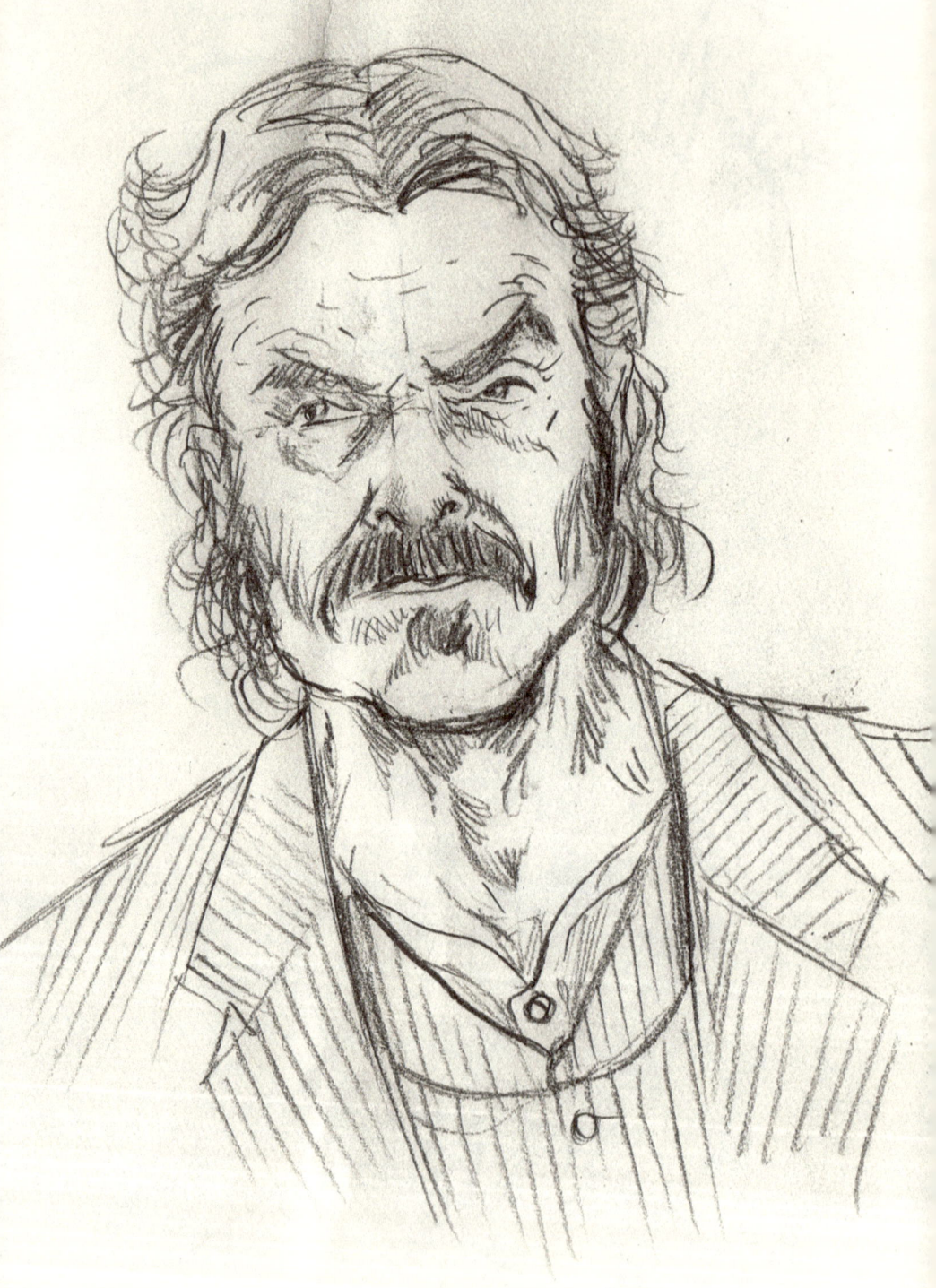

SOPHISTICATES AND WEIRDOS

SOPHISTICATES AND WEIRDOS

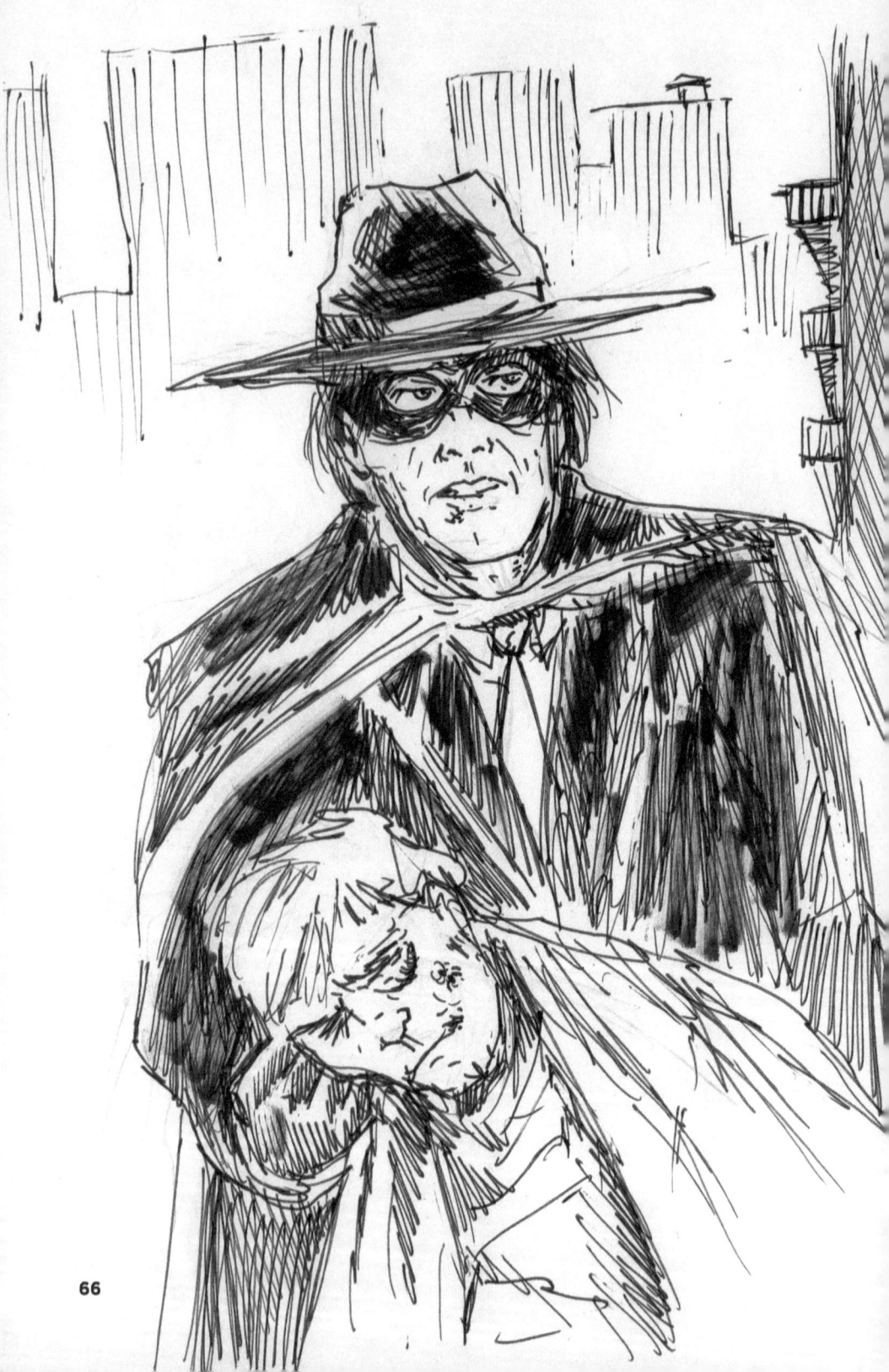

SOPHISTICATES AND WEIRDOS

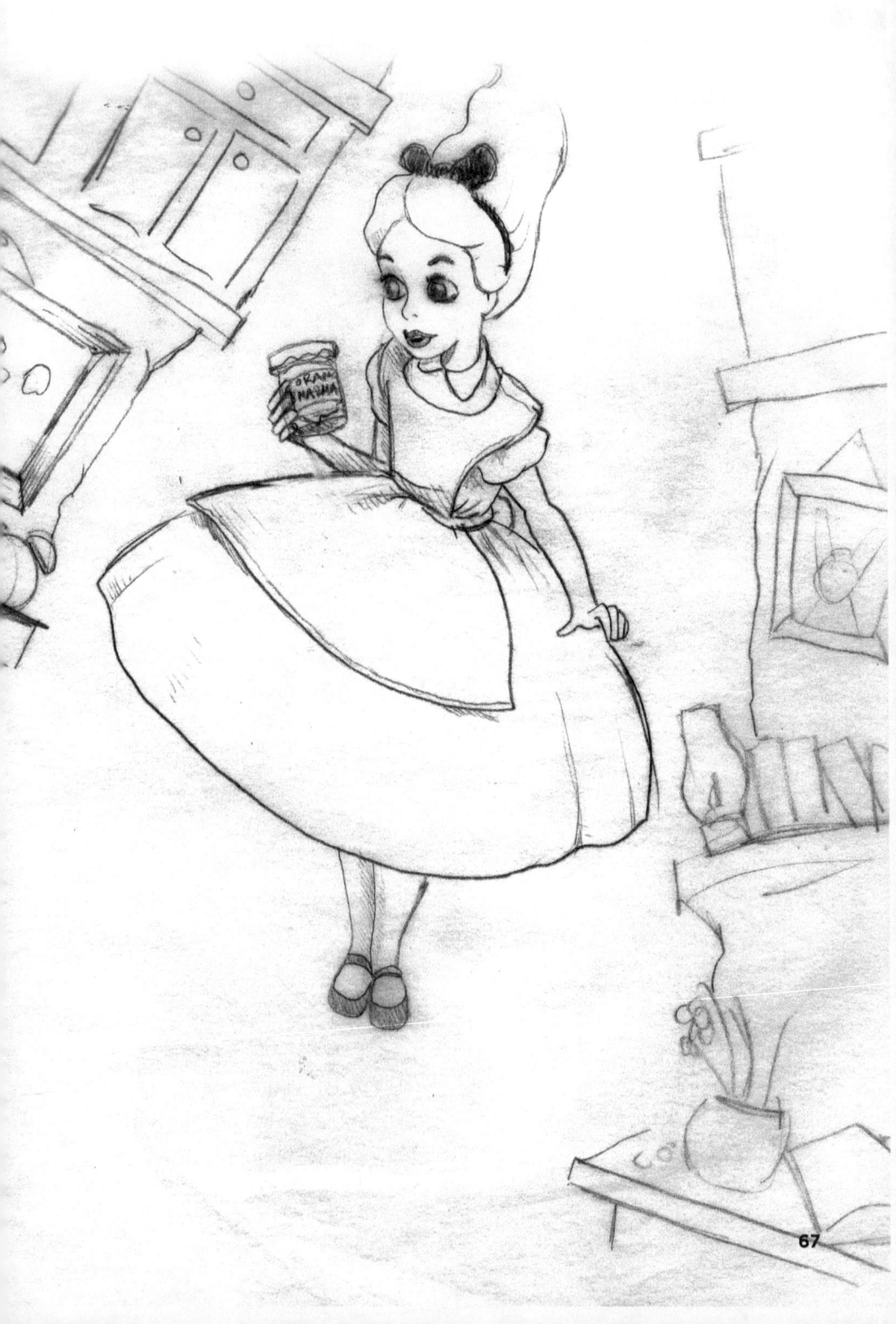

SOPHISTICATES AND WEIRDOS

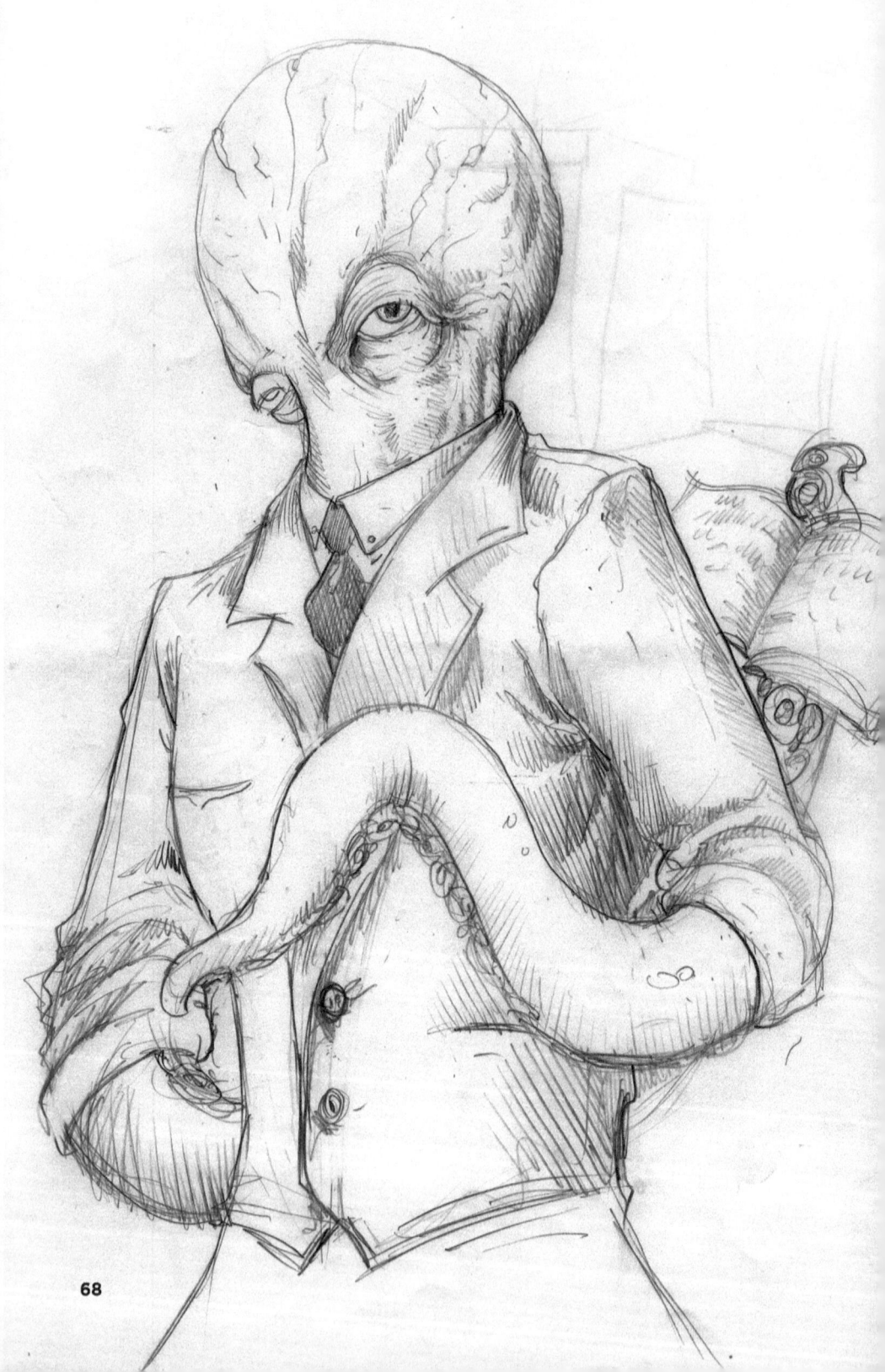

SOPHISTICATES AND WEIRDOS

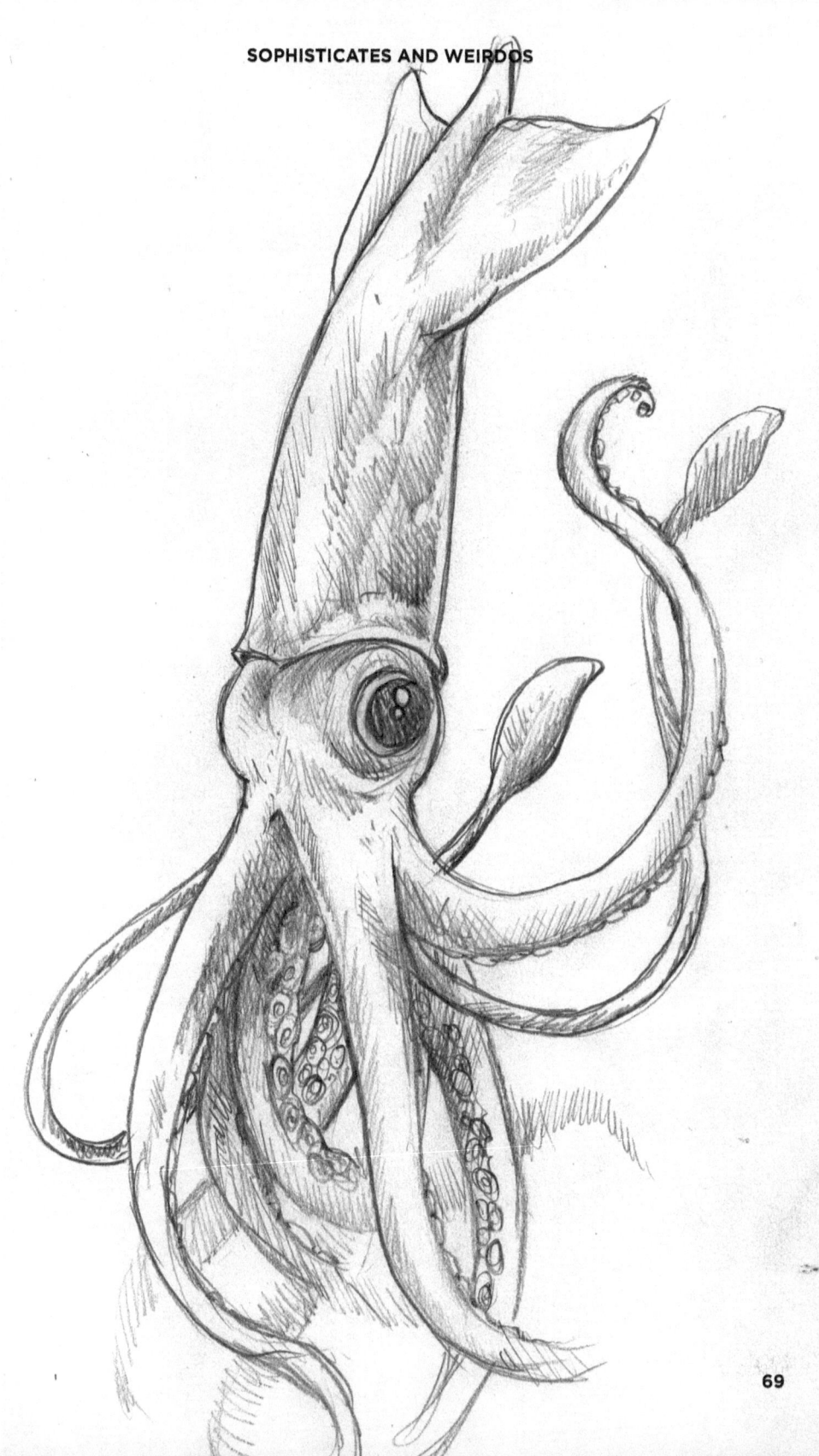

SOPHISTICATES AND WEIRDOS

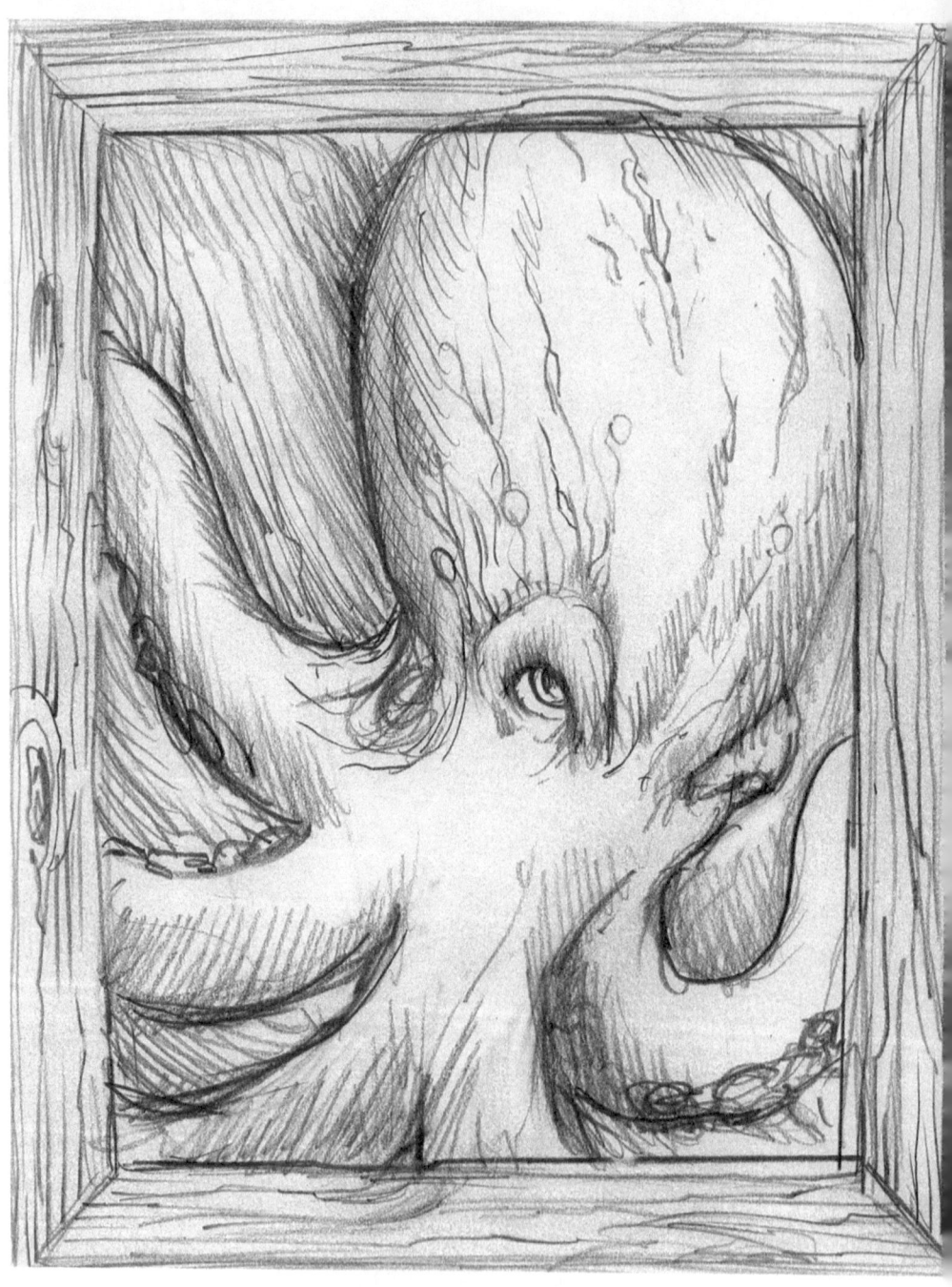

SOPHISTICATES AND WEIRDOS

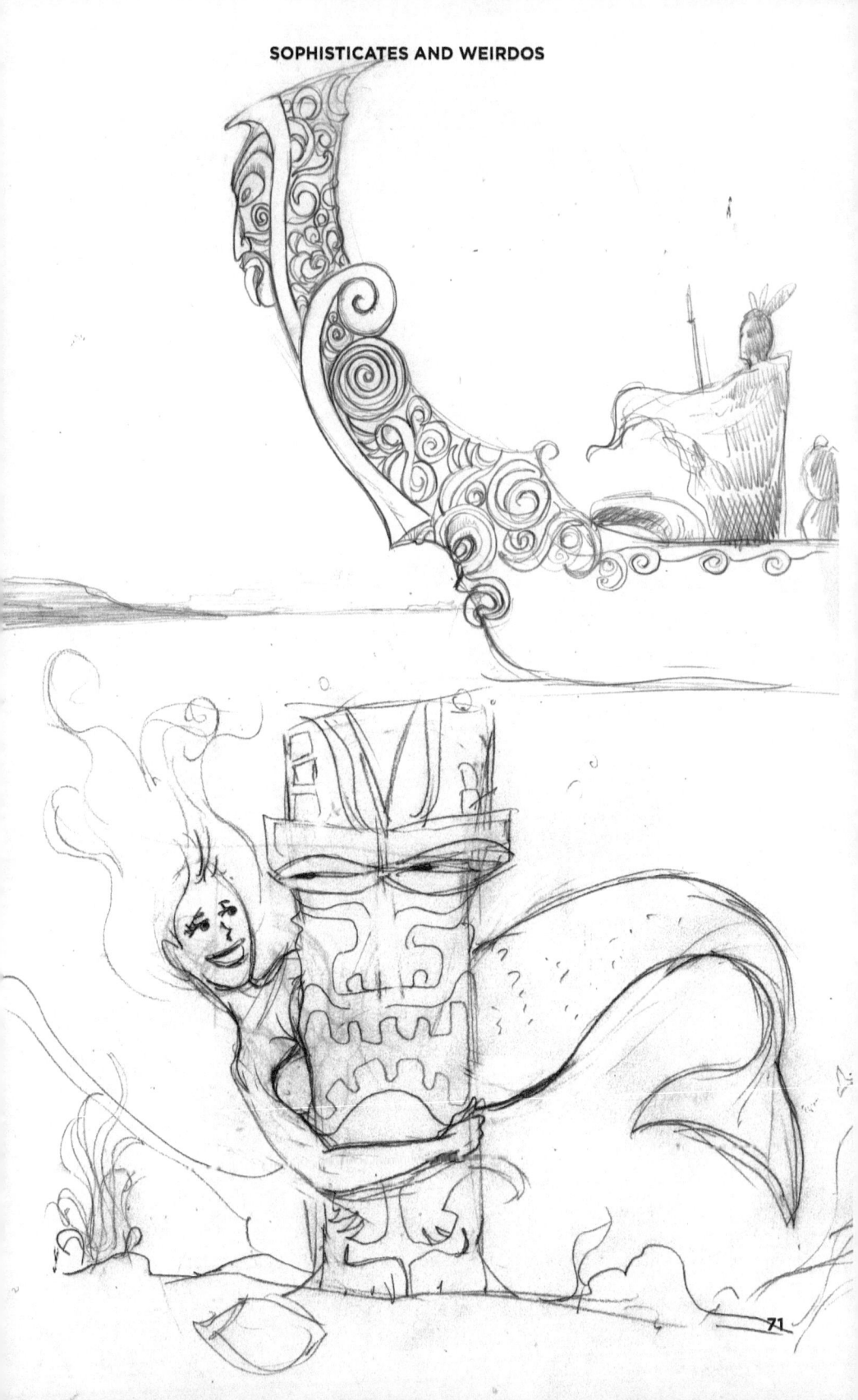

SOPHISTICATES AND WEIRDOS

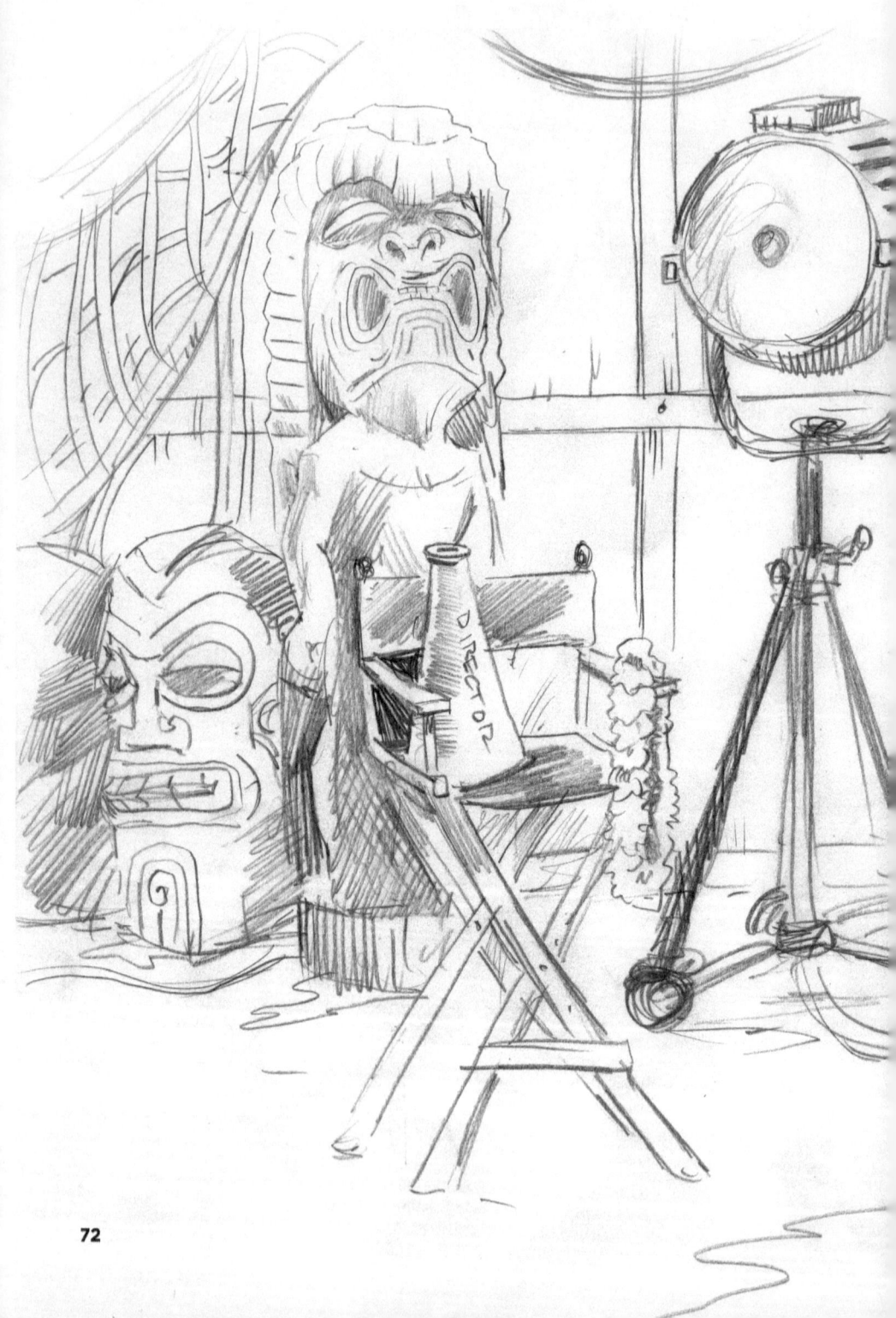

SOPHISTICATES AND WEIRDOS

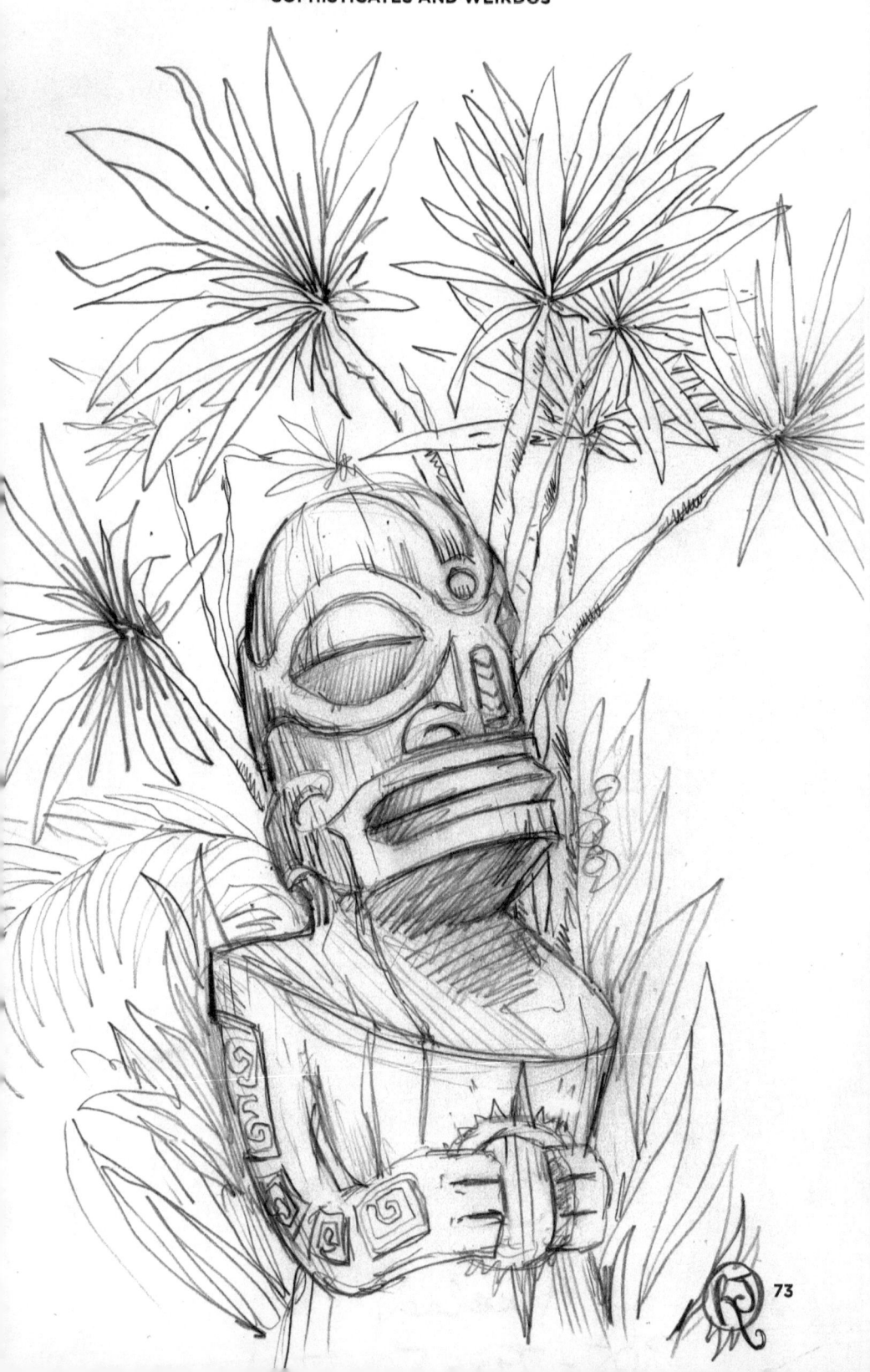

SOPHISTICATES AND WEIRDOS

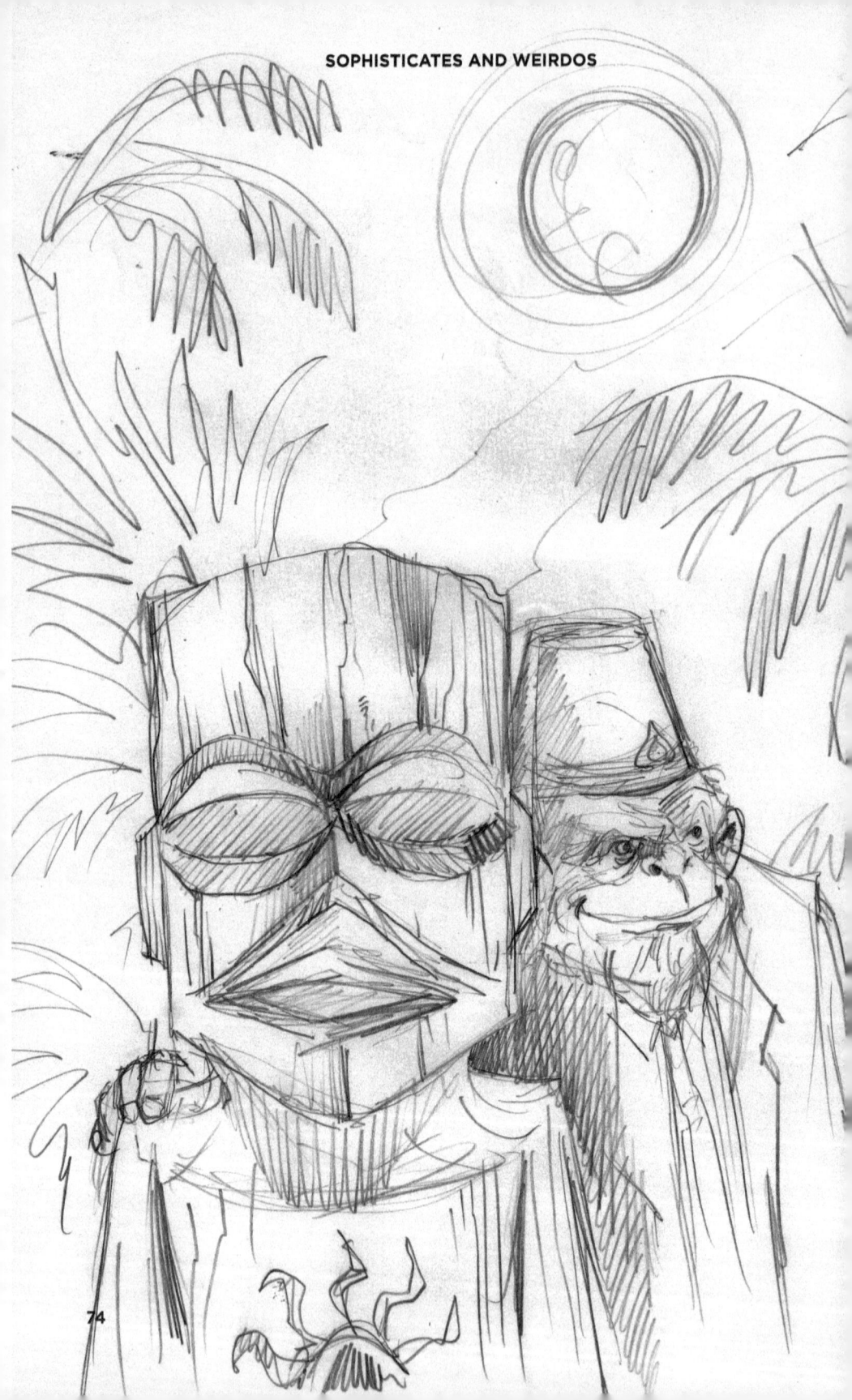

SOPHISTICATES AND WEIRDOS

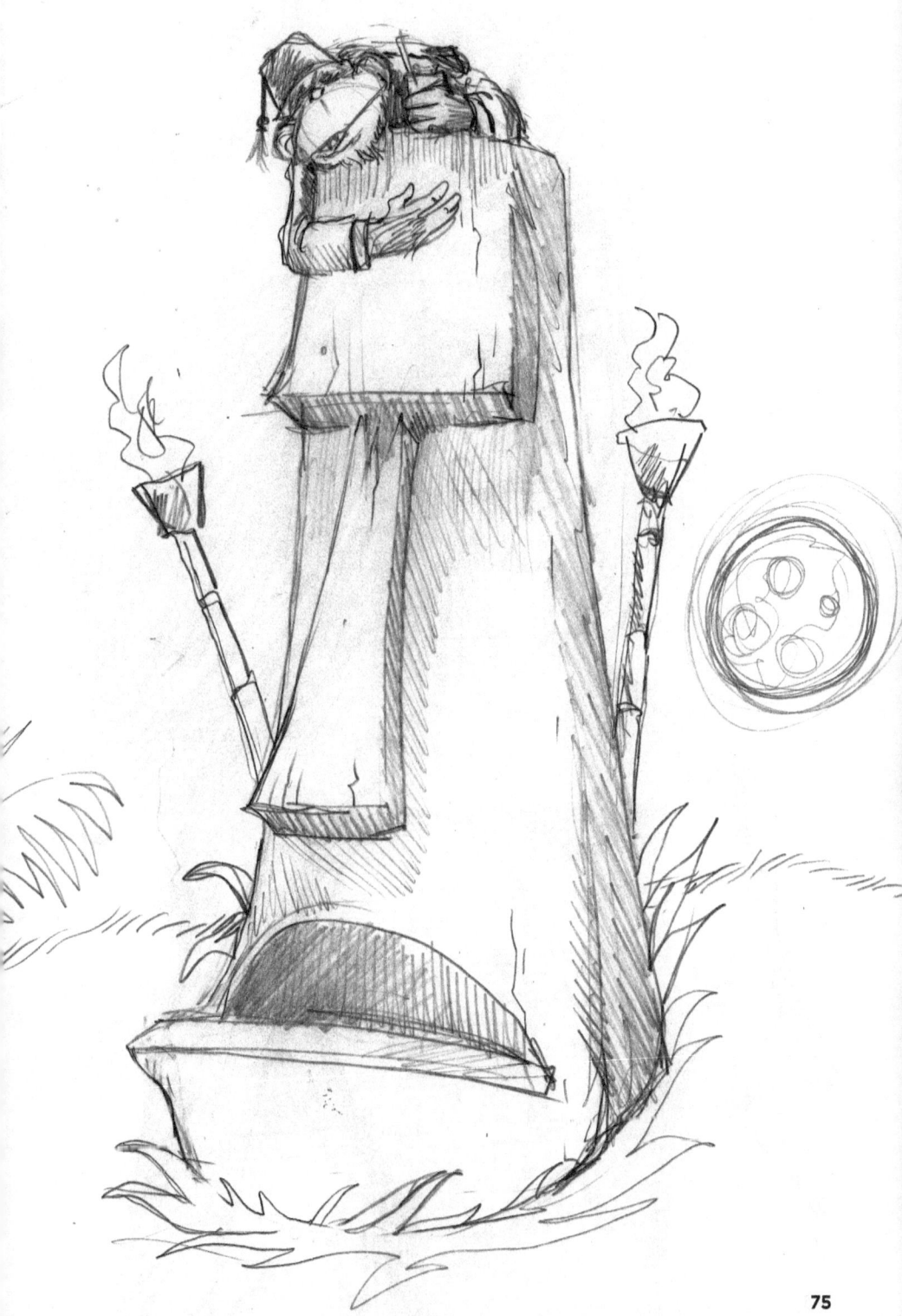

SOPHISTICATES AND WEIRDOS

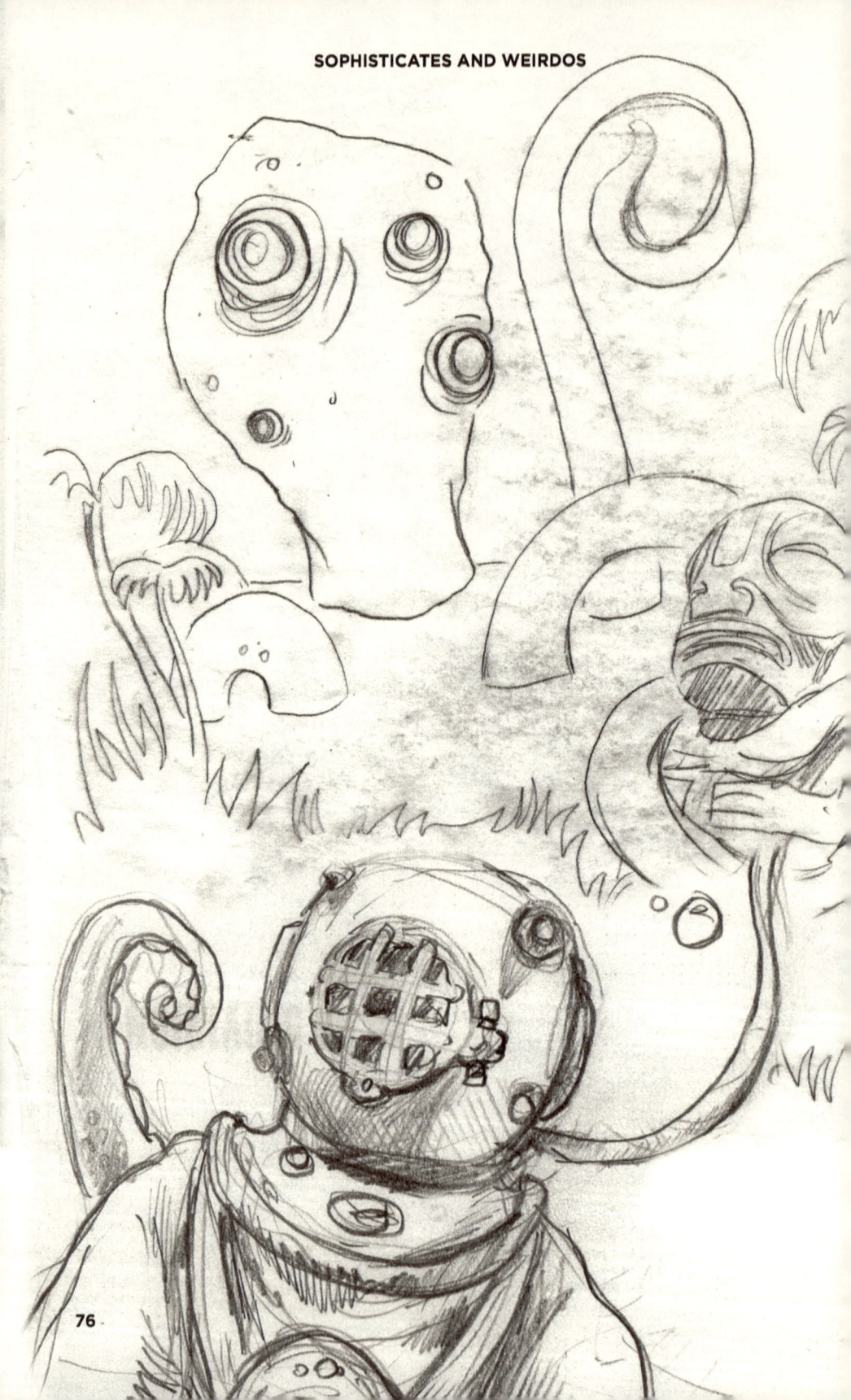

SOPHISTICATES AND WEIRDOS

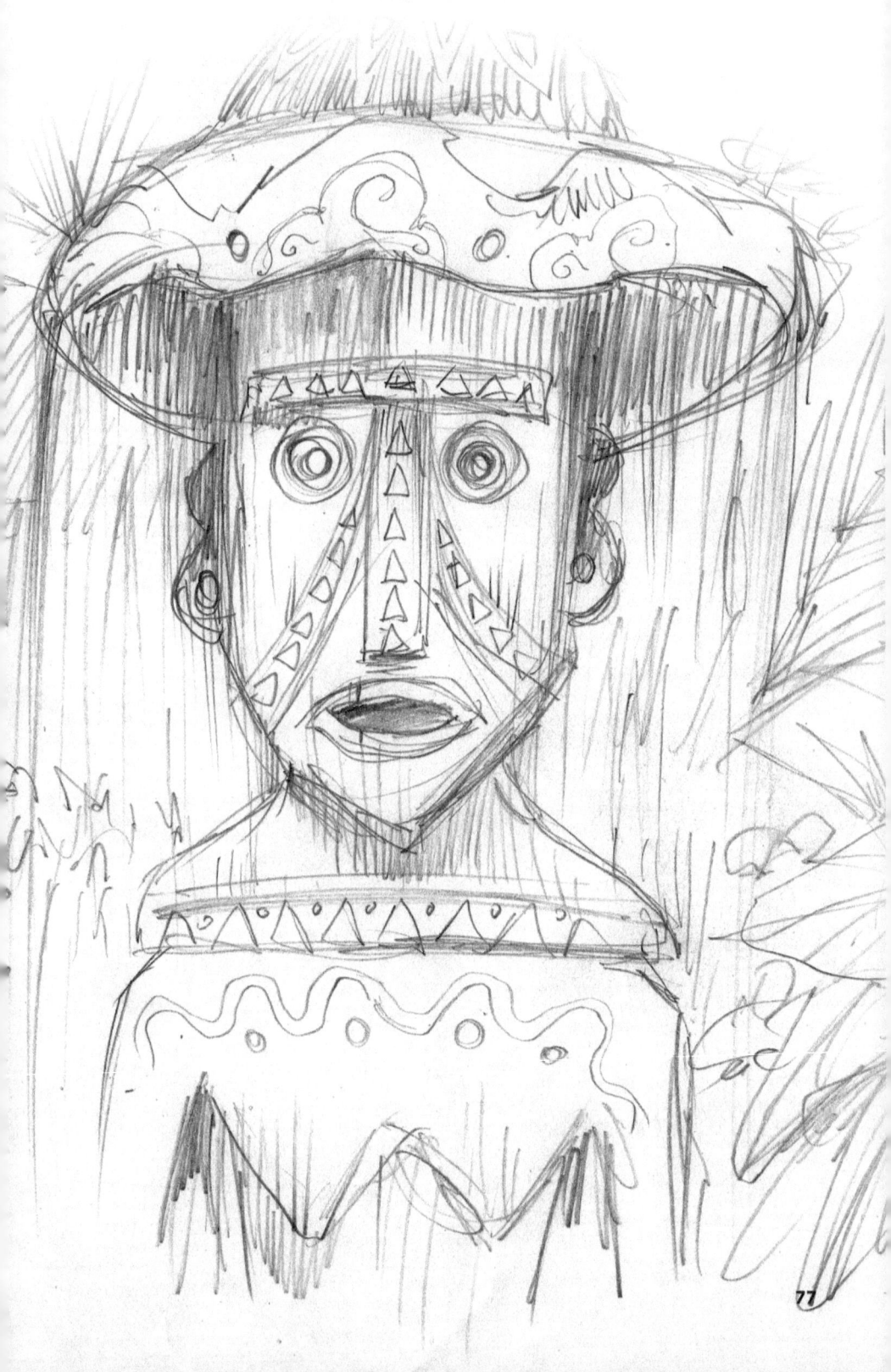

SOPHISTICATES AND WEIRDOS

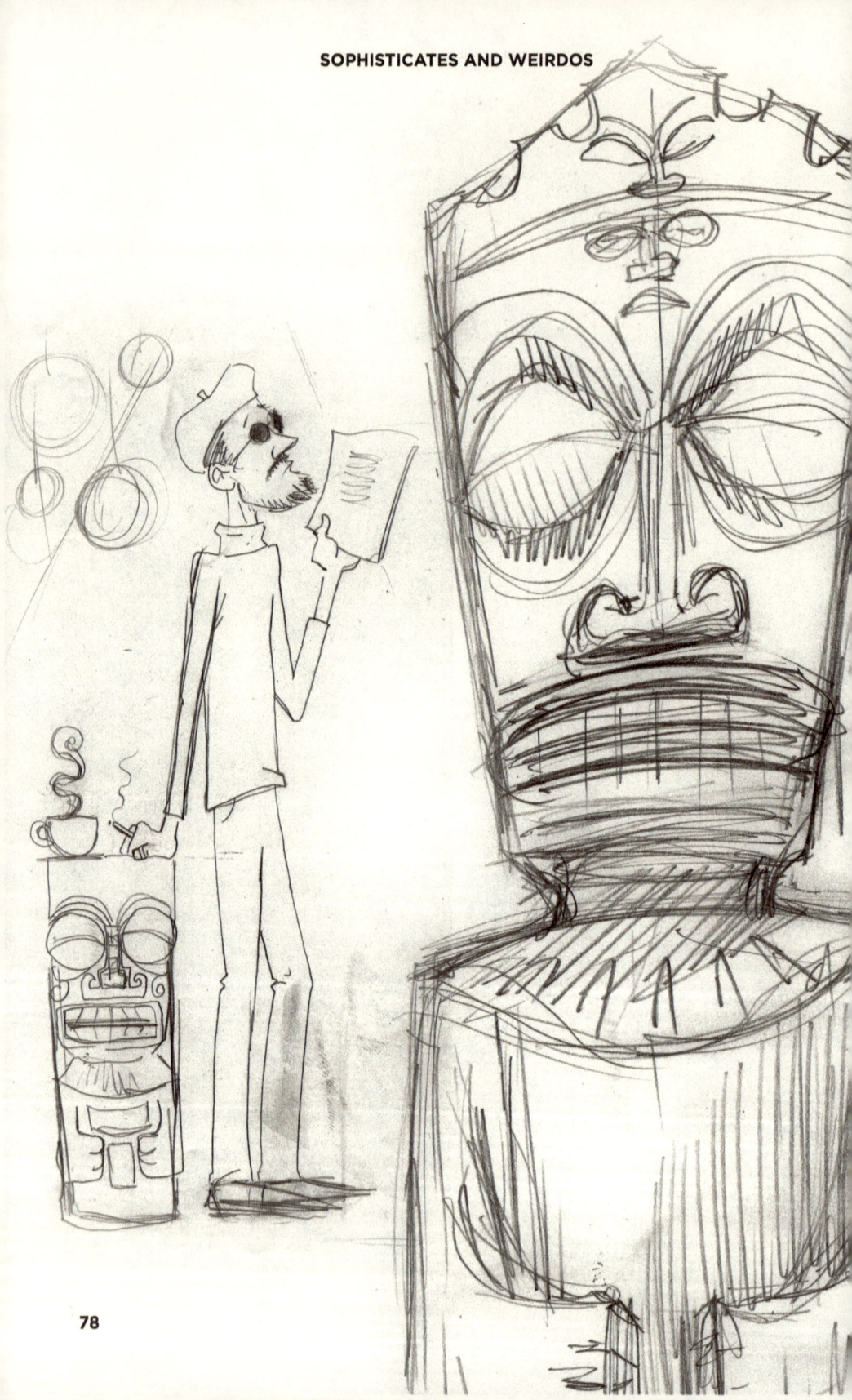

SOPHISTICATES AND WEIRDOS

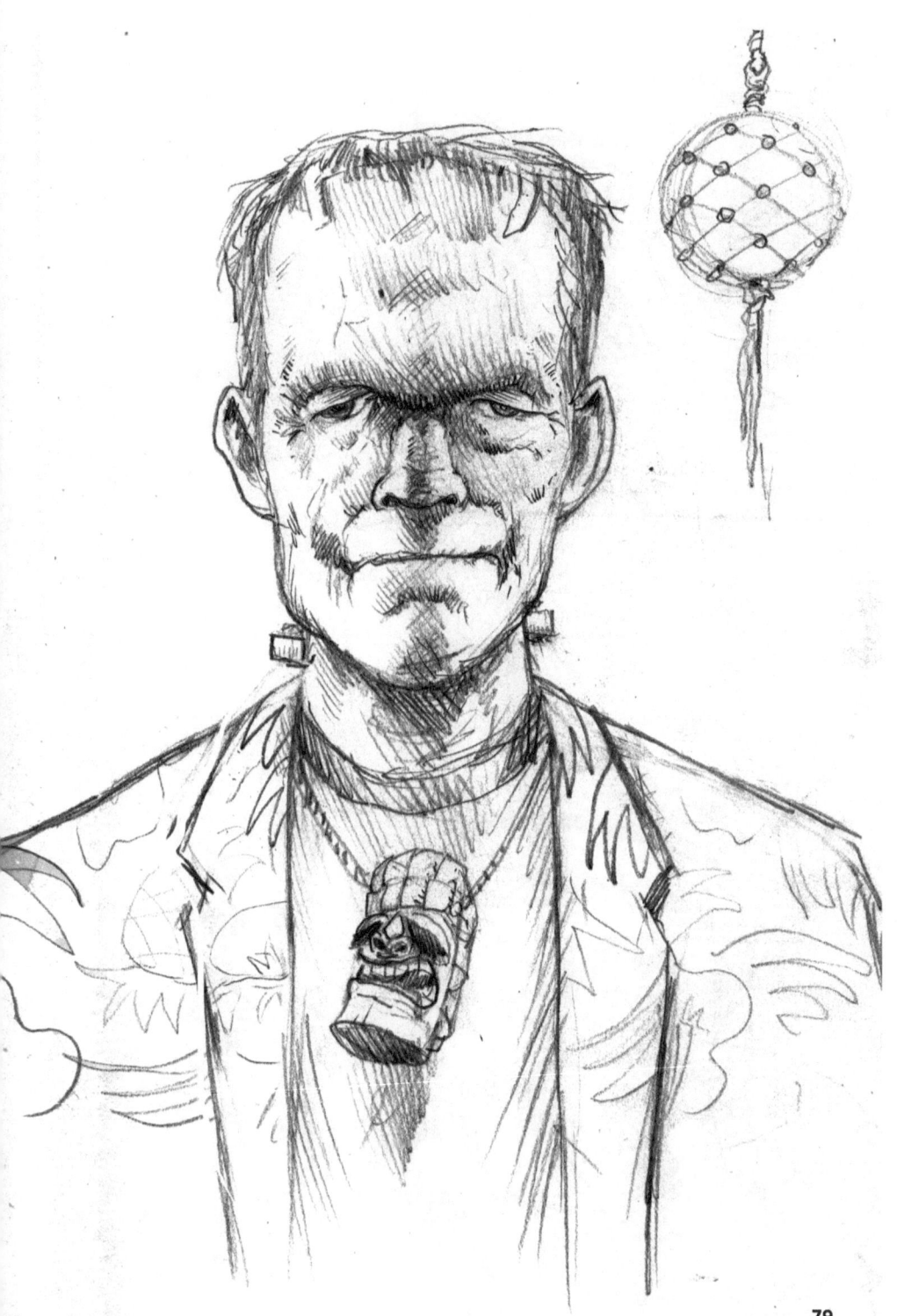

SOPHISTICATES AND WEIRDOS

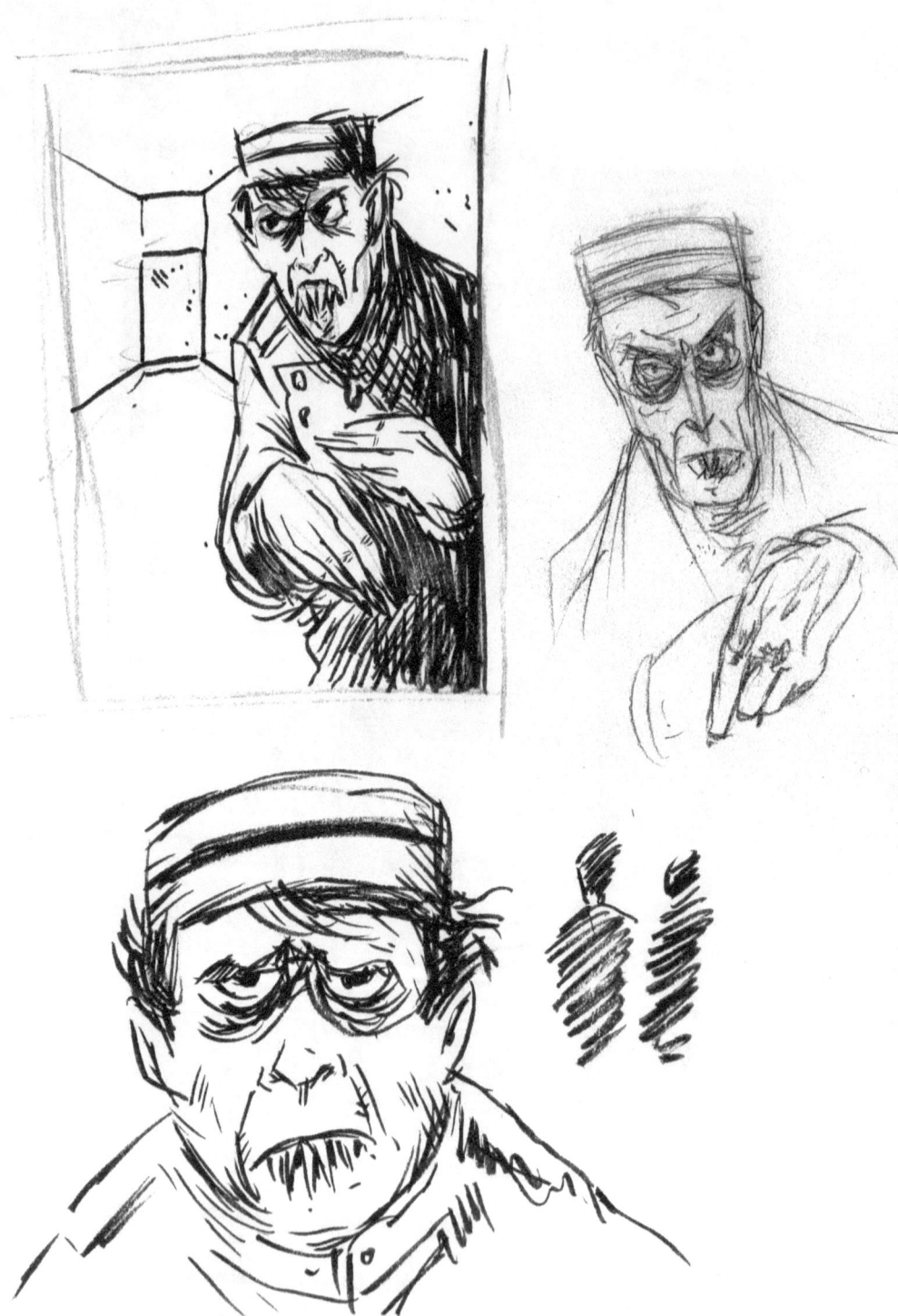

SOPHISTICATES AND WEIRDOS

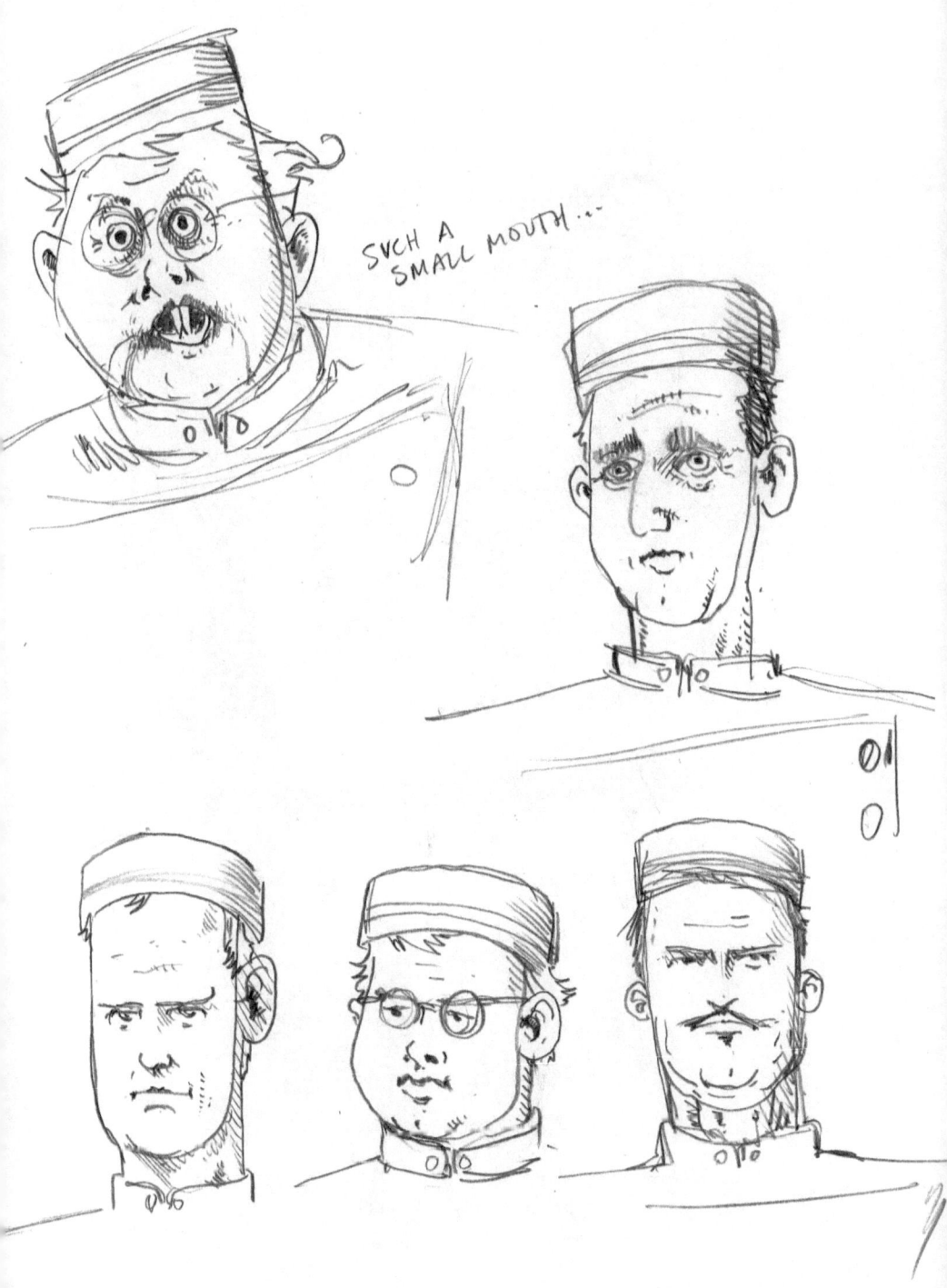

SOPHISTICATES AND WEIRDOS

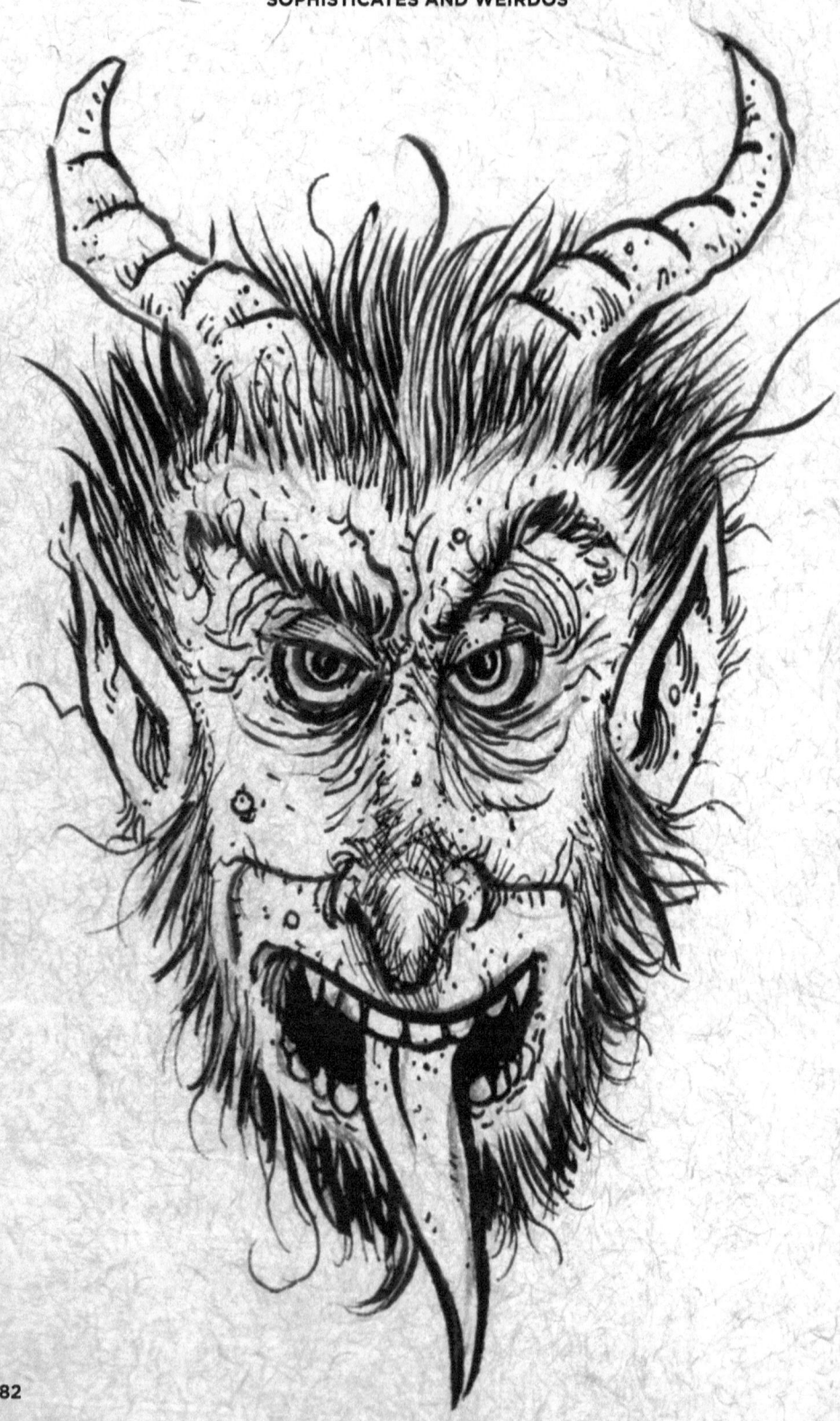

SOPHISTICATES AND WEIRDOS

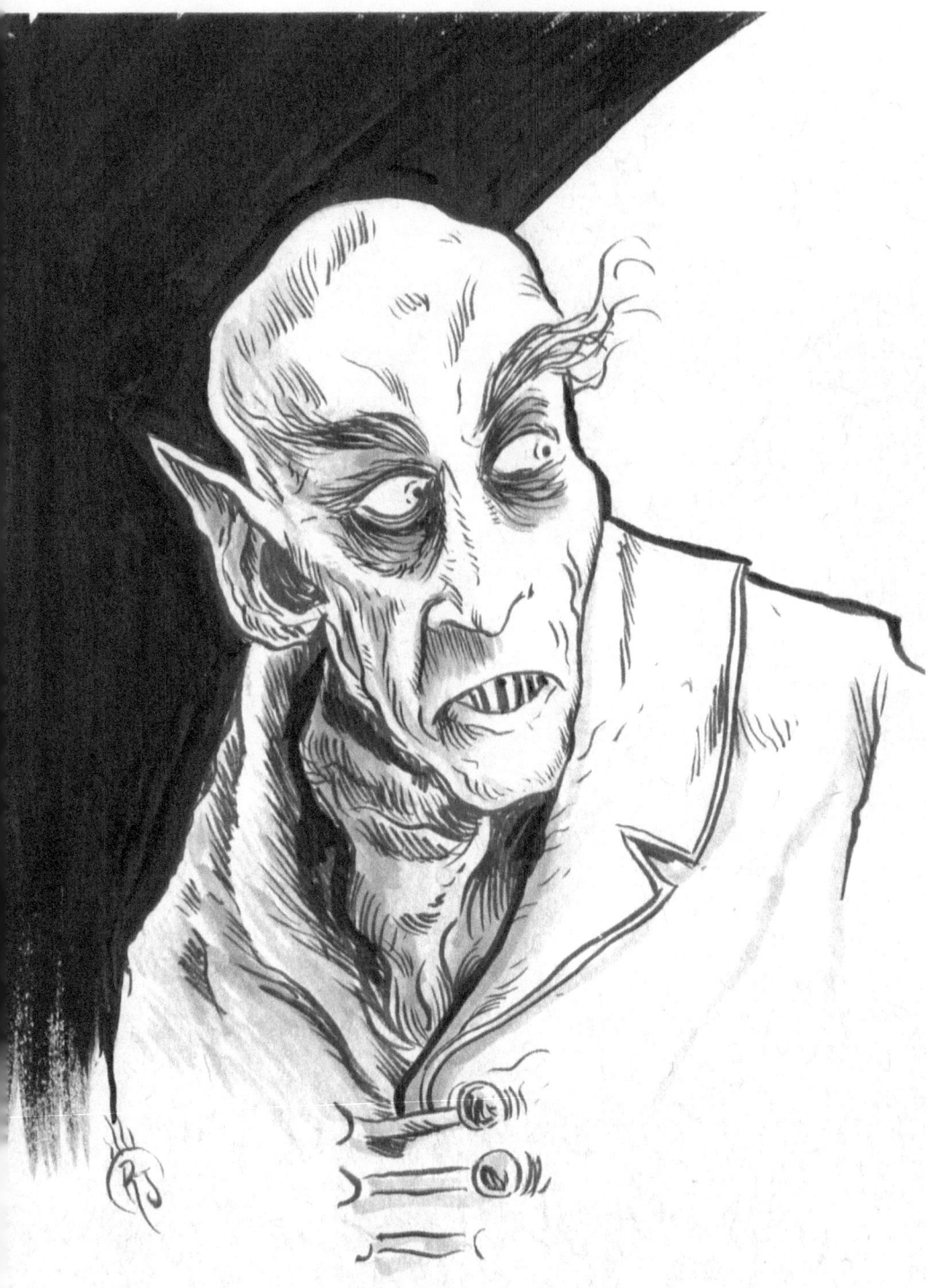

SOPHISTICATES AND WEIRDOS

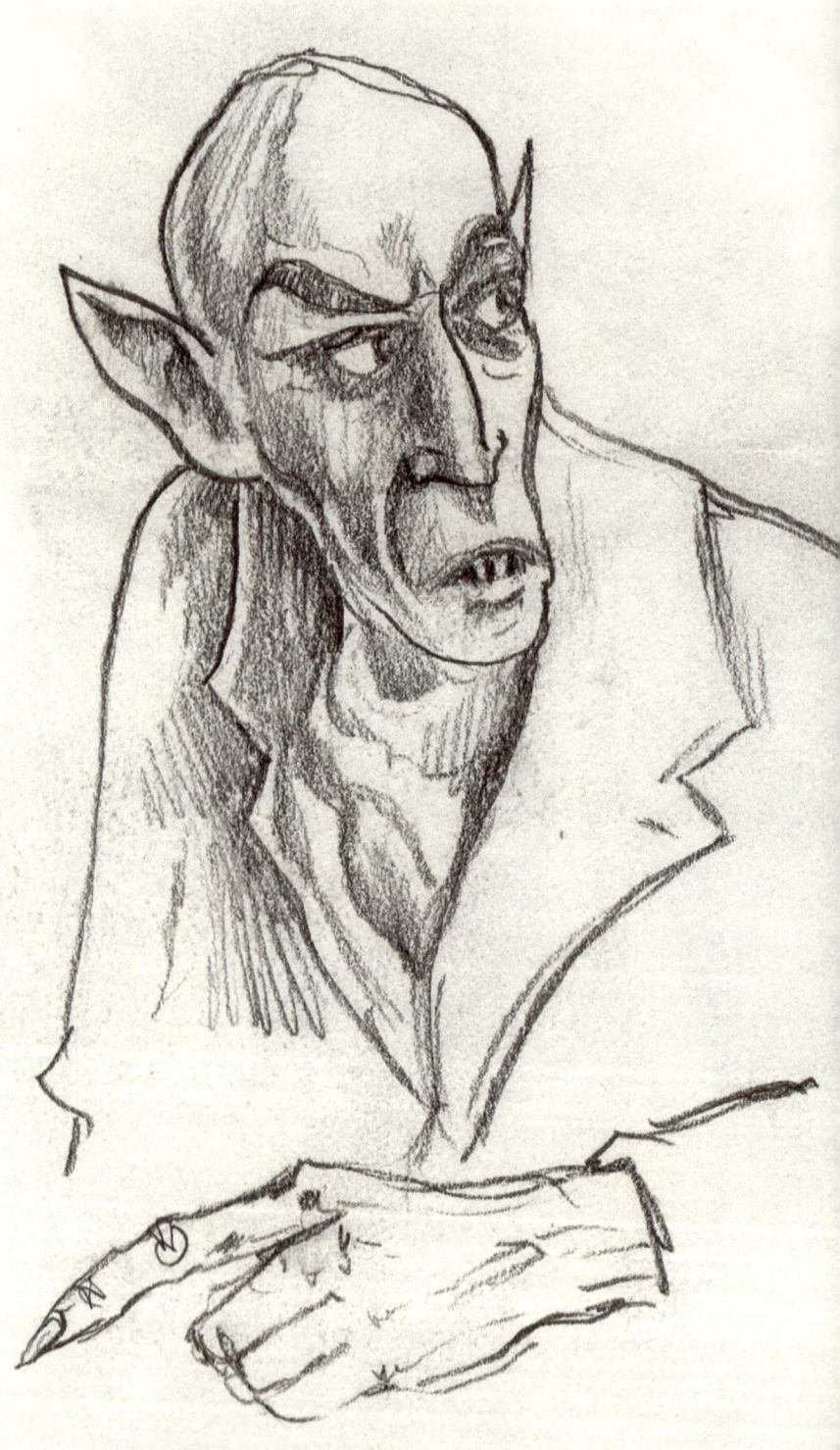

SOPHISTICATES AND WEIRDOS

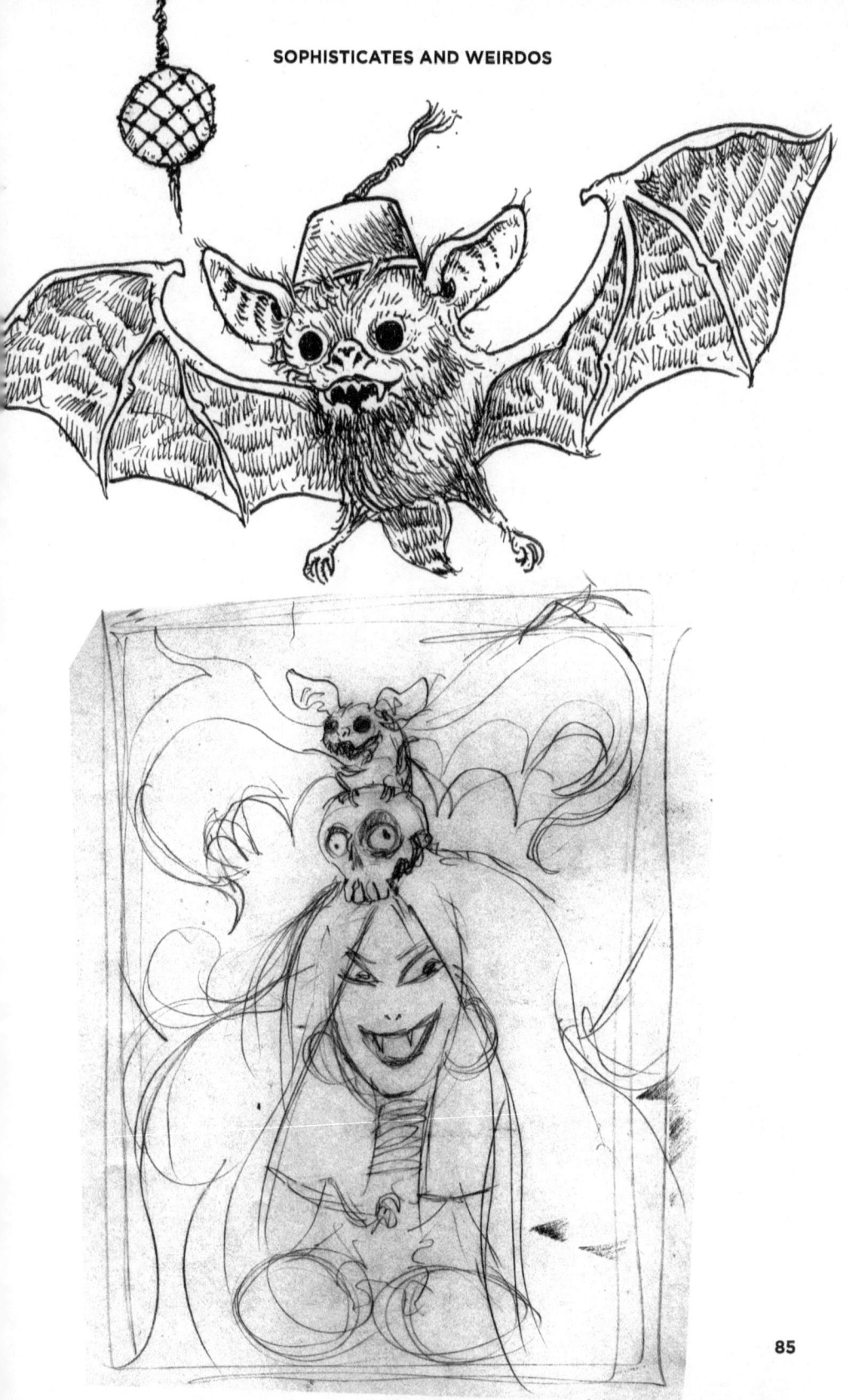

SOPHISTICATES AND WEIRDOS

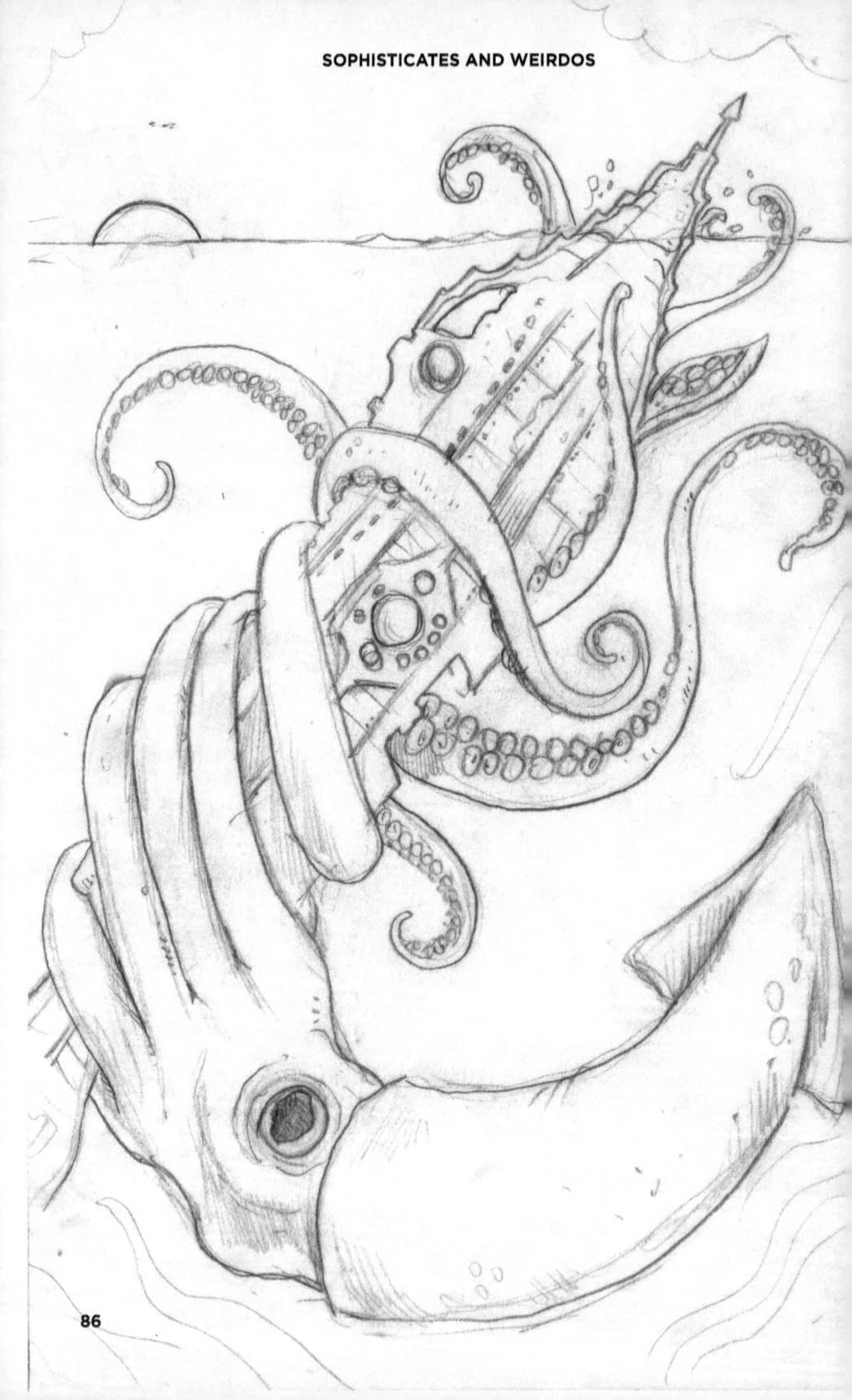

SOPHISTICATES AND WEIRDOS

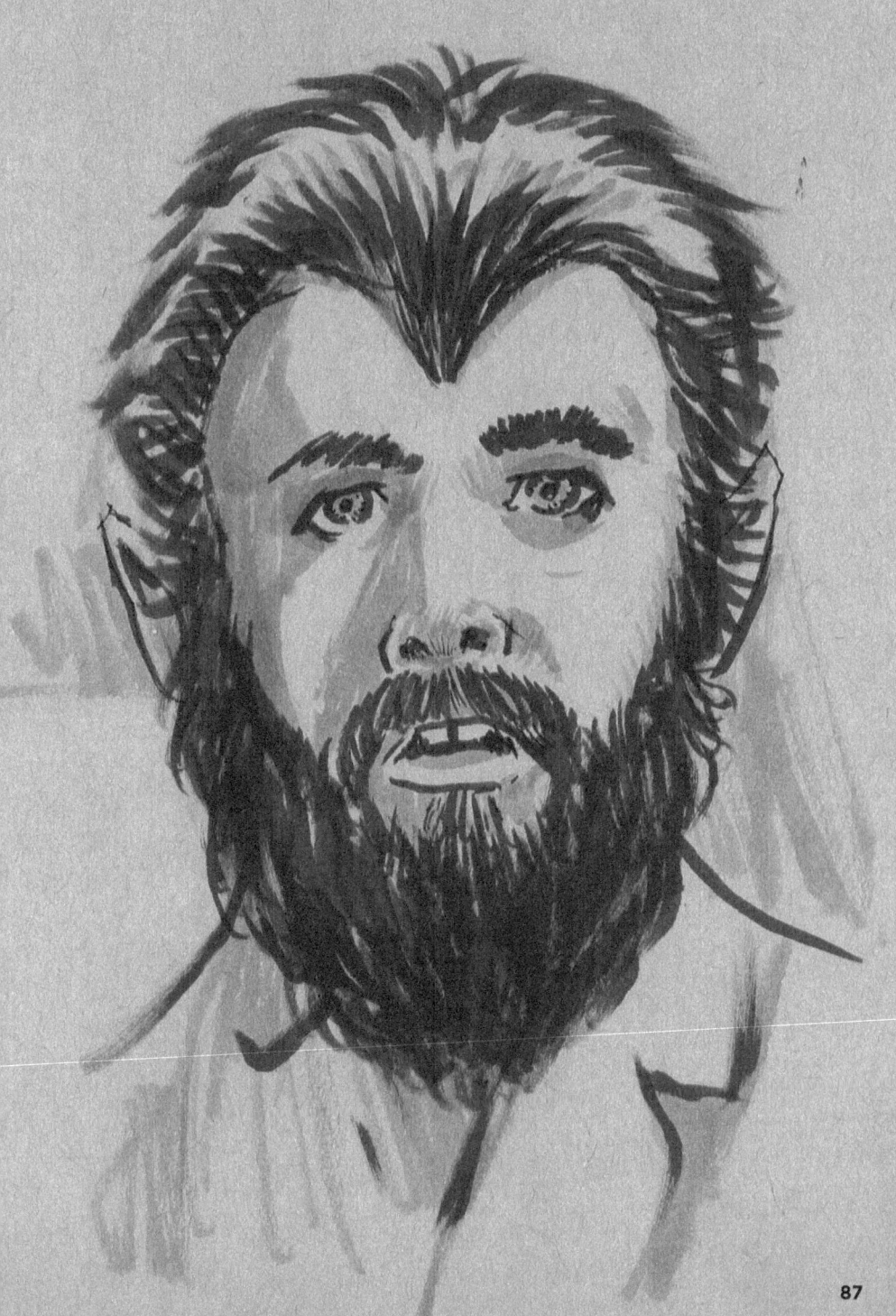

SOPHISTICATES AND WEIRDOS

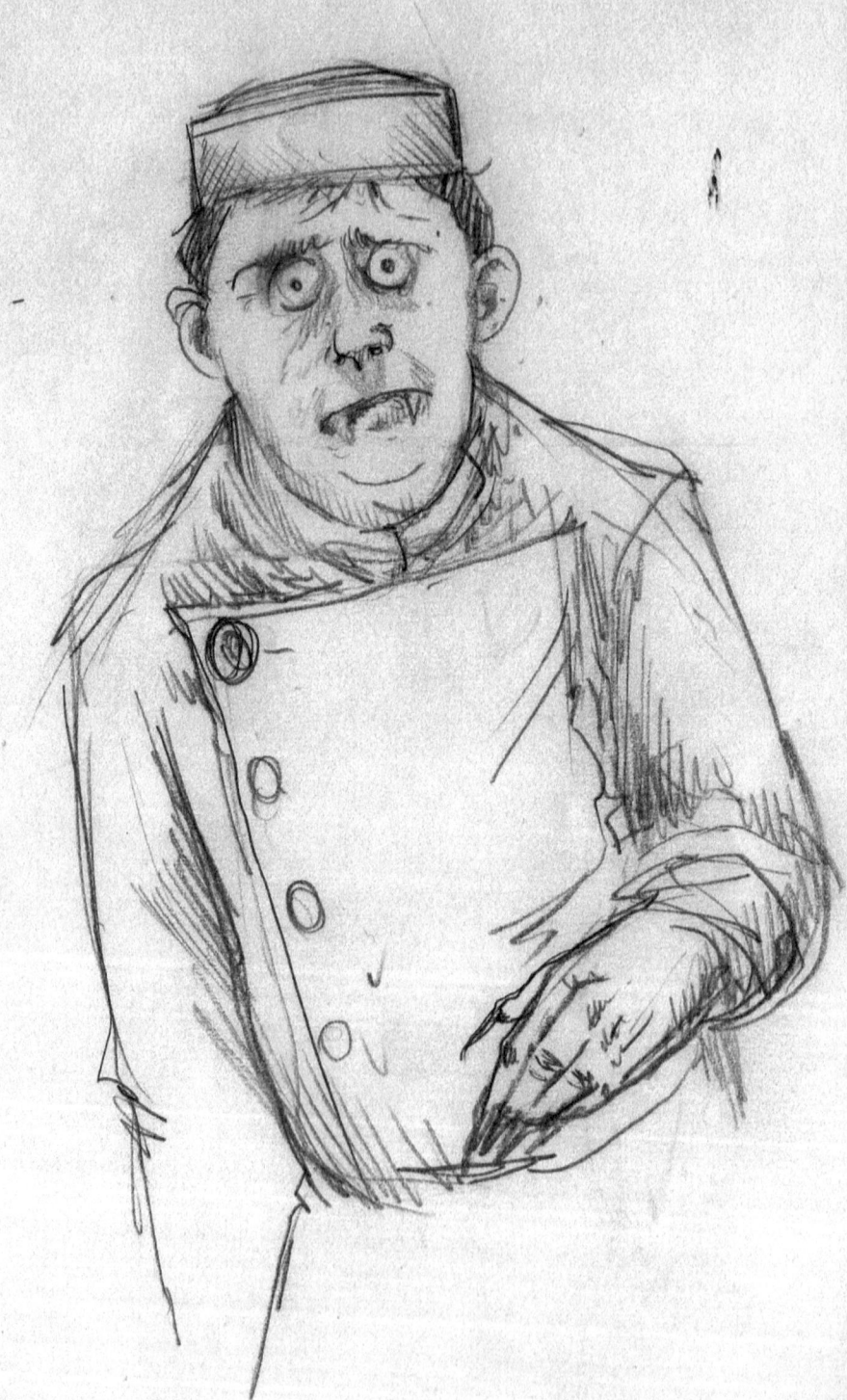

SOPHISTICATES AND WEIRDOS

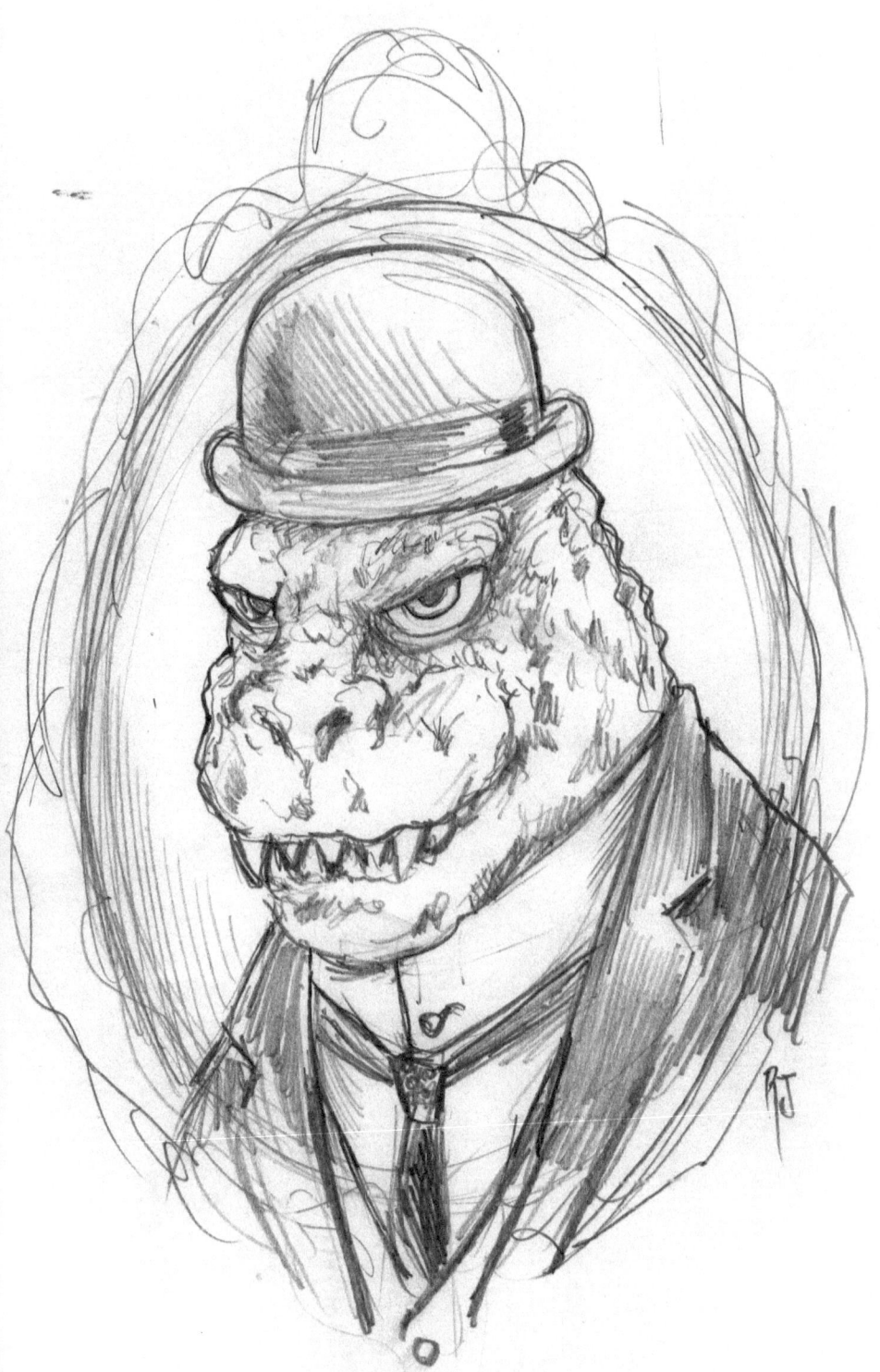

SOPHISTICATES AND WEIRDOS

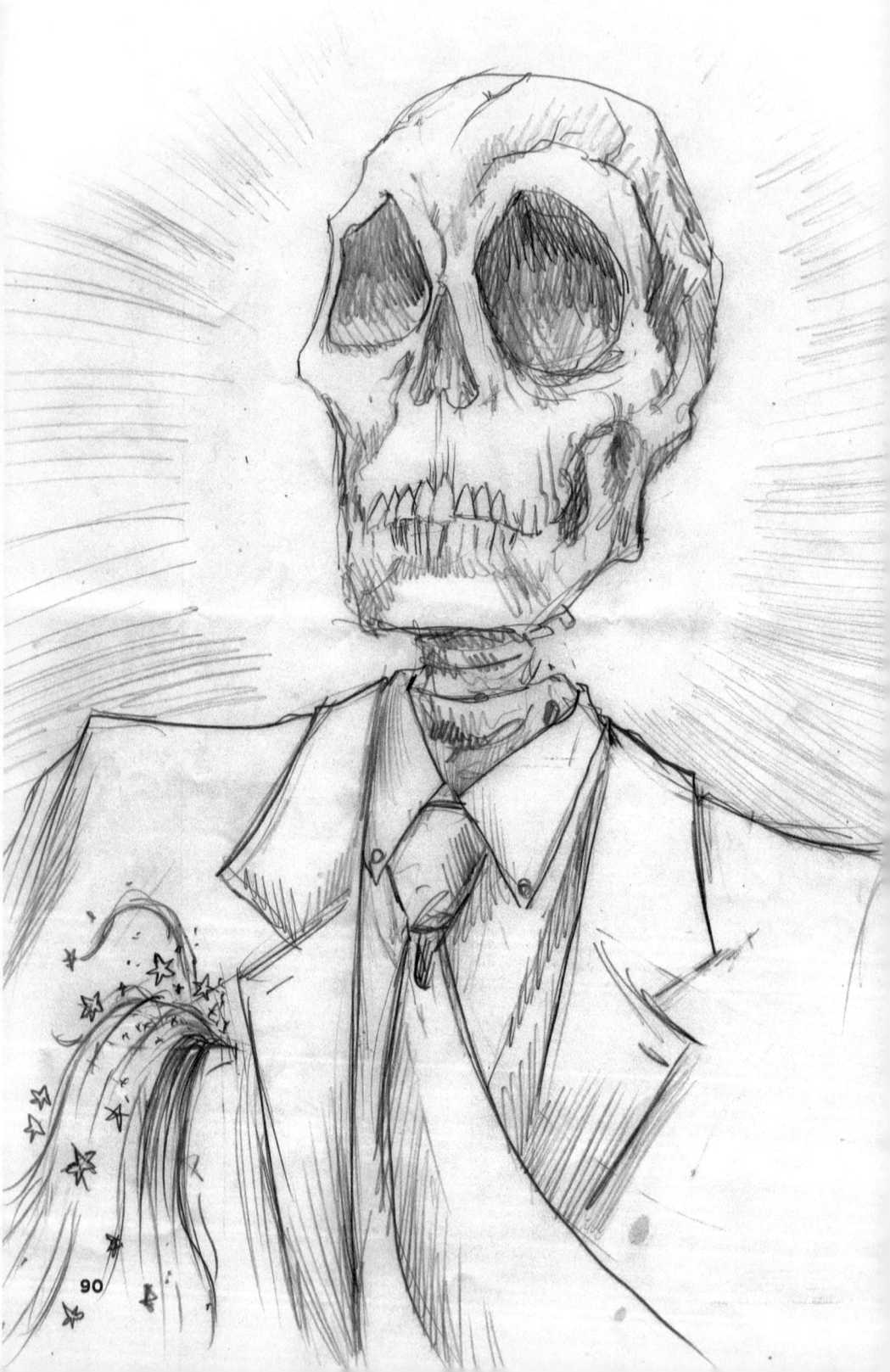

SOPHISTICATES AND WEIRDOS

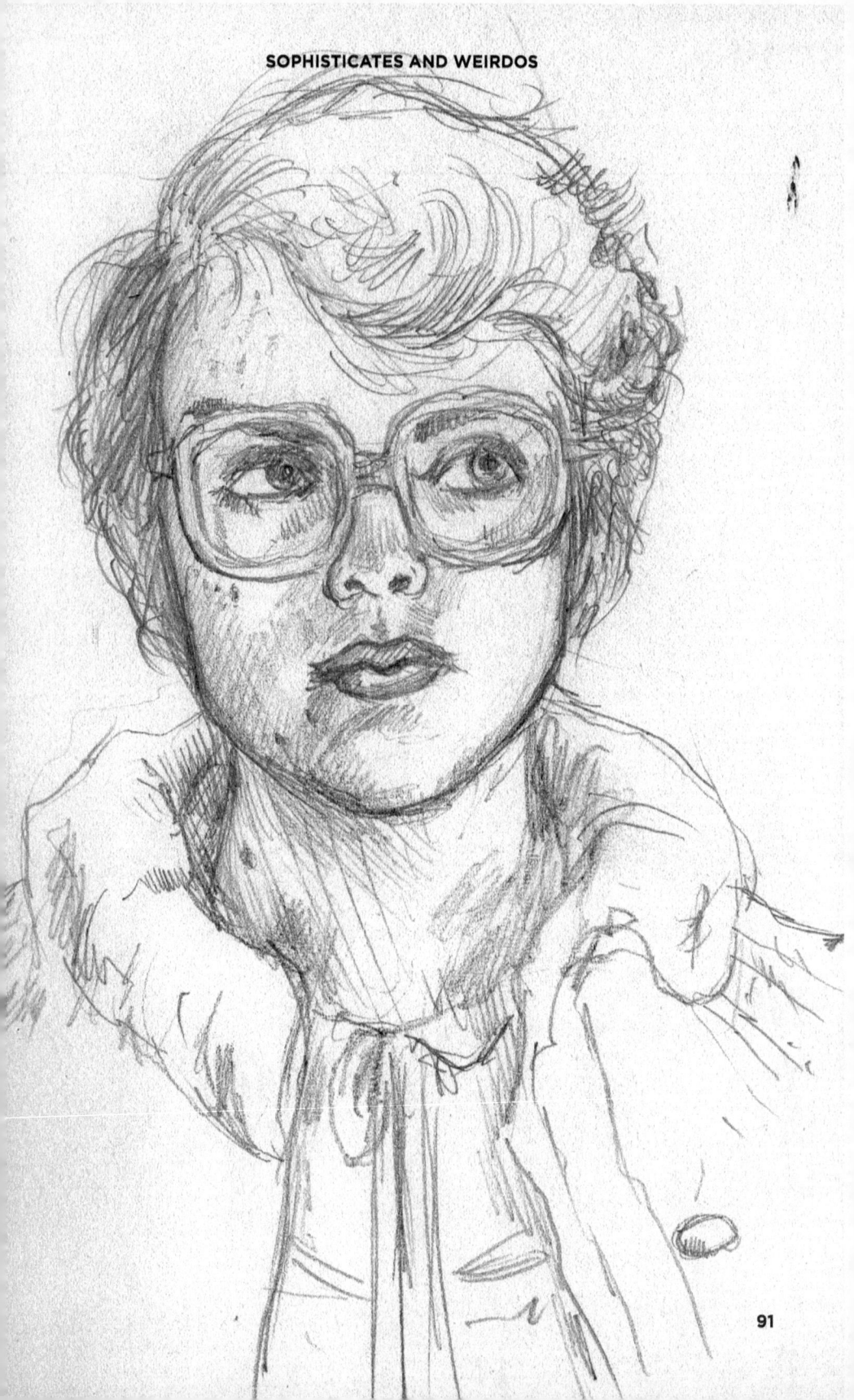

SOPHISTICATES AND WEIRDOS

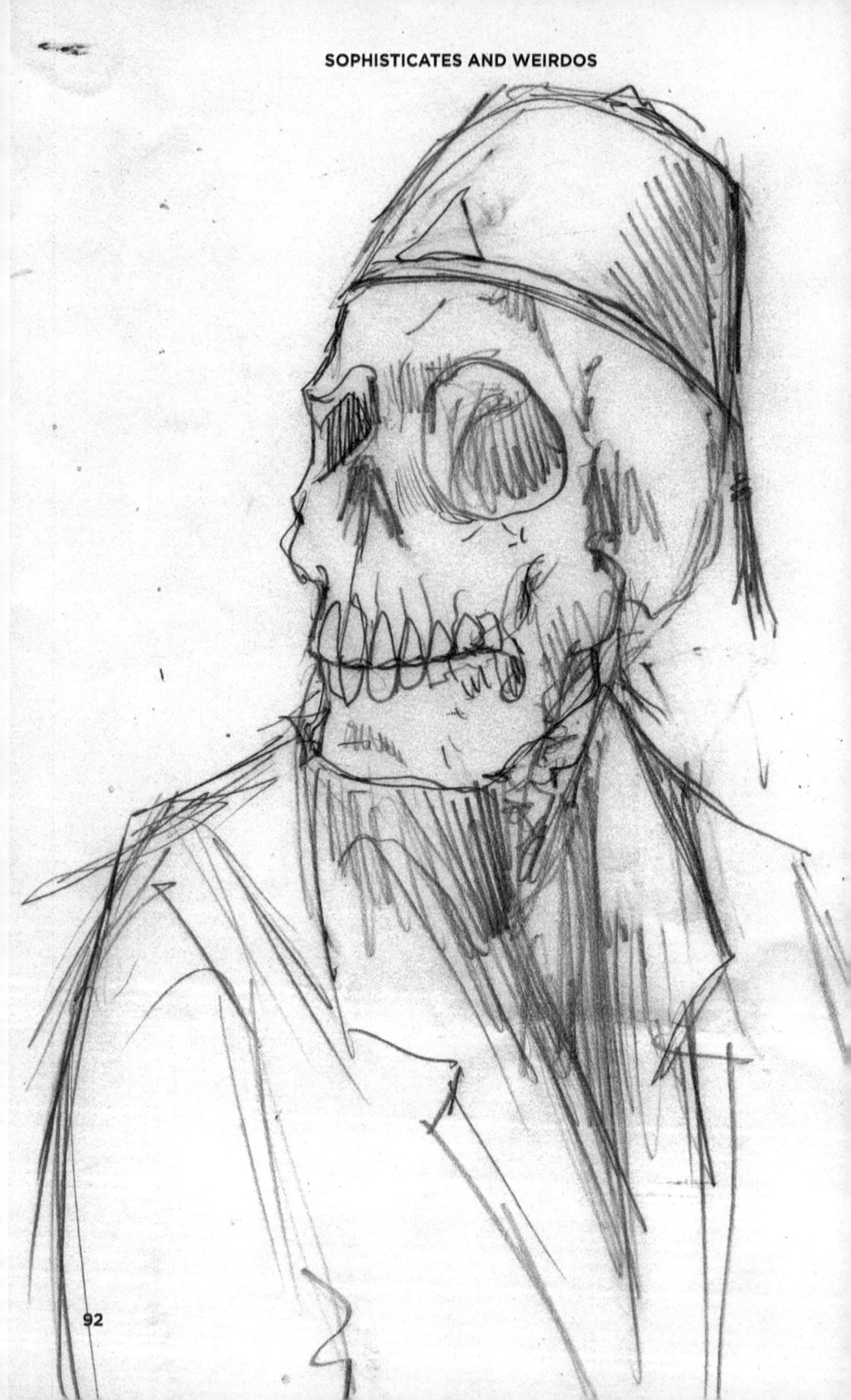

SOPHISTICATES AND WEIRDOS

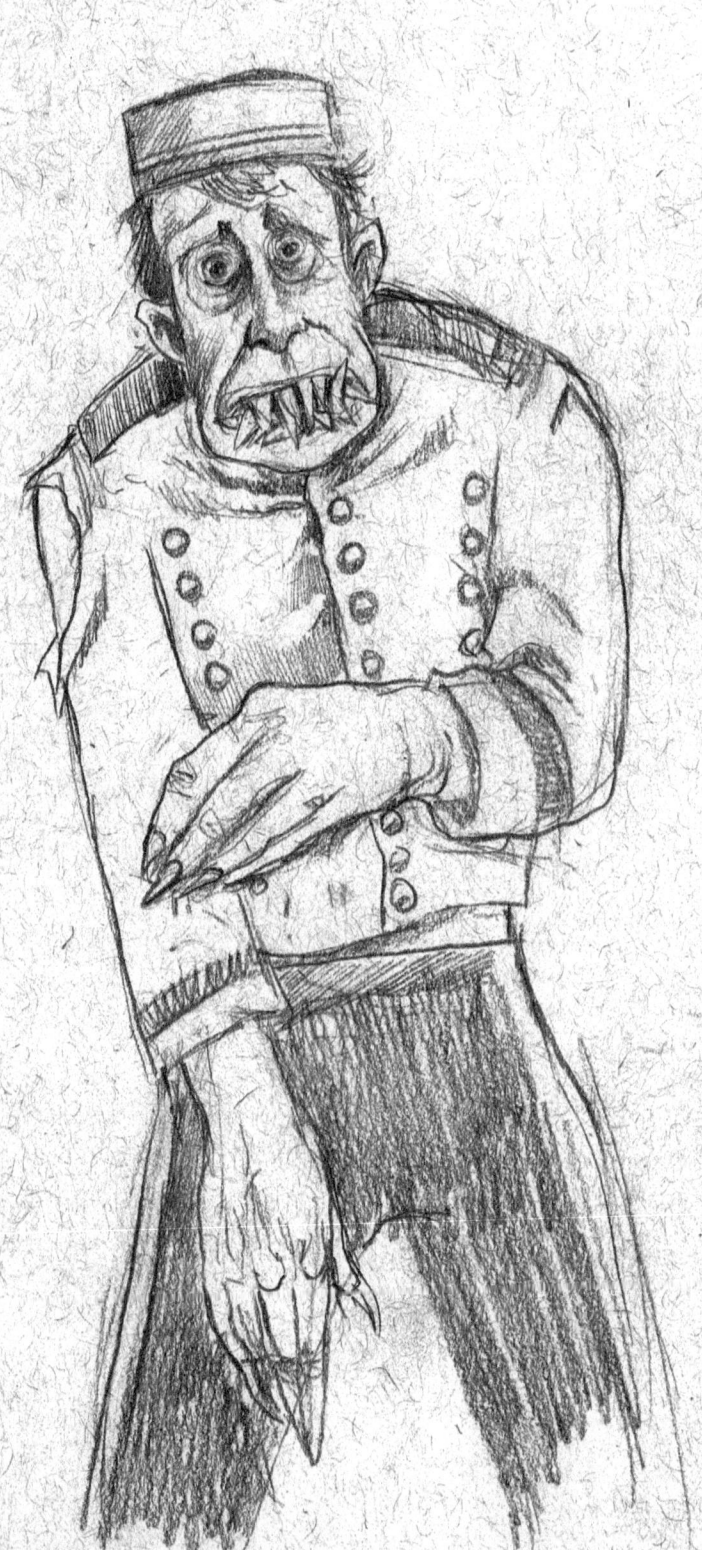

SOPHISTICATES AND WEIRDOS

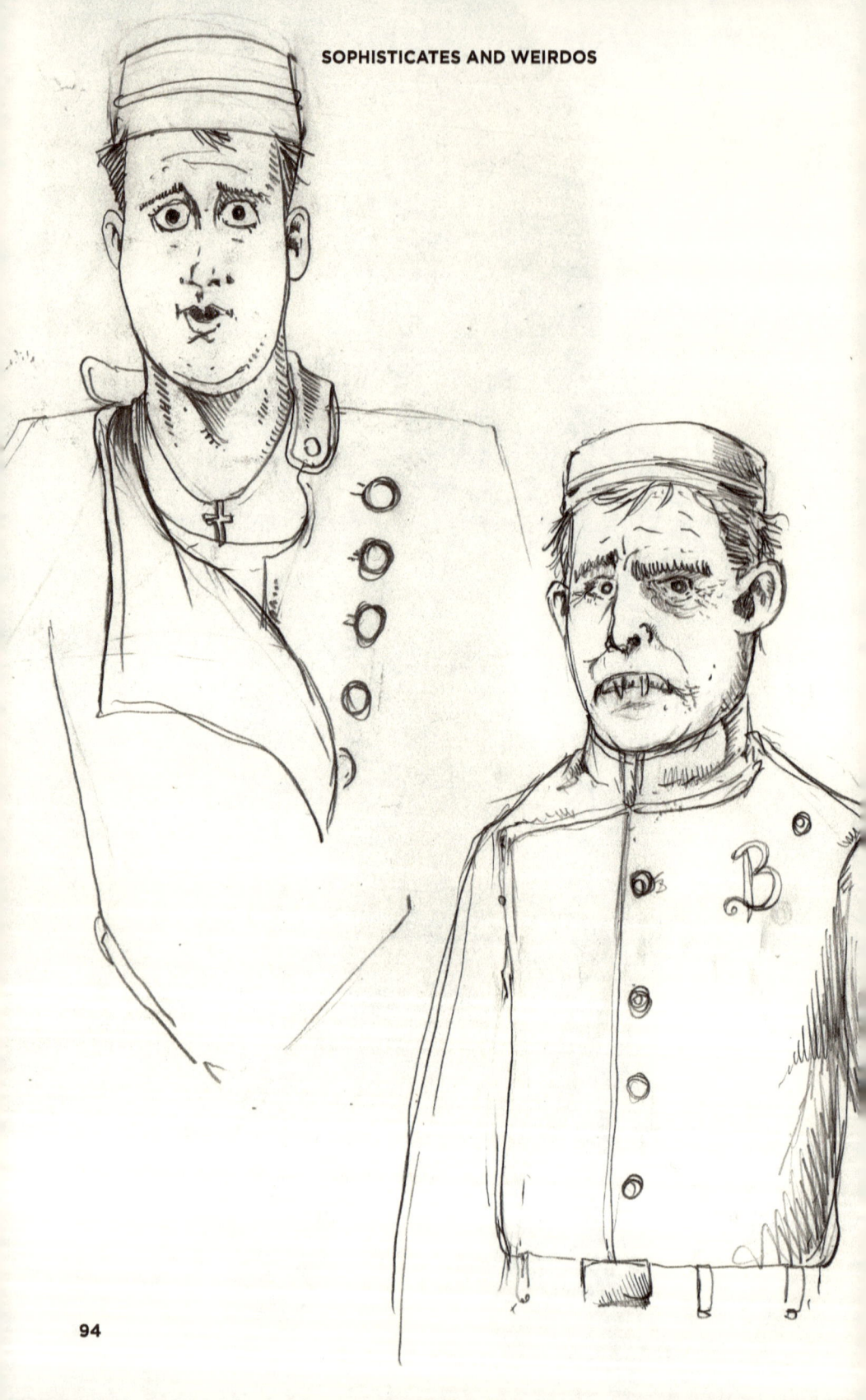

SOPHISTICATES AND WEIRDOS

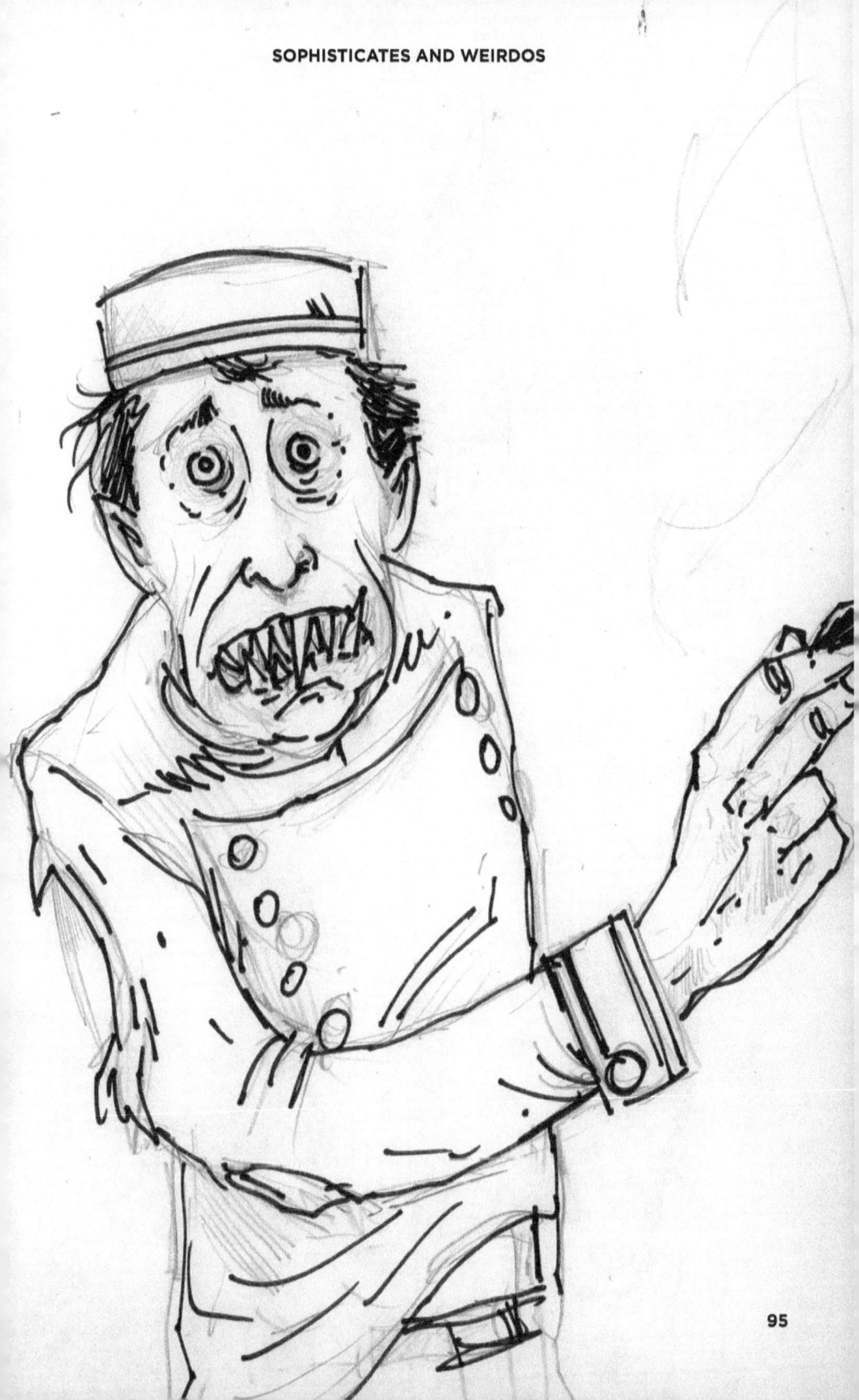

SOPHISTICATES AND WEIRDOS

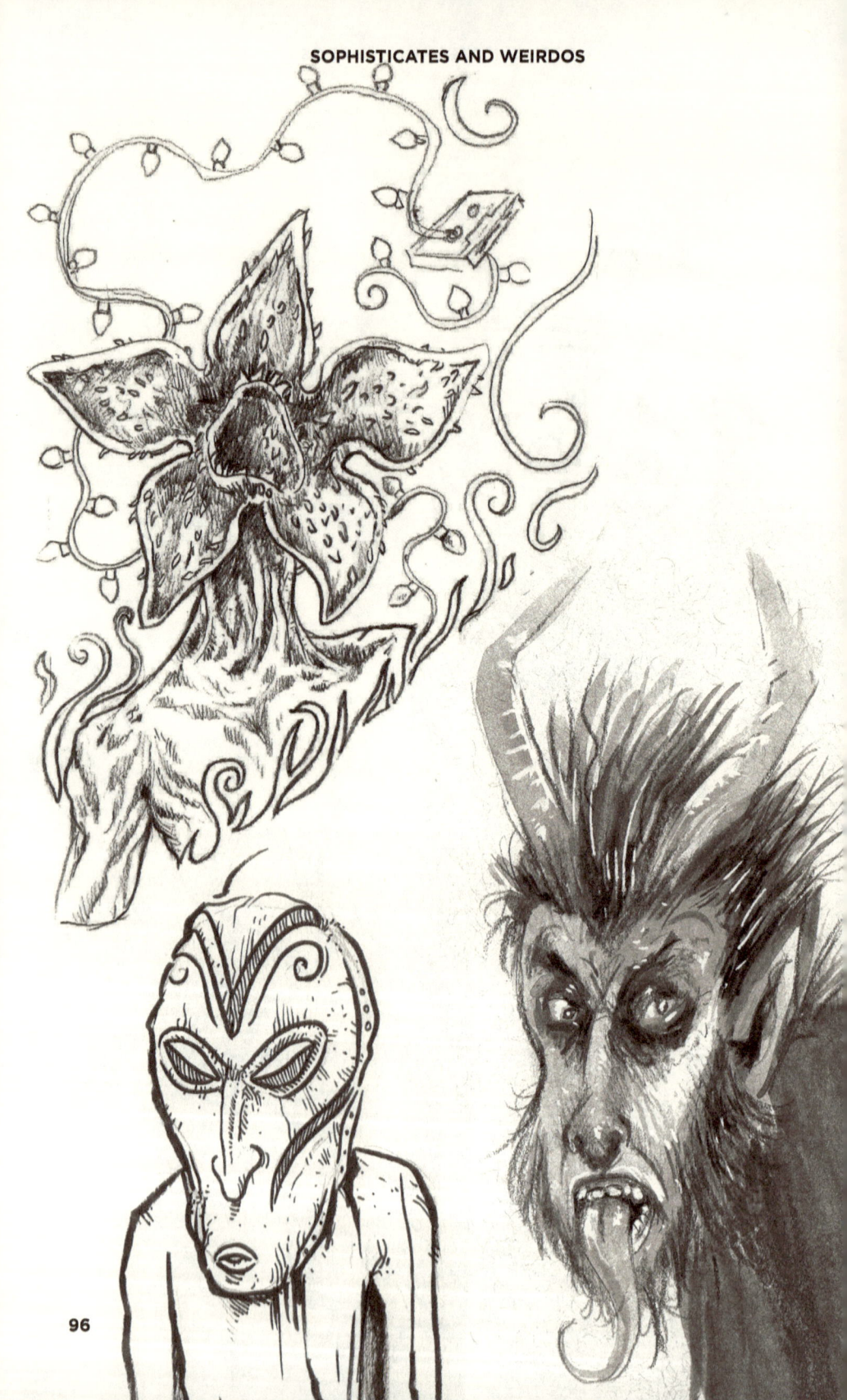

SOPHISTICATES AND WEIRDOS

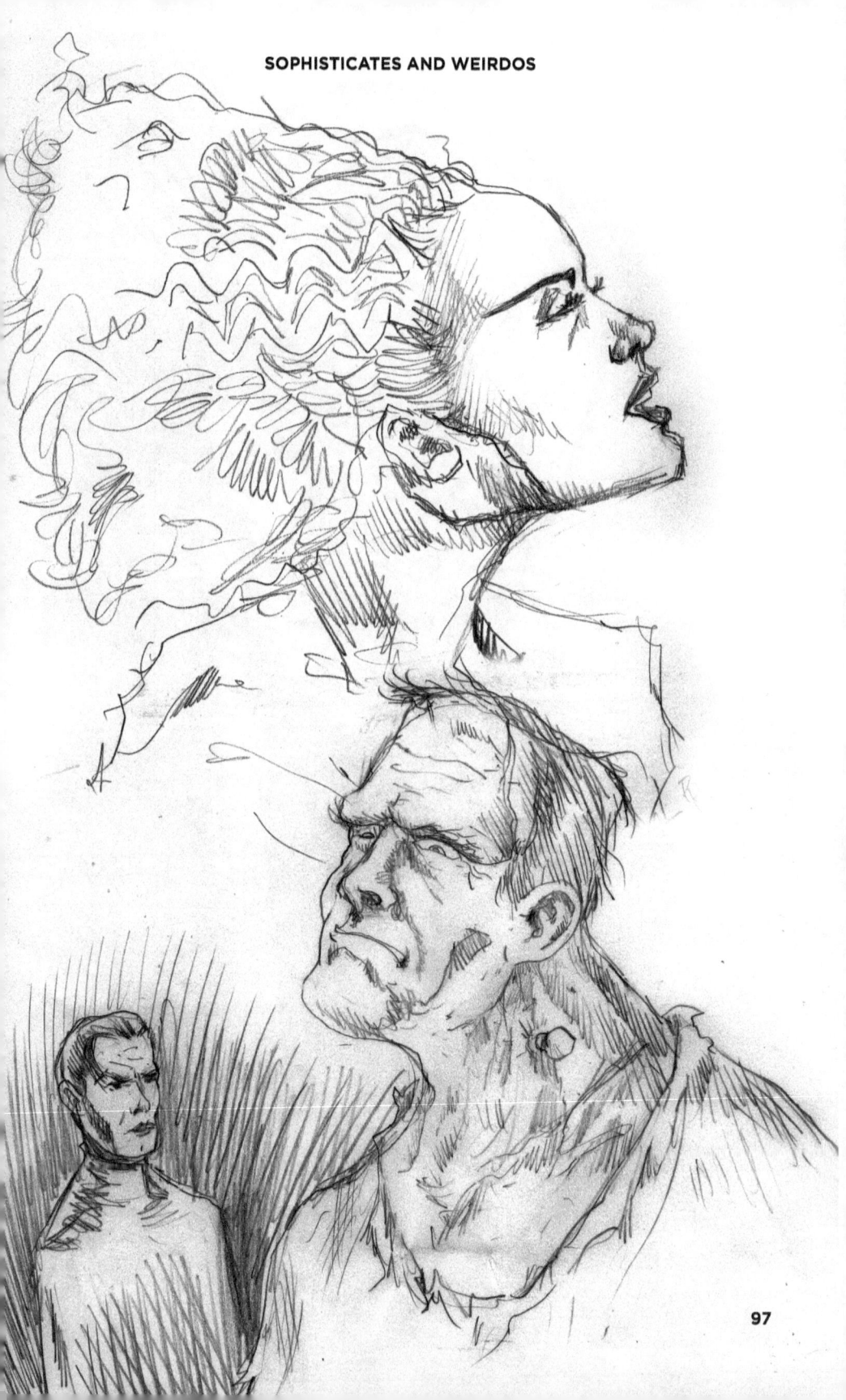

SOPHISTICATES AND WEIRDOS

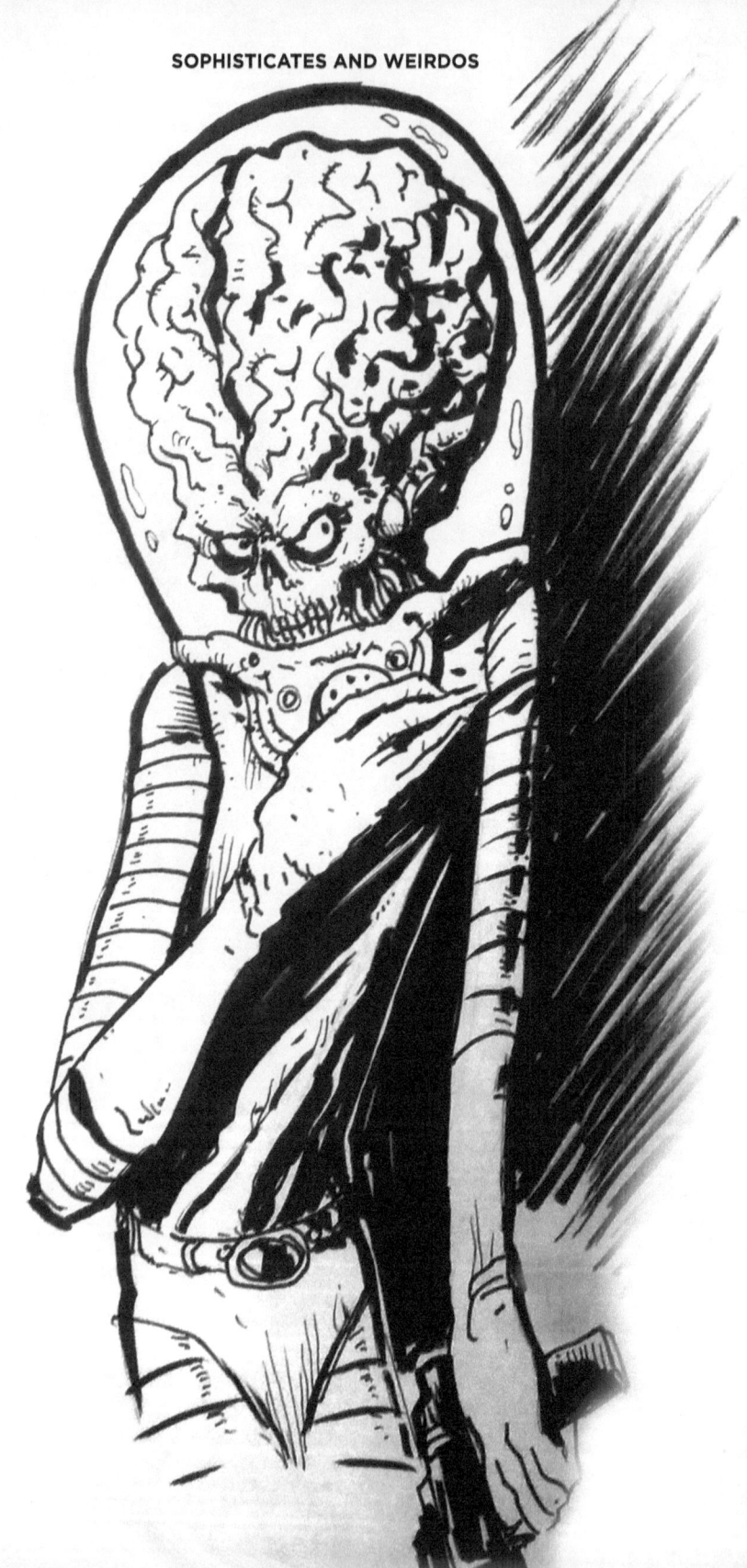

SOPHISTICATES AND WEIRDOS

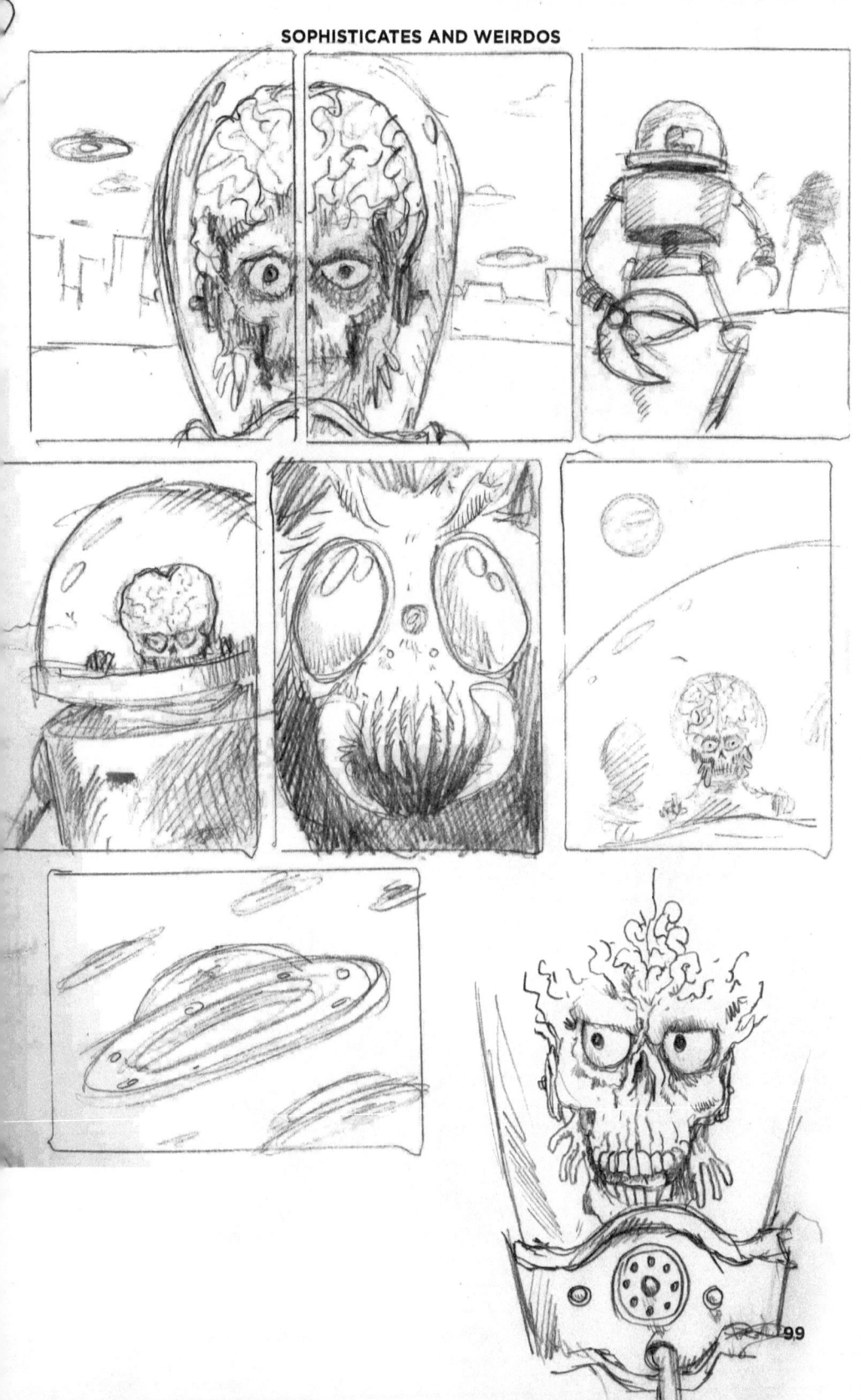

SOPHISTICATES AND WEIRDOS

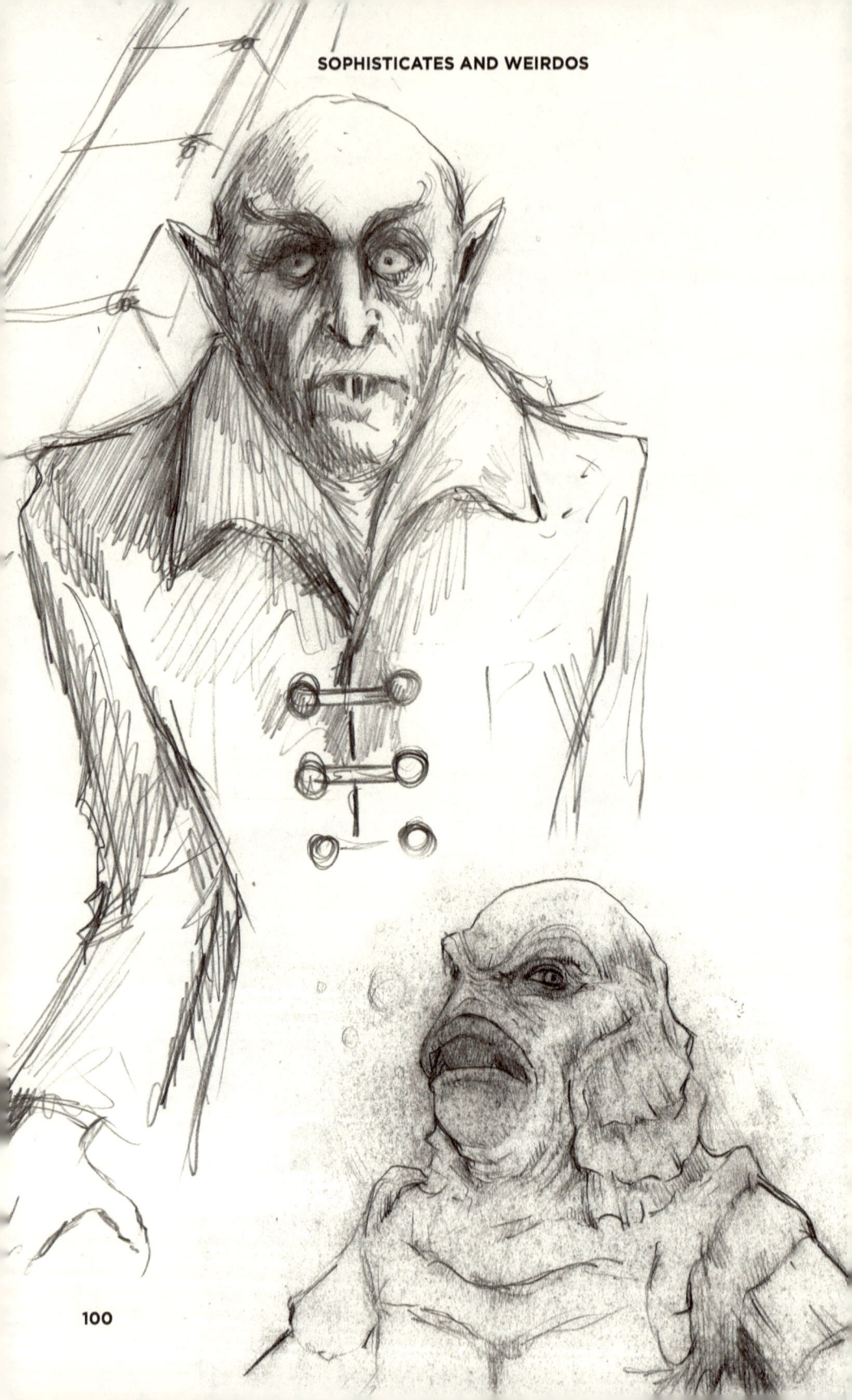

SOPHISTICATES AND WEIRDOS

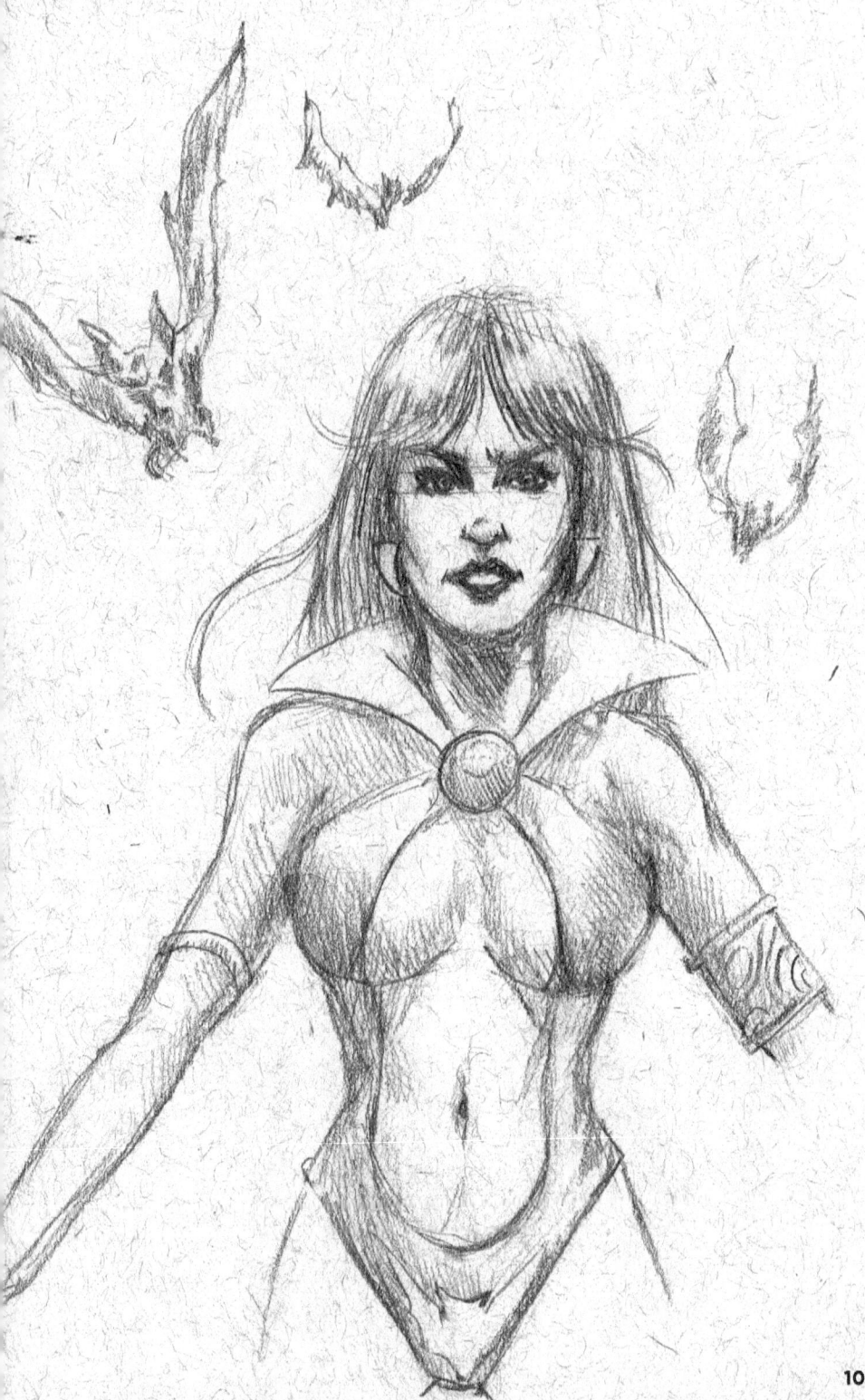

SOPHISTICATES AND WEIRDOS

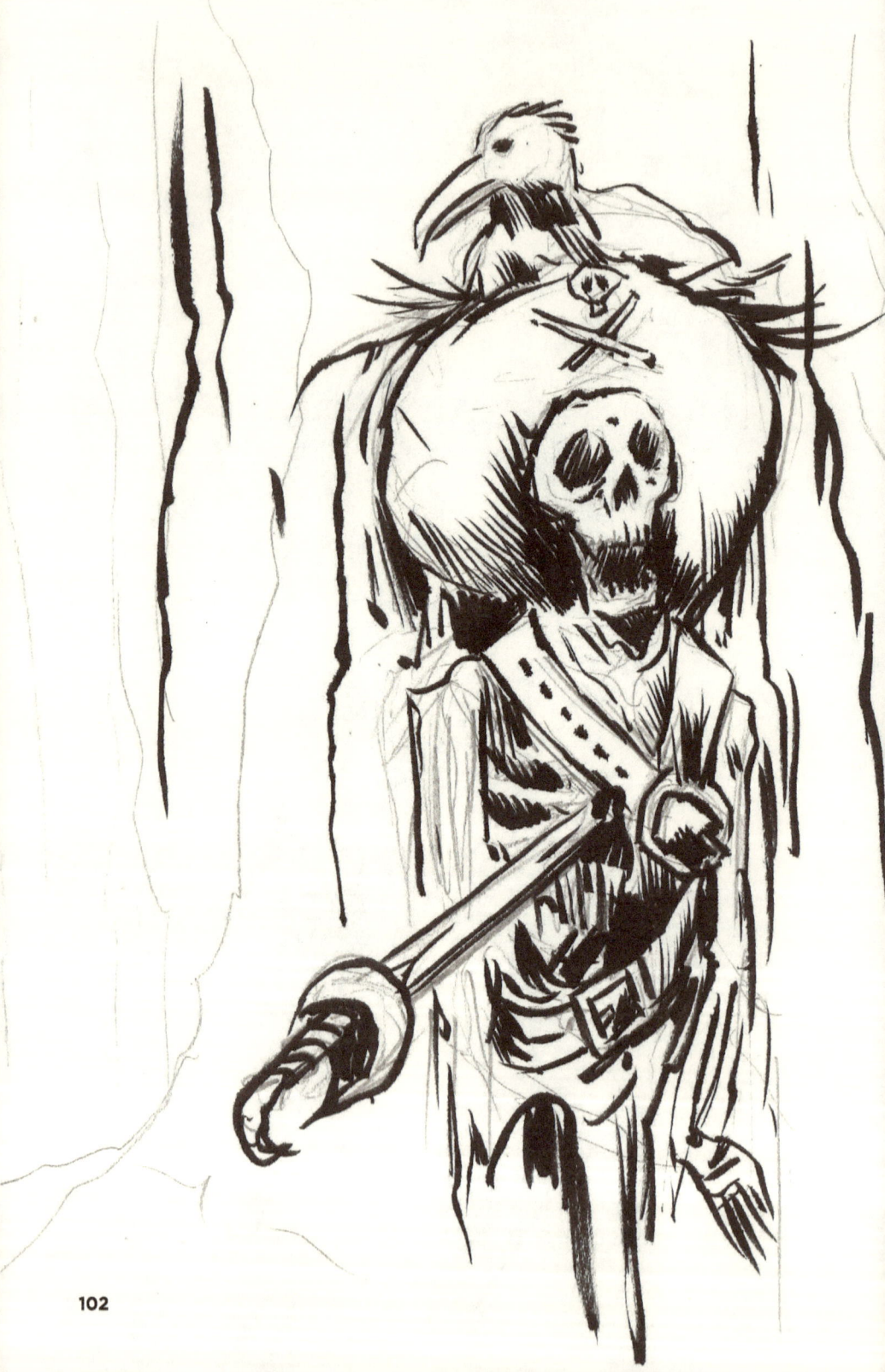

SOPHISTICATES AND WEIRDOS

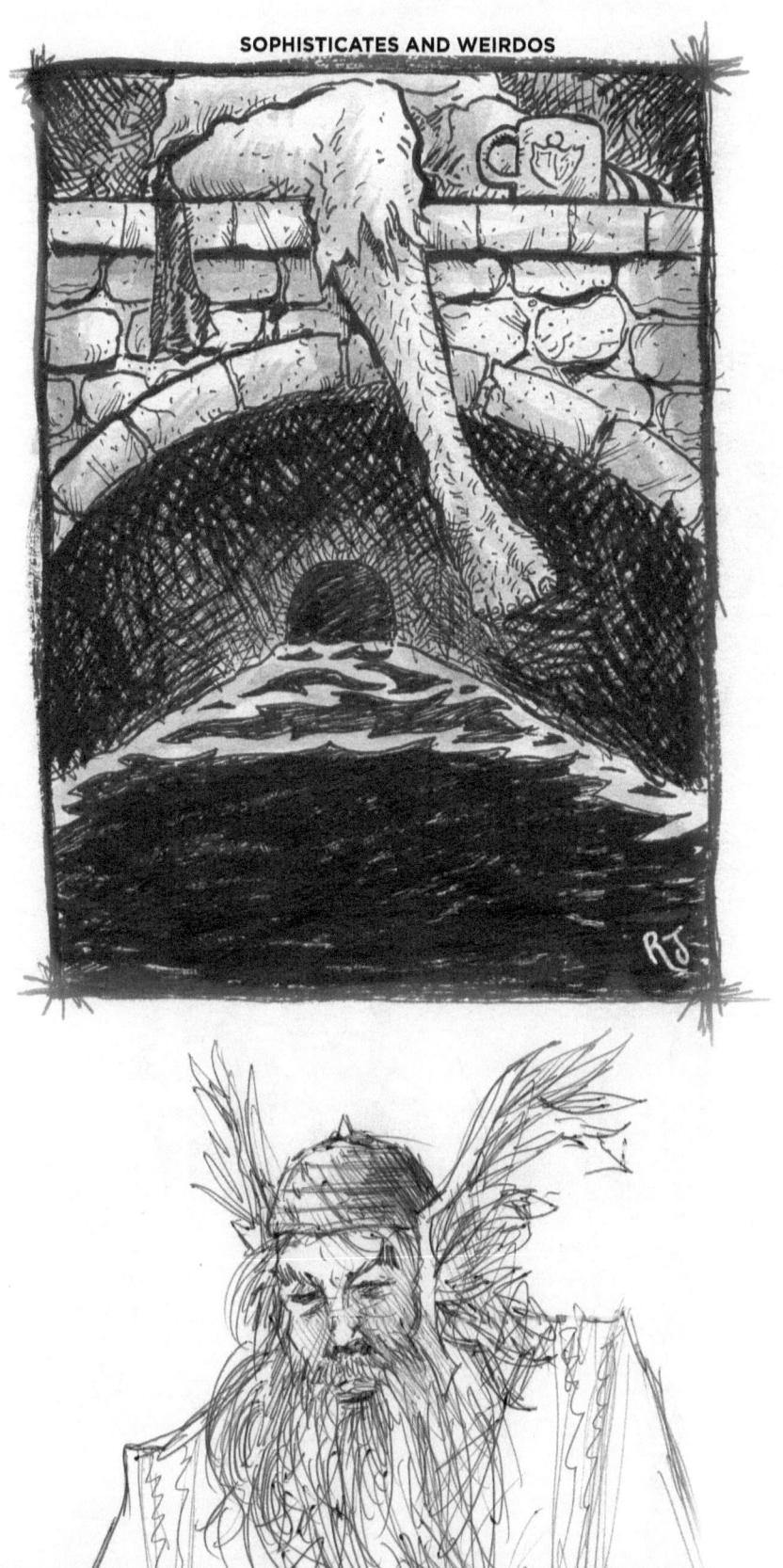

SOPHISTICATES AND WEIRDOS

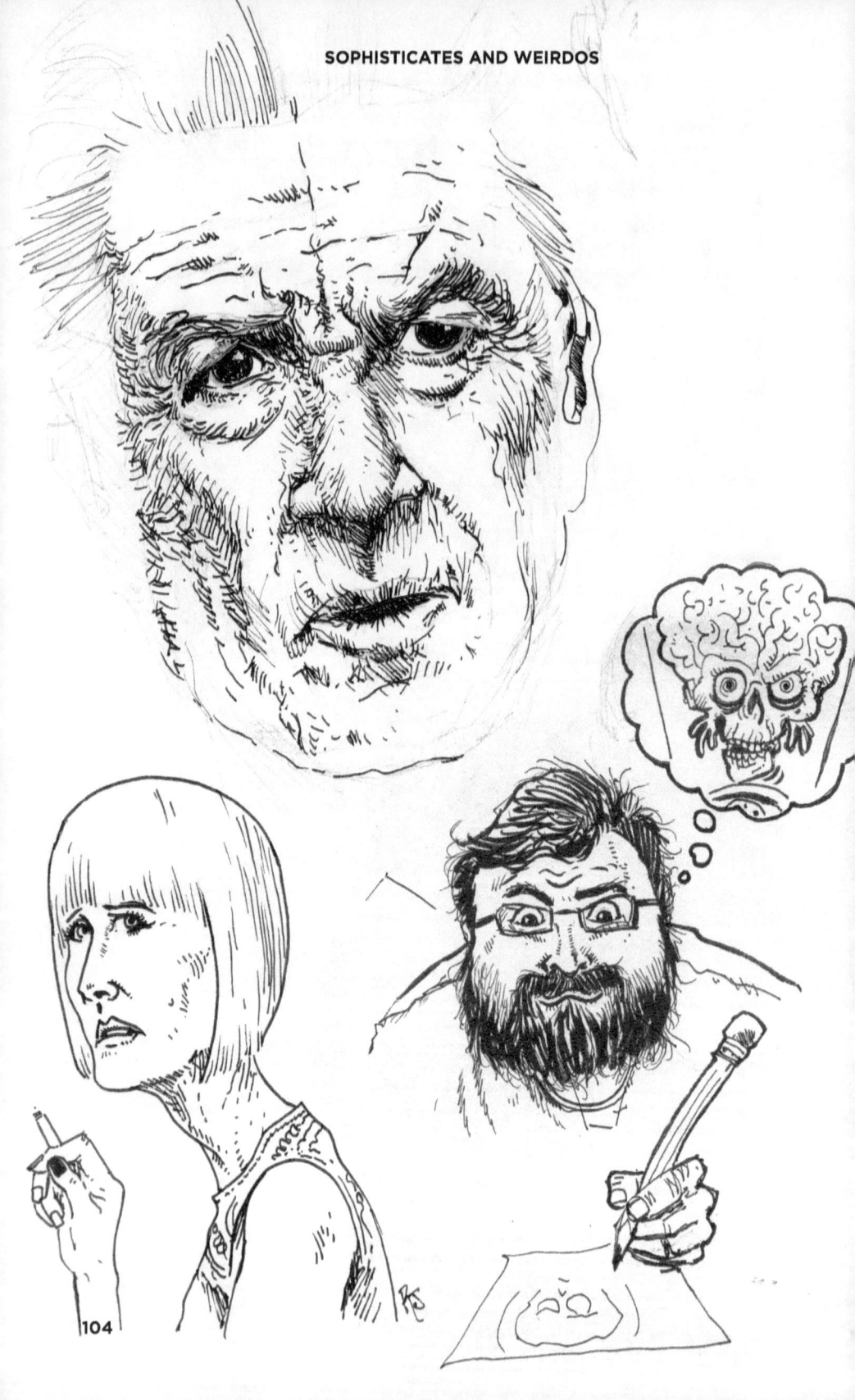

SOPHISTICATES AND WEIRDOS

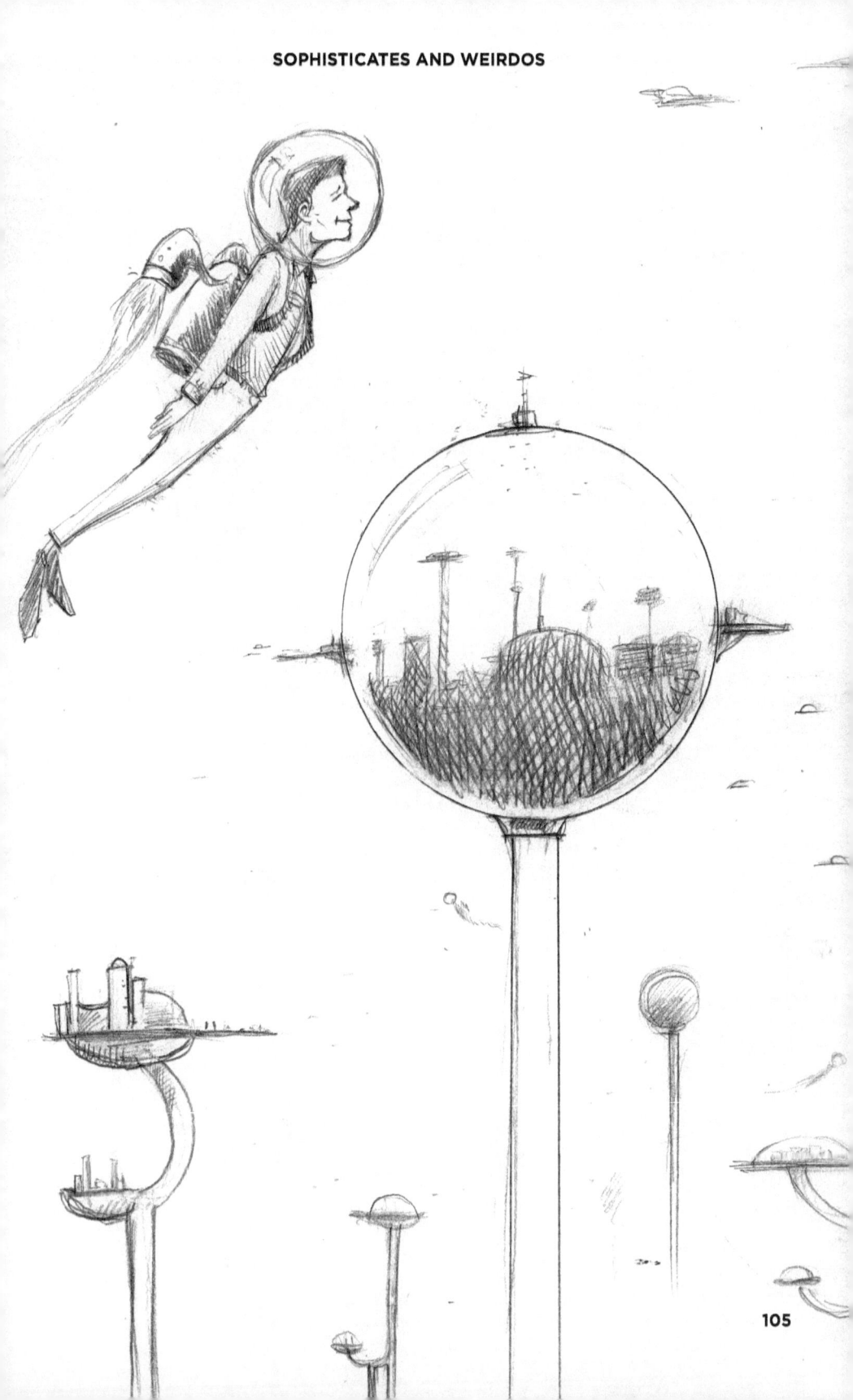

SOPHISTICATES AND WEIRDOS

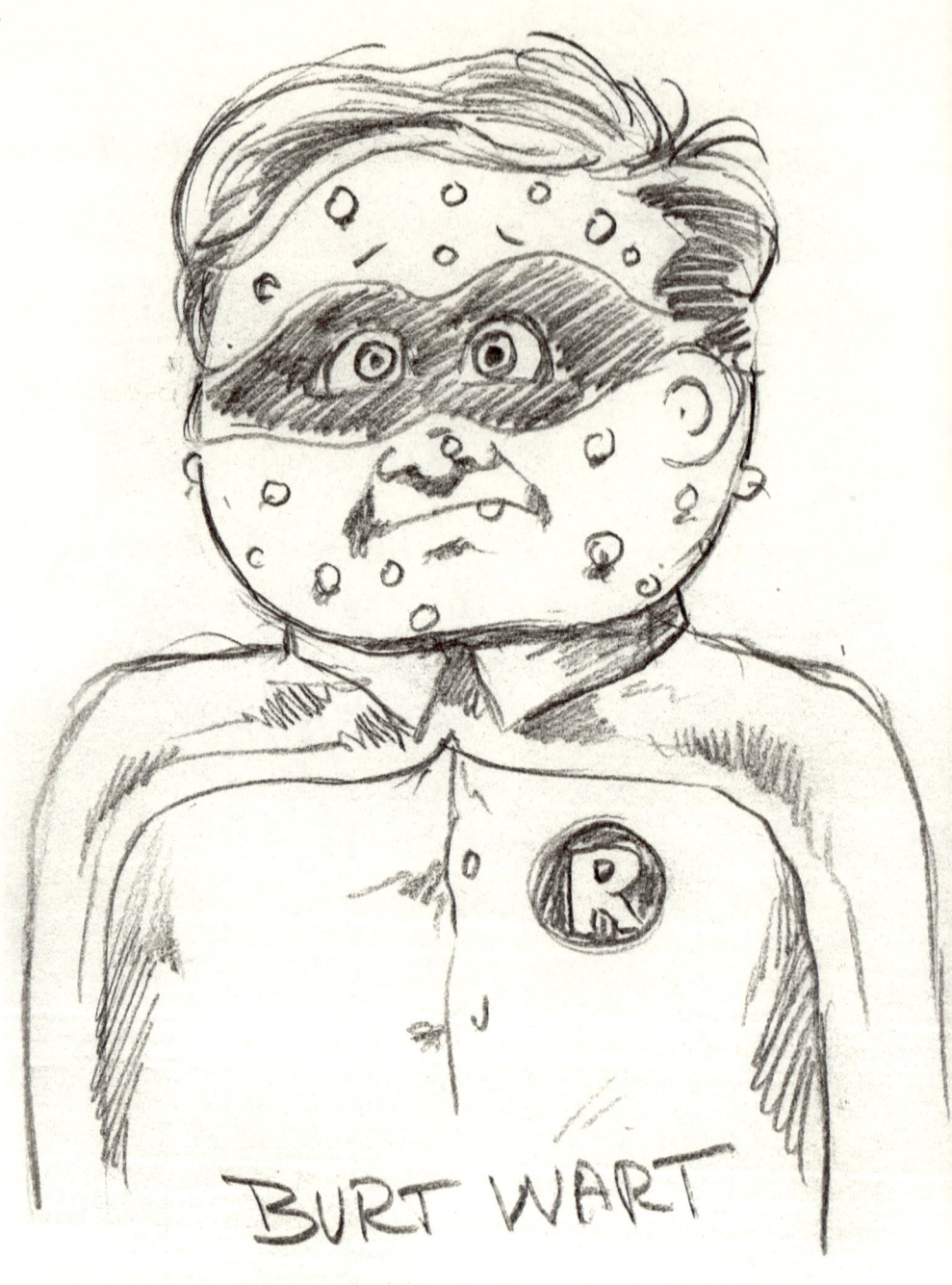

SOPHISTICATES AND WEIRDOS

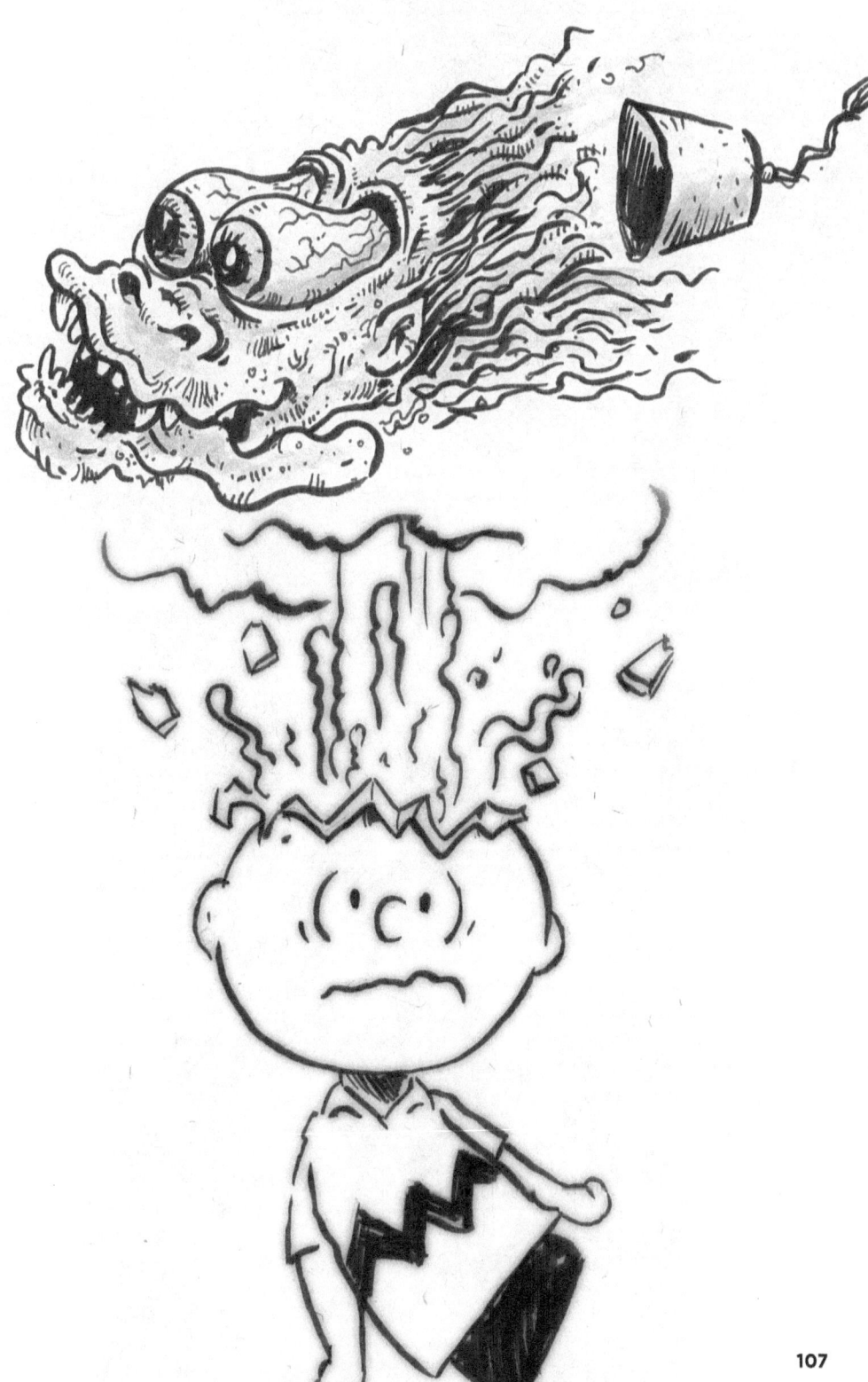

SOPHISTICATES AND WEIRDOS

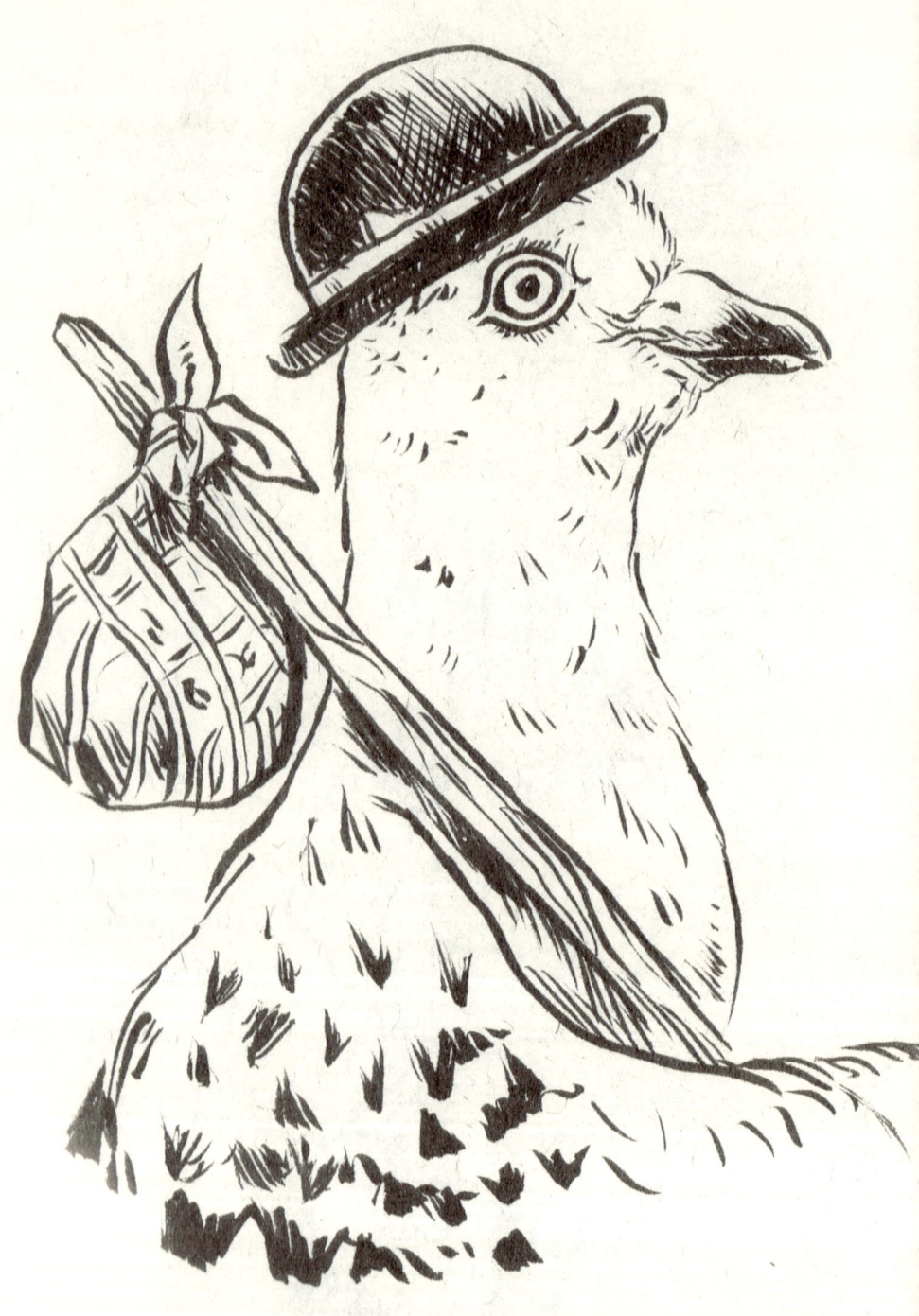

SOPHISTICATES AND WEIRDOS

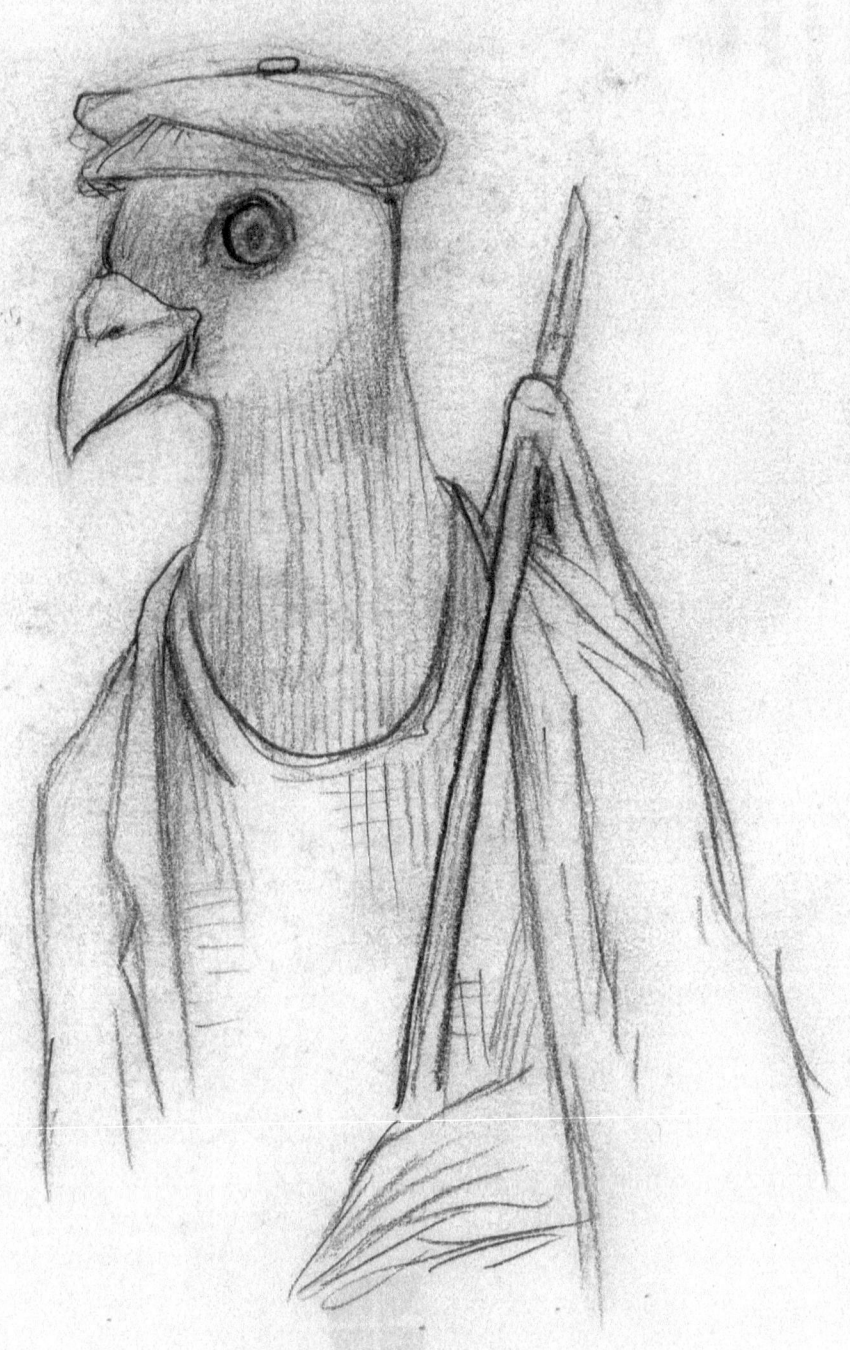

SOPHISTICATES AND WEIRDOS

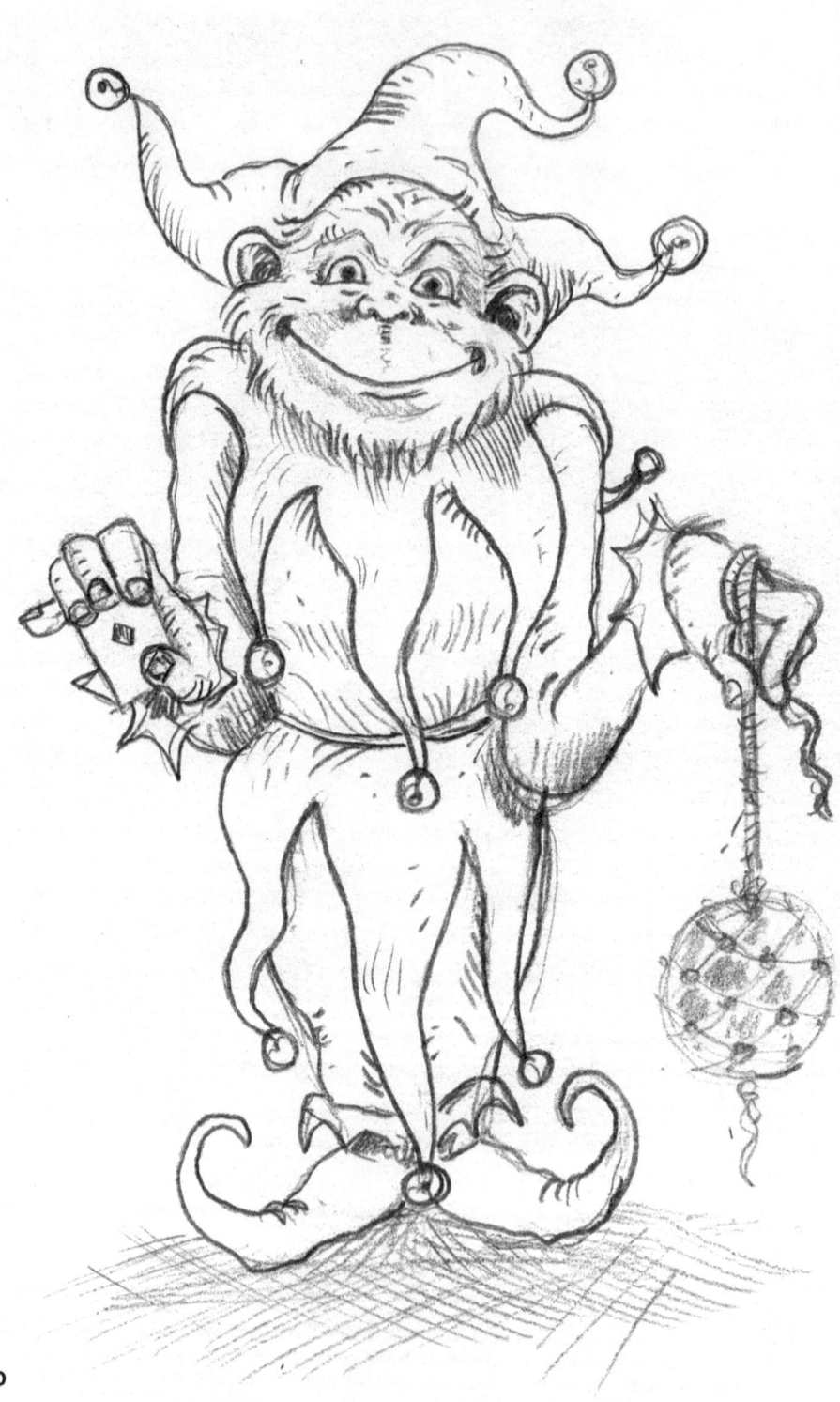

SOPHISTICATES AND WEIRDOS

SOPHISTICATES AND WEIRDOS

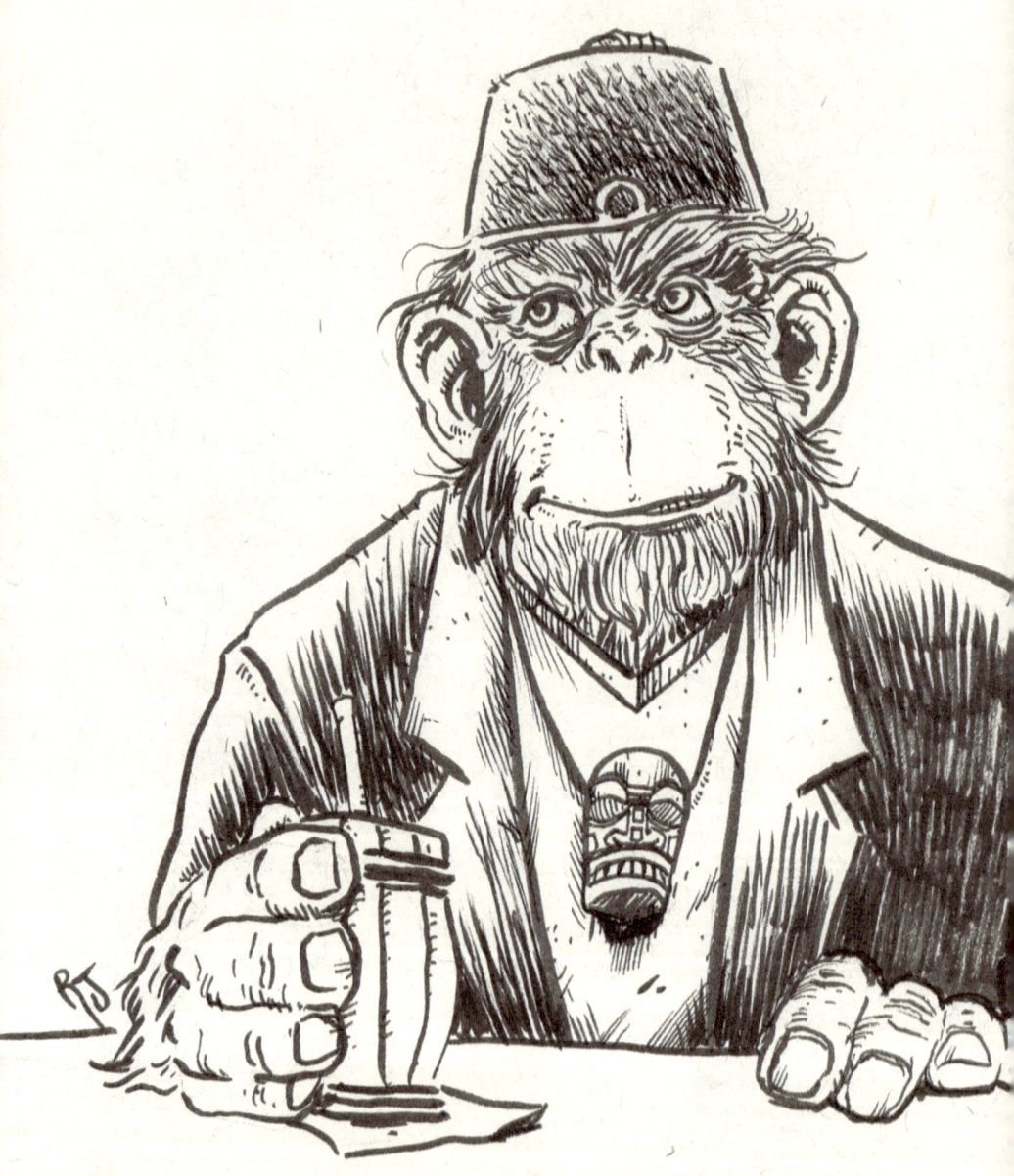

SOPHISTICATES AND WEIRDOS

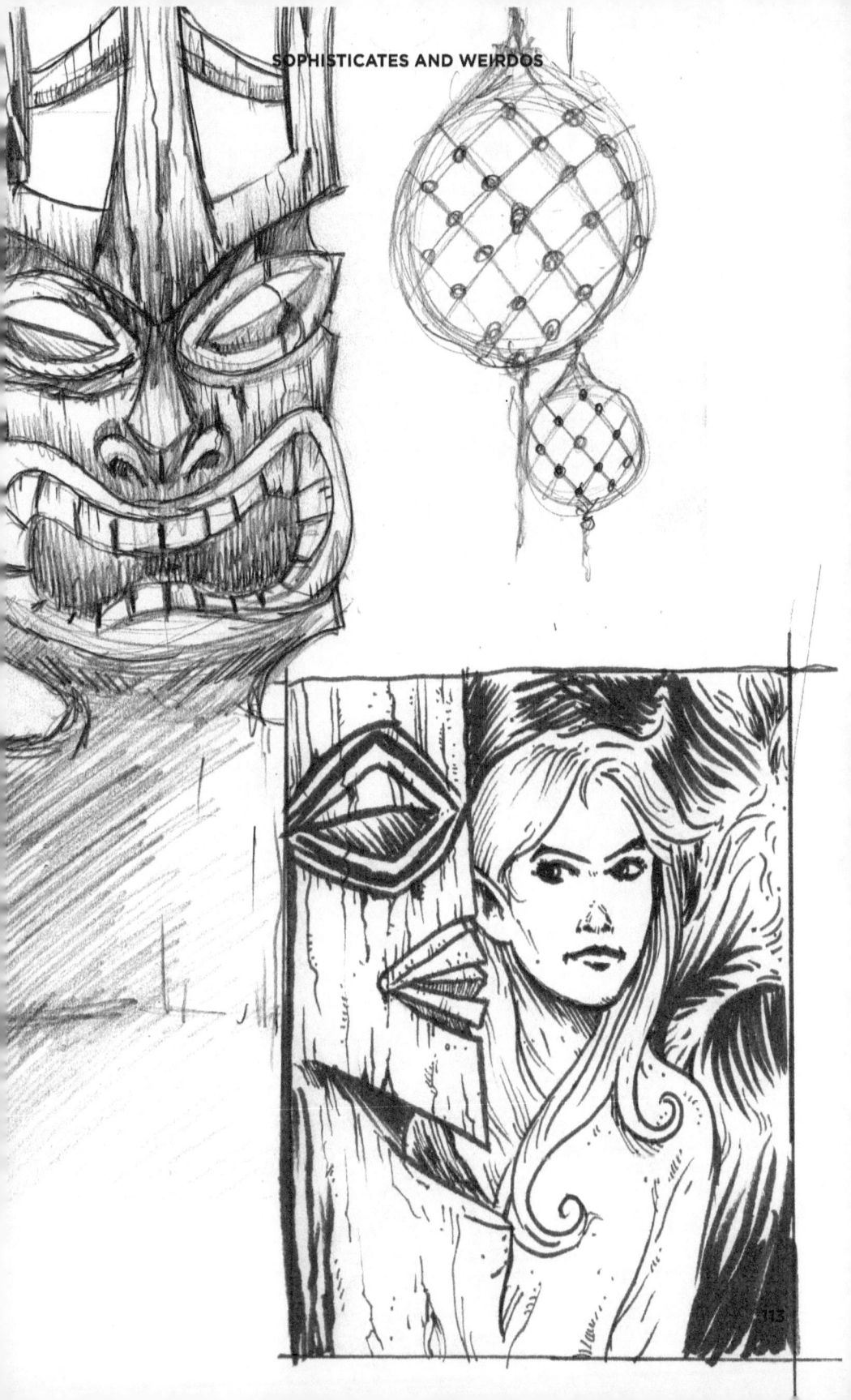

SOPHISTICATES AND WEIRDOS

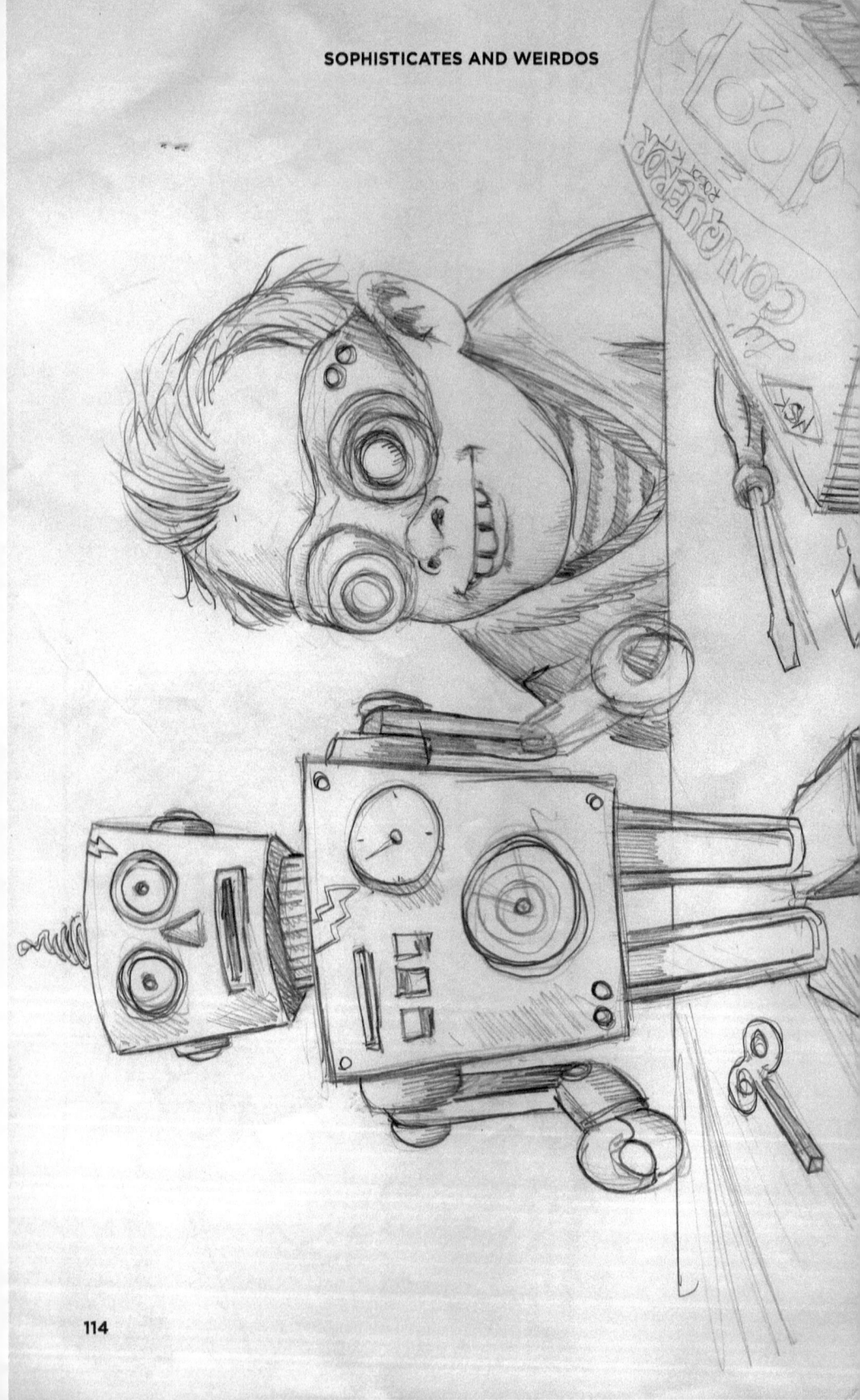

SOPHISTICATES AND WEIRDOS

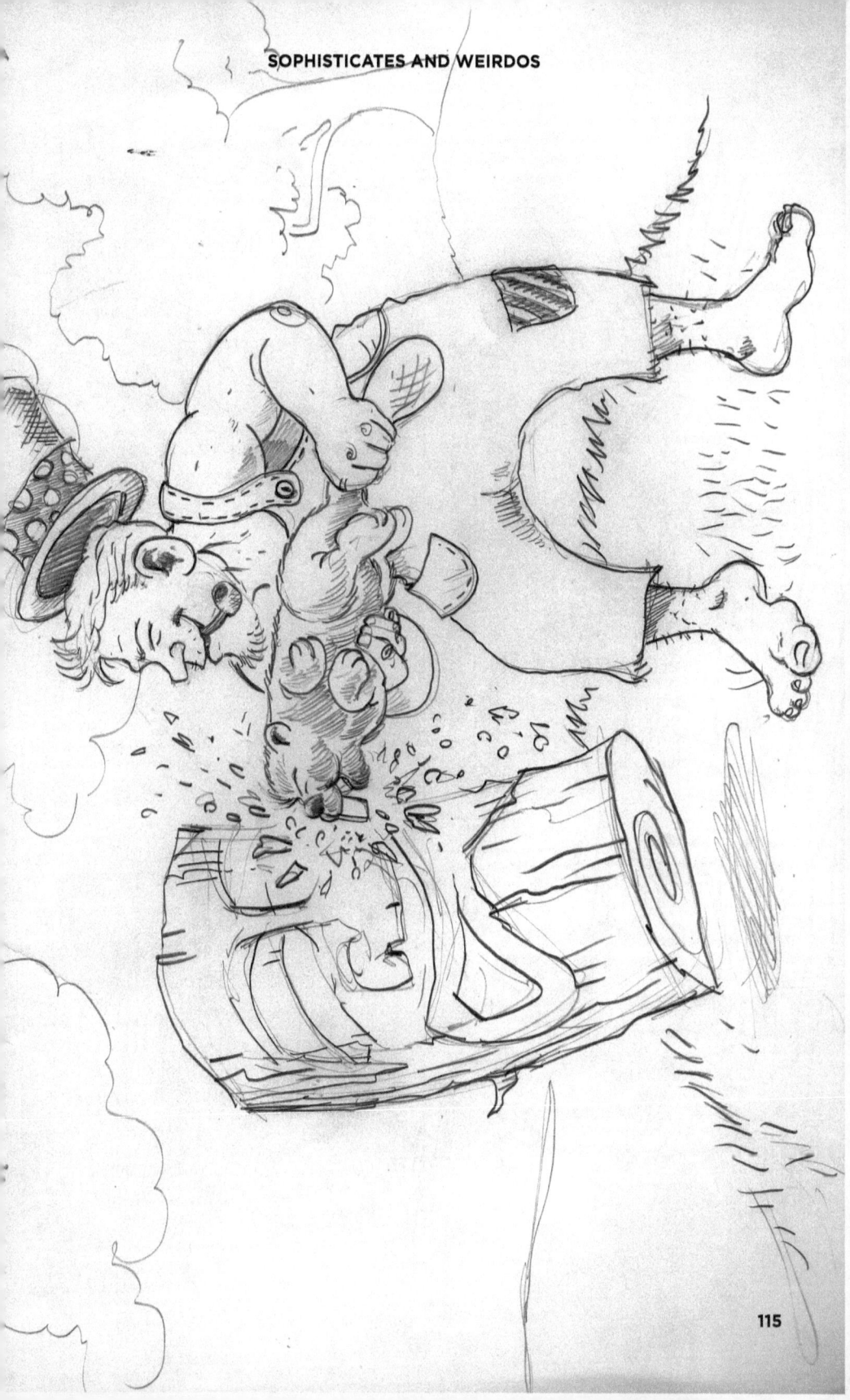

SOPHISTICATES AND WEIRDOS

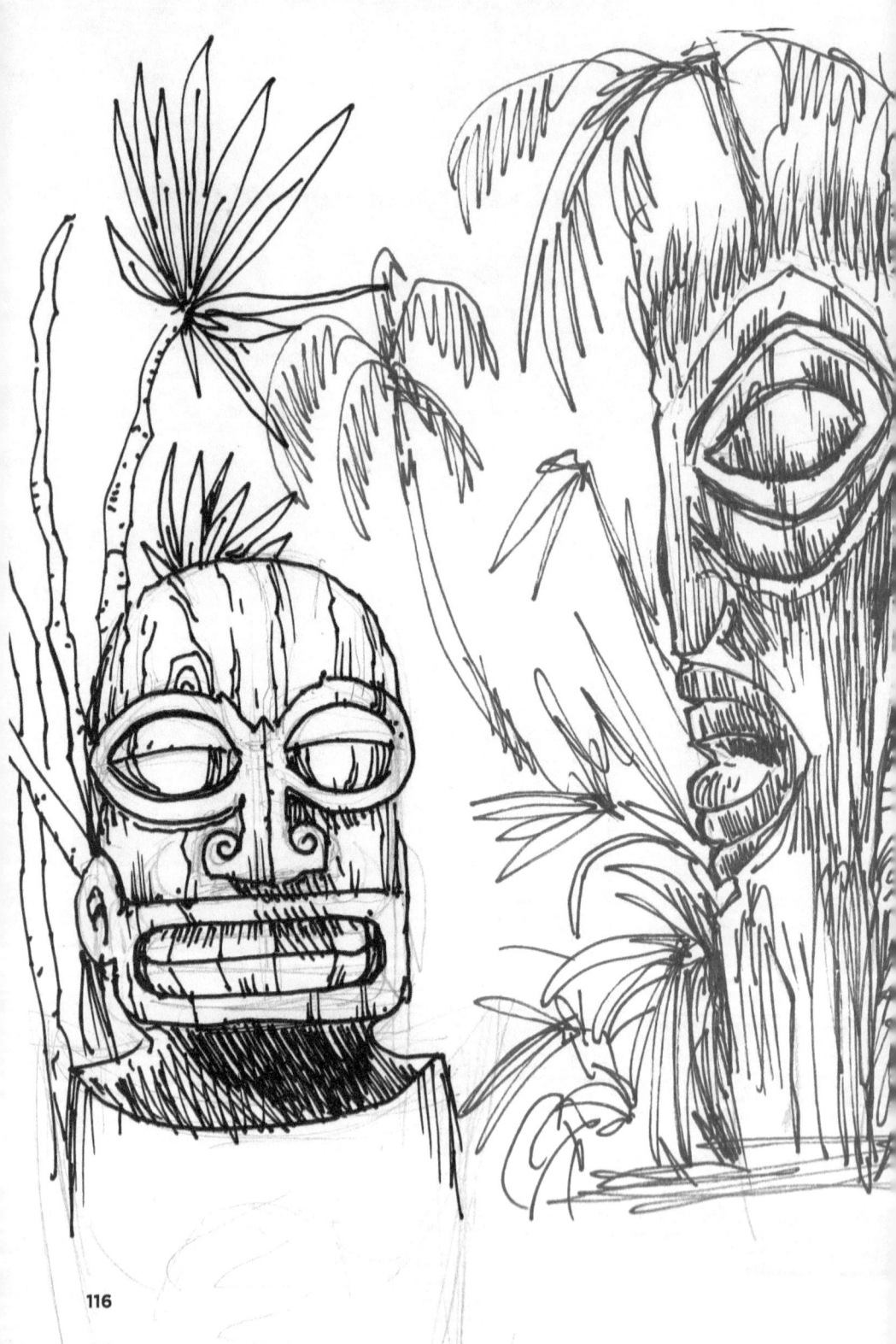

SOPHISTICATES AND WEIRDOS

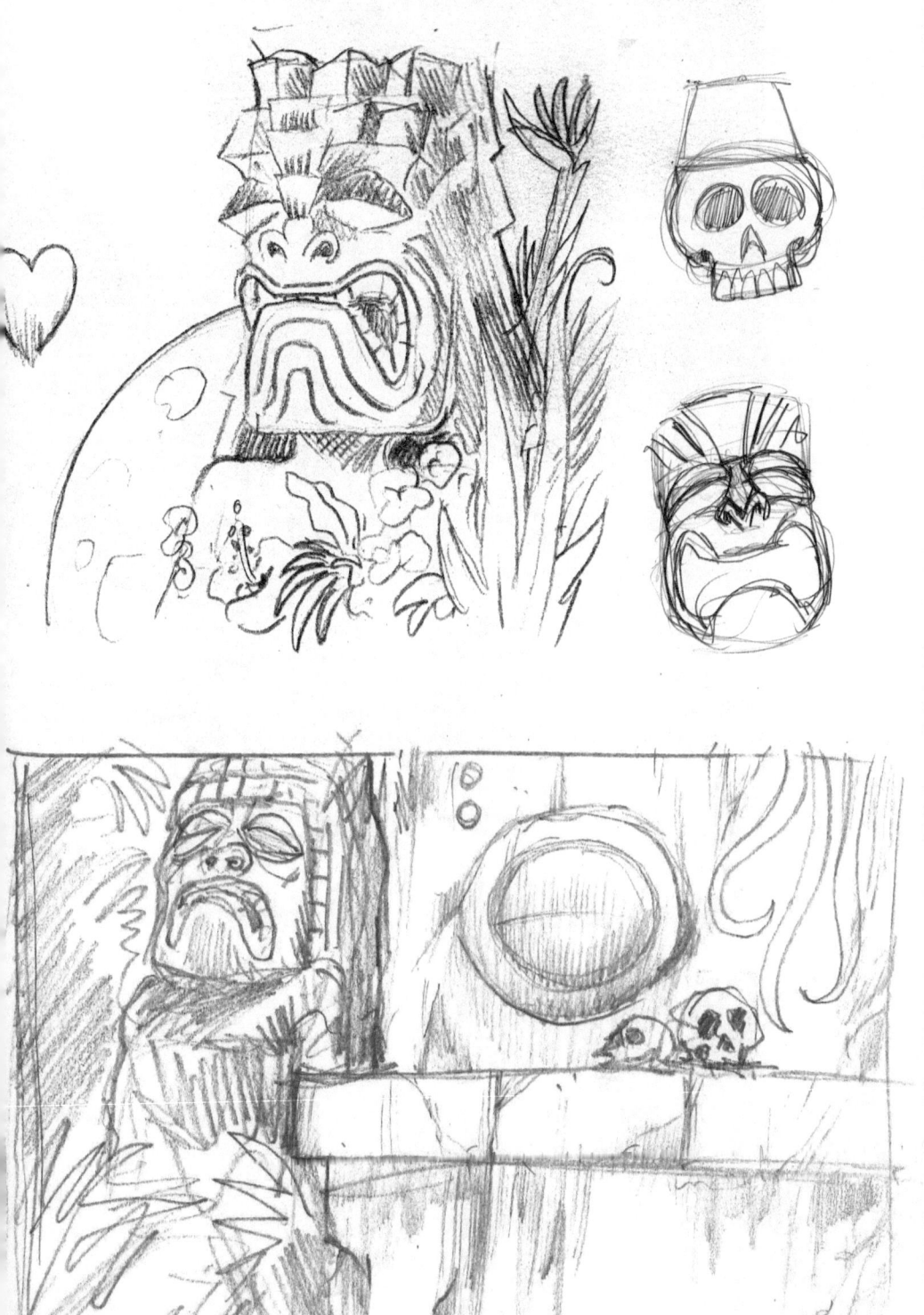

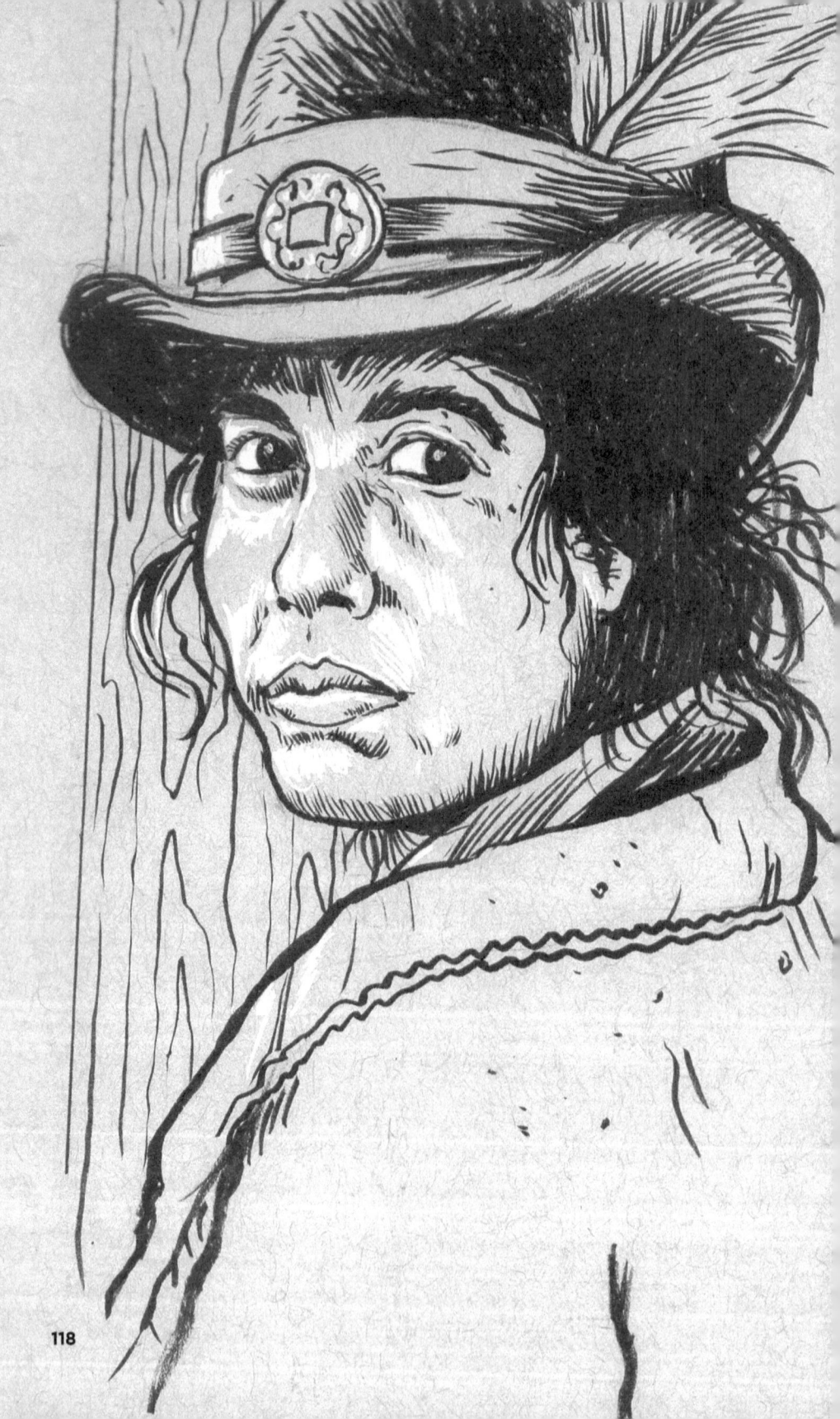

SOPHISTICATES AND WEIRDOS

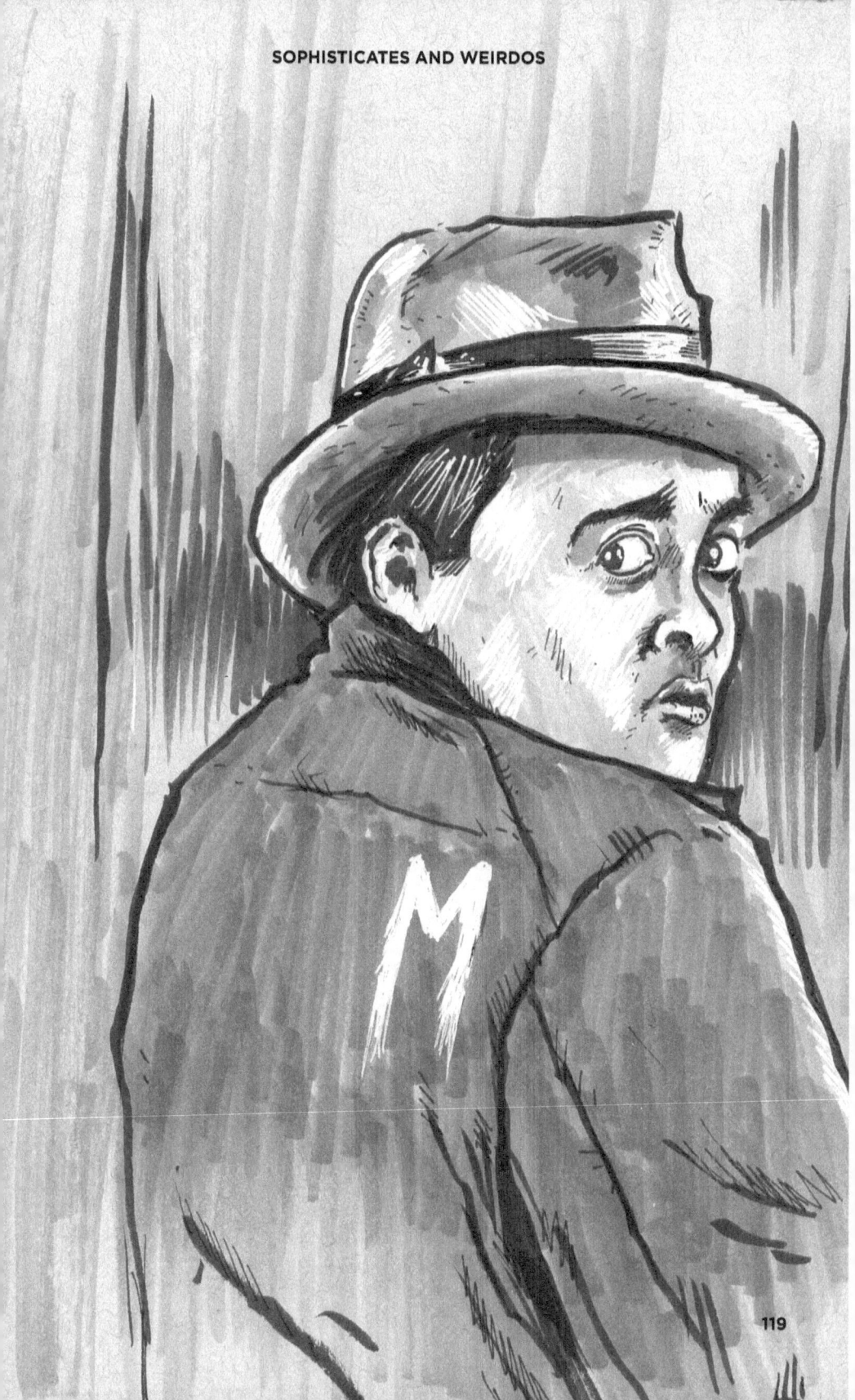

SOPHISTICATES AND WEIRDOS

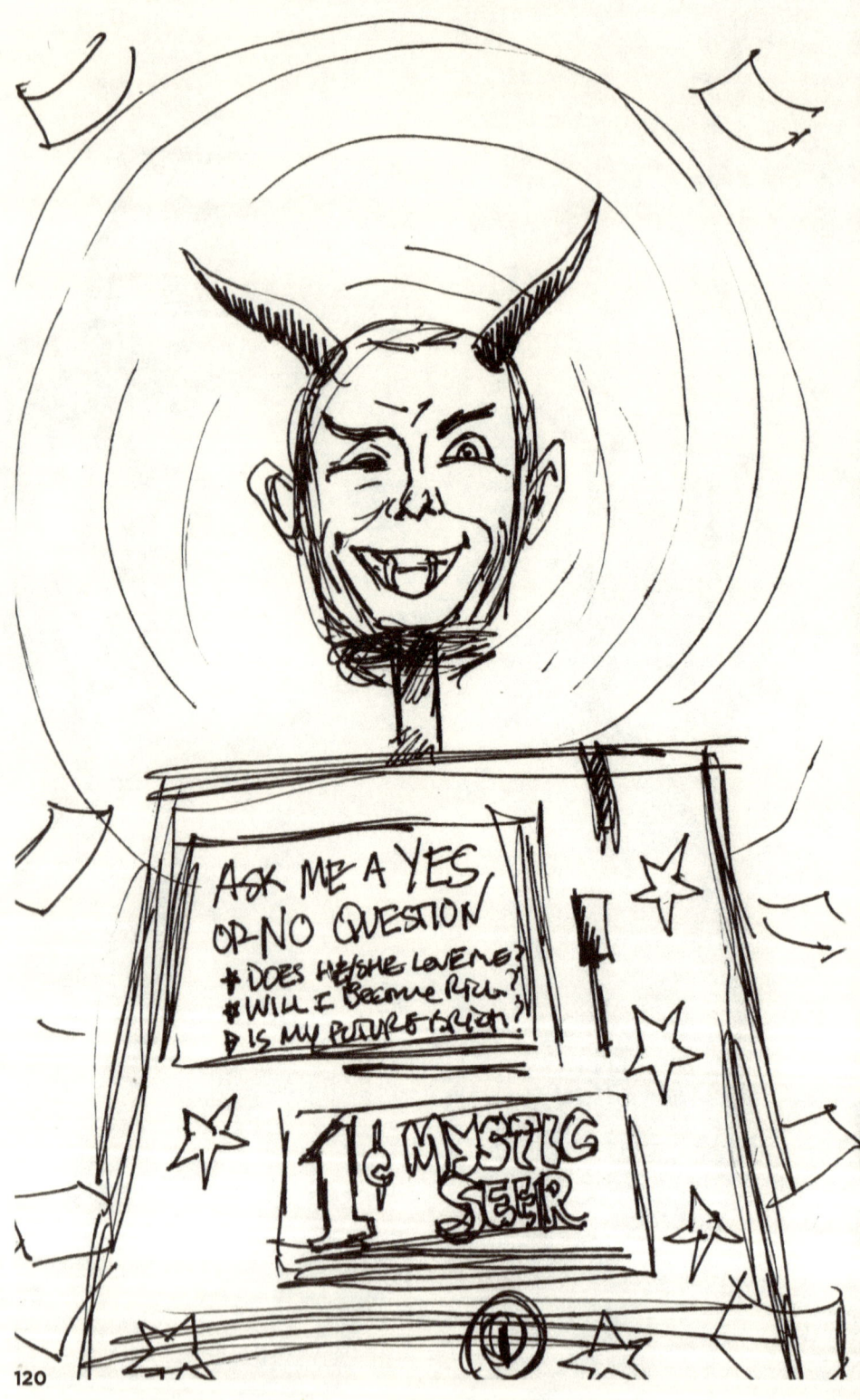

SOPHISTICATES AND WEIRDOS

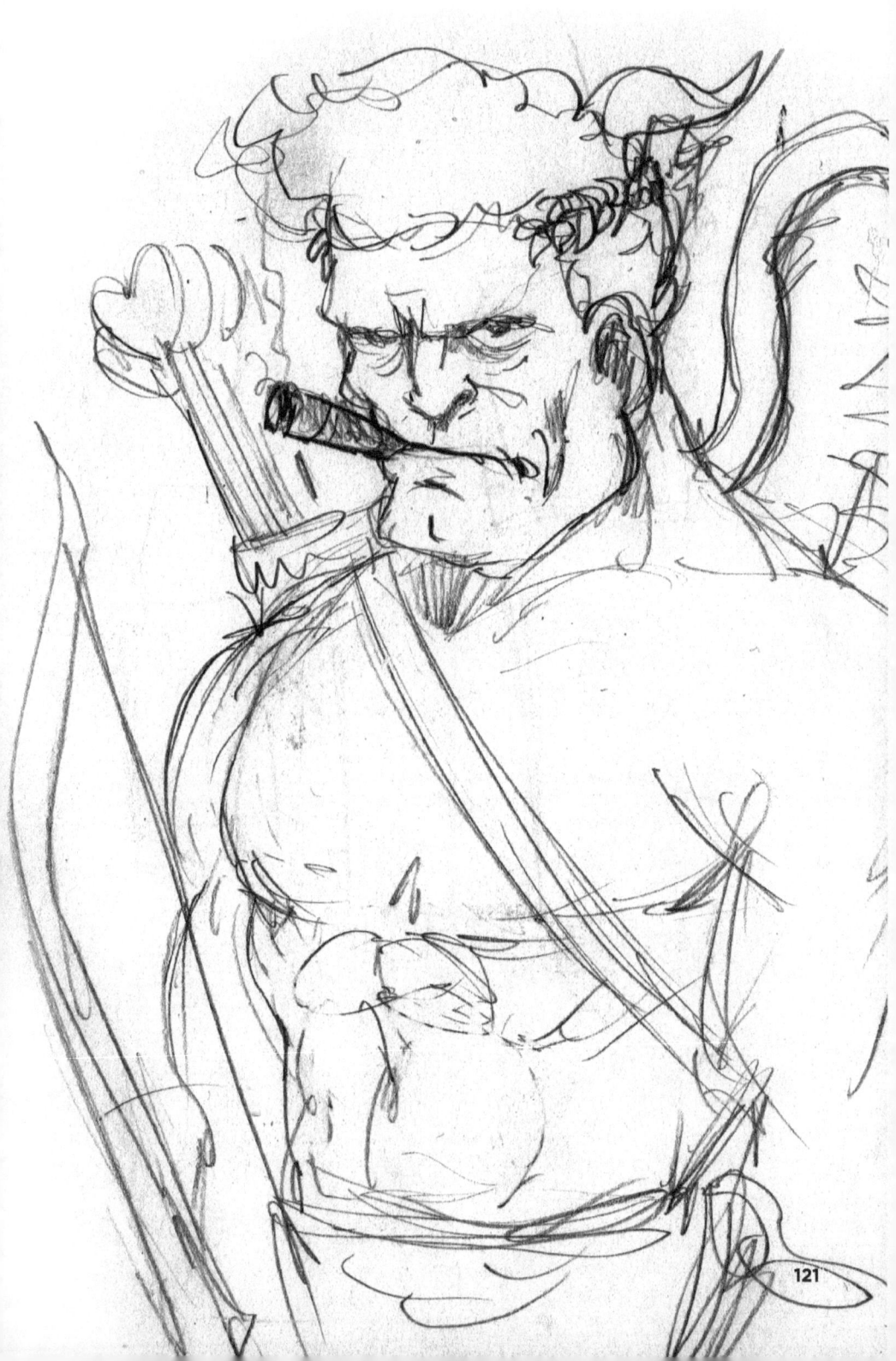

SOPHISTICATES AND WEIRDOS

SOPHISTICATES AND WEIRDOS

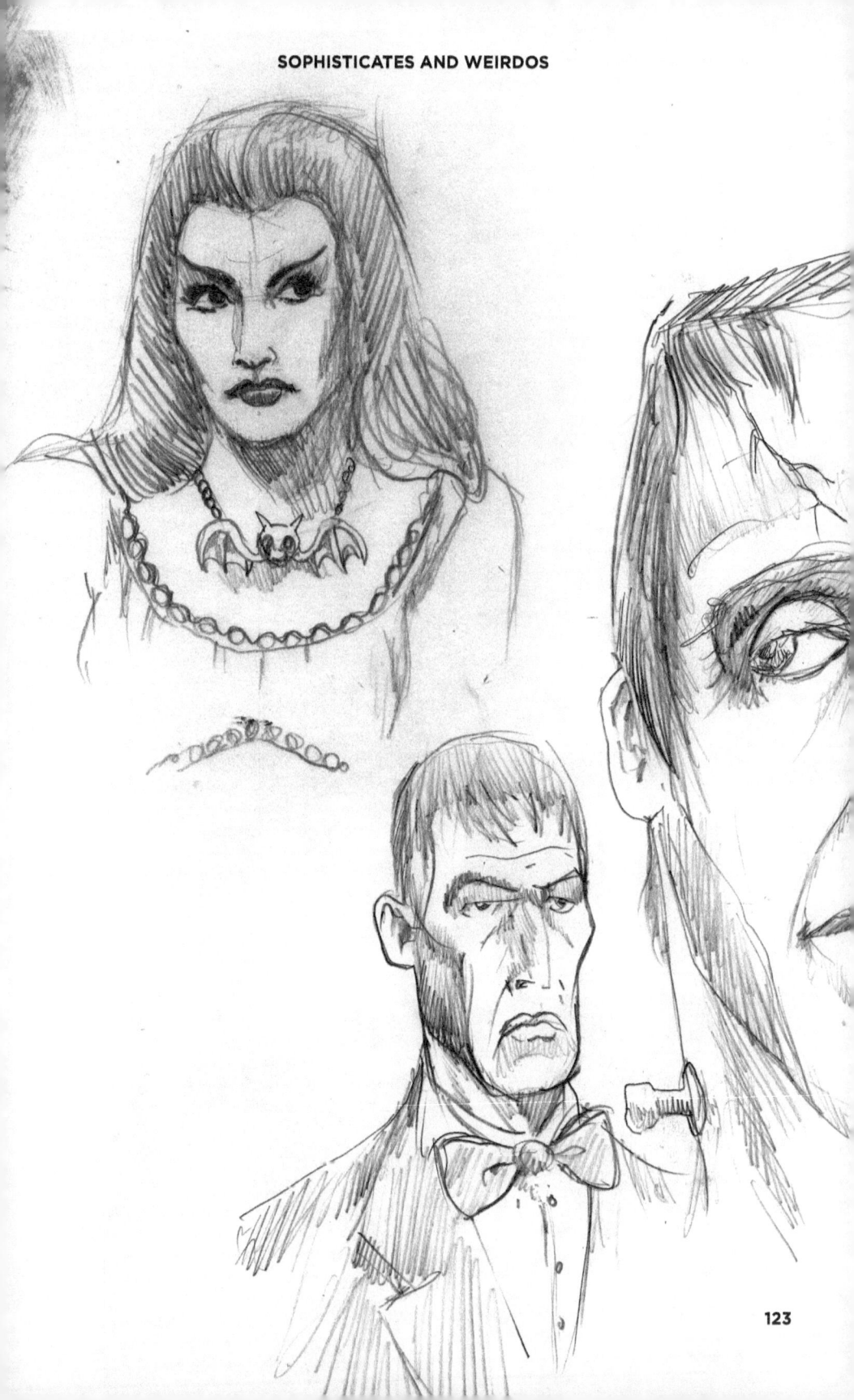

SOPHISTICATES AND WEIRDOS

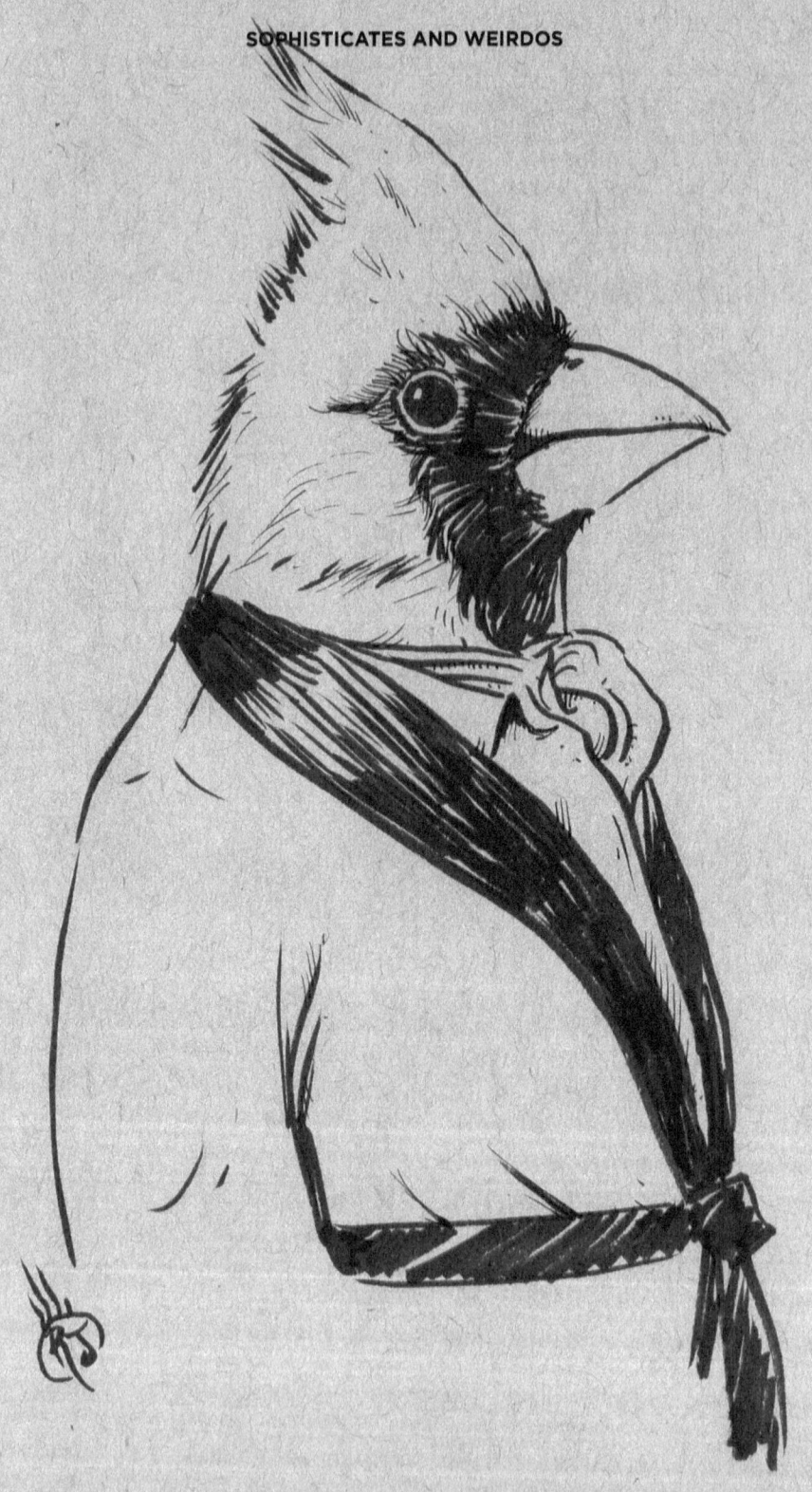

SOPHISTICATES AND WEIRDOS

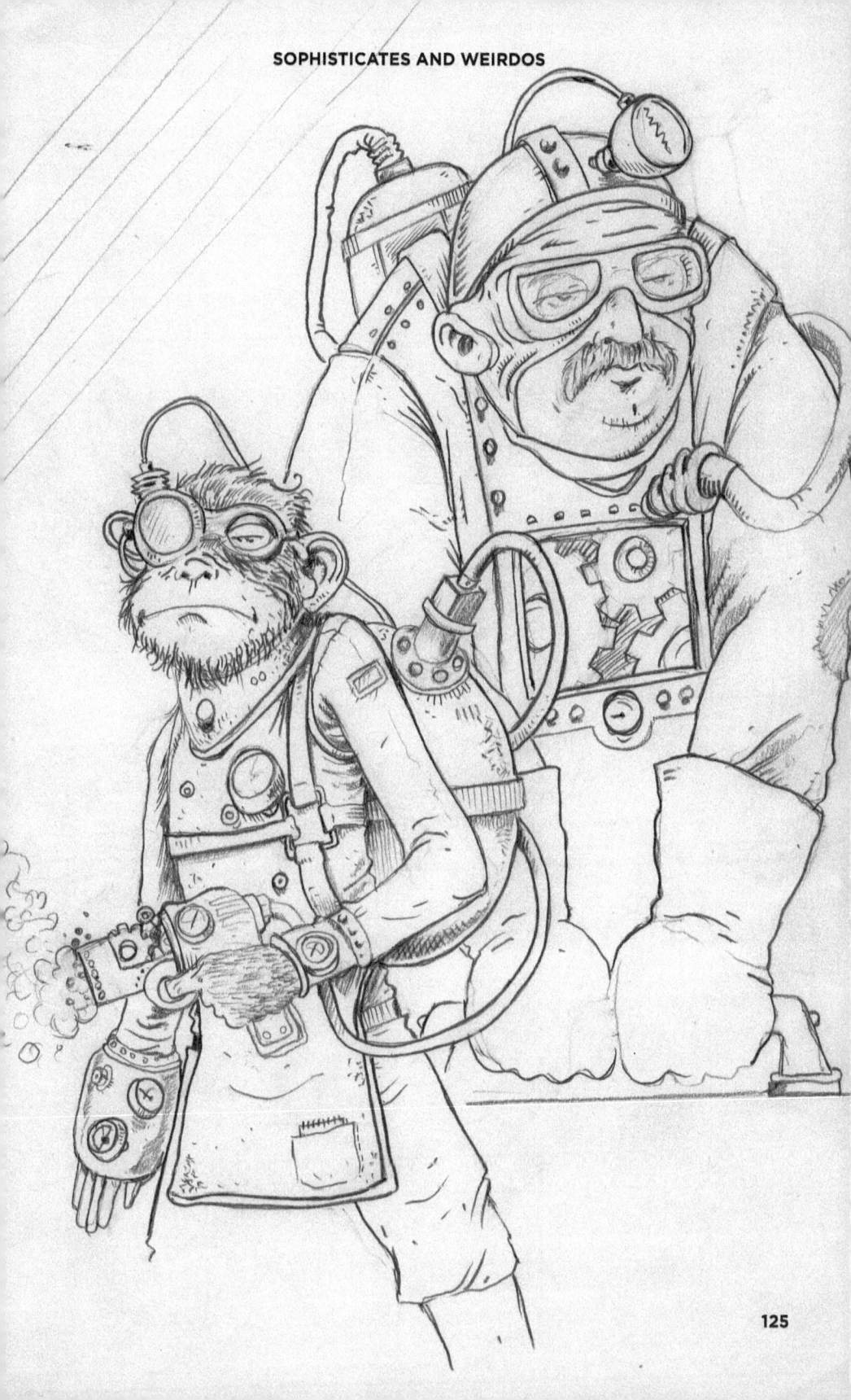

SOPHISTICATES AND WEIRDOS

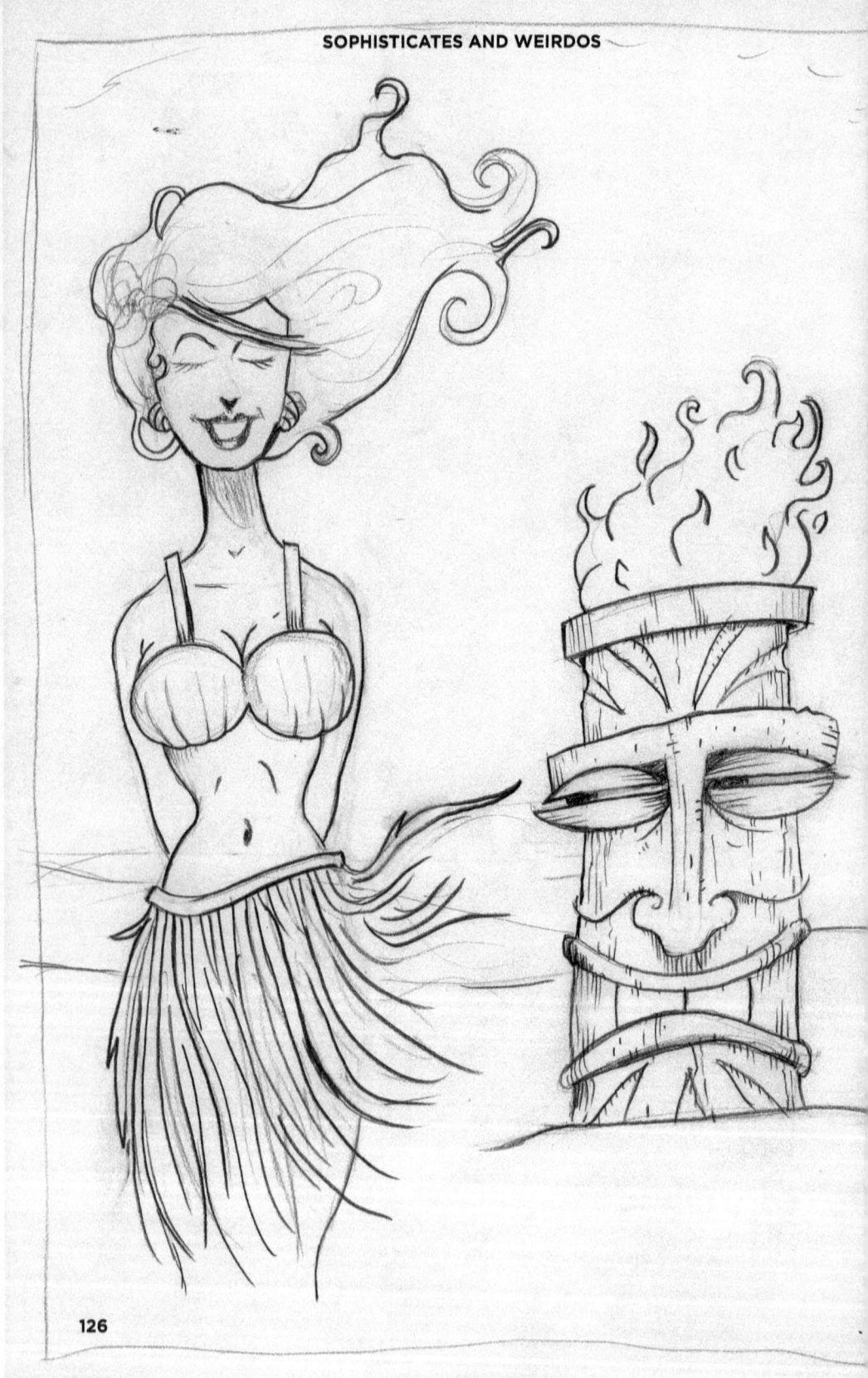

SOPHISTICATES AND WEIRDOS

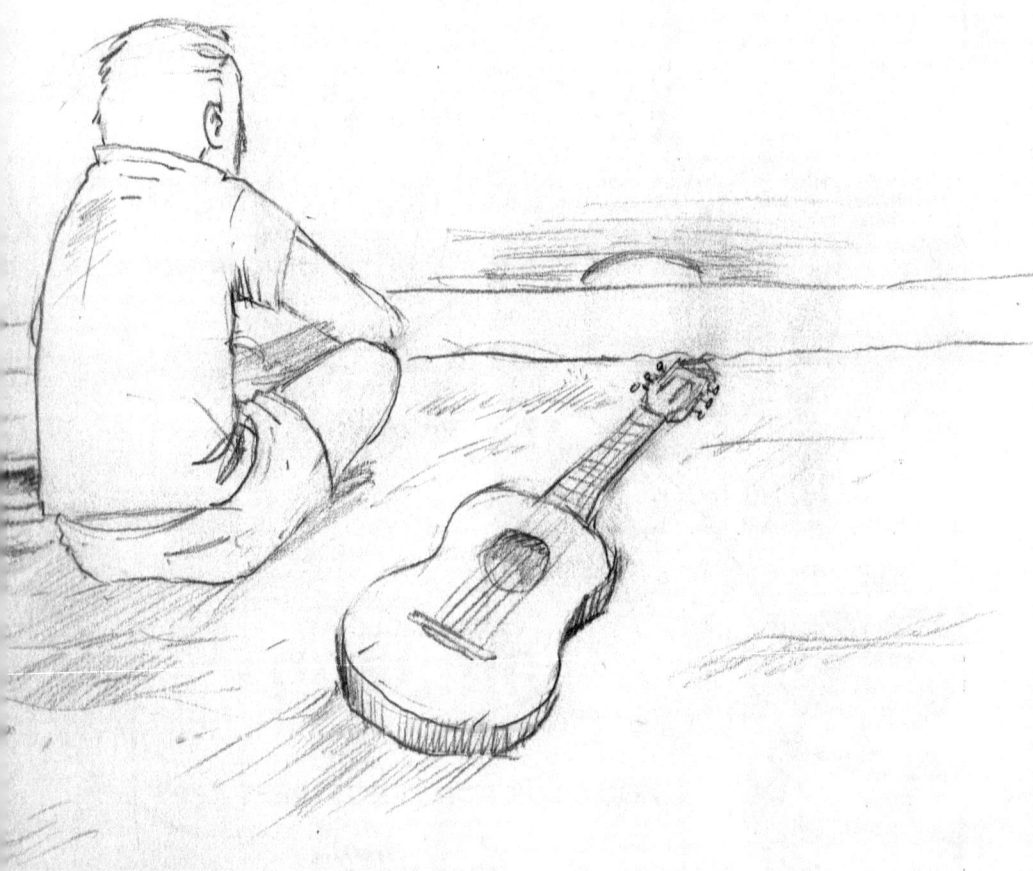

CHIMPS & TIKIS AND RAVEN-HARIED BEAUTIES

LAST CALL AT TIKILANDIA

NOSFERATU'S CHRISTMAS IN NEW YORK

STRANGEWISE NO.9

WEIRD-ASS FACES

AVAILABLE AT

AND LOOK FOR ZEROSTREET APPS

ABOUT THE ARTIST

ROBERT'S IMAGINATION AND DESIRE TO DRAW WERE FIRST FUELED BY HIS FREQUENT VISITS TO THE CORNER NEWSSTAND IN HIS BROOKLYN NEIGHBORHOOD TO PURCHASE COMIC BOOKS AND TRADING CARDS. LATER, THE FILMS SEEN ON LOCAL TV, EVERYTHING FROM THE COMEDIES OF ABBOTT & COSTELLO AND THE MARX BROTHERS, B MONSTER MOVIES, AND ESPECIALLY THE PLANET OF THE APES SERIES, LEFT A DEFINITE IMPRINT IN HIS WORK.

ROBERT'S WORK HAS APPEARED ON ALBUM COVERS, IN PUBLICATIONS SUCH AS THE THING: ARTBOOK, TIKI MAGAZINE AND PINSTRIPING & KUSTOM GRAPHICS MAGAZINE, AND HAS SHOWN IN GALLERIES INCLUDING DISNEYLAND'S WONDERGROUND, HAROLD GOLEN, M MODERN, CREATURE FEATURES, AND BEAR & BIRD AMONG OTHERS.

YOU CAN ALSO SEE ROBERT'S WORK IN TRADING CARD SETS FOR TOPPS, CRYPTOZOIC, AND UPPER DECK ON LICENSES SUCH AS GARBAGE PAIL KIDS, WACKY PACKAGES, MARS ATTACKS, STAR WARS, DC COMICS, MARVEL COMICS, RICK AND MORTY, GHOSTBUSTERS, ADVENTURE TIME AND MORE.

ROBERT IS ALSO THE AUTHOR AND ILLUSTRATOR OF THE BOOKS LAST CALL AT TIKILANDIA, STRANGEWISE NO.9 AND CHIMPS & TIKIS AND RAVEN-HAIRED BEAUTIES: AN ADULT COLORING BOOK, NOSFERATU'S CHRISTMAS IN NEW YORK AND WEIRD-ASS FACES VOL.1.

SEE MORE OF HIS WORK AT:

ZEROSTREET.COM

TIKITOWER.COM

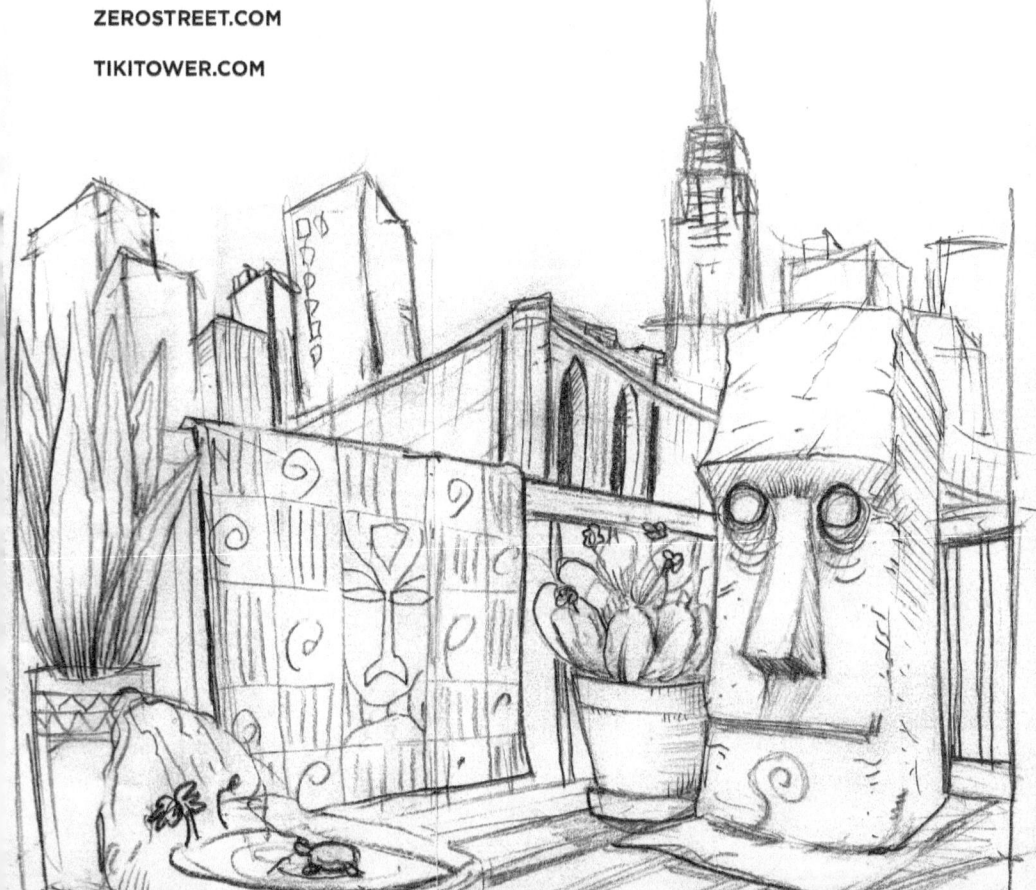

www.ingramcontent.com/pod-product-compliance
Lightning Source LLC
Chambersburg PA
CBHW030659220526
45463CB00005B/1849